Writing as a
Visual Art

intellect series
in Language and Writing

Available at www.intellectbooks.com

Writing as a Visual Art

Graziella Tonfoni

Abridged by James Richardson

THE SCARECROW PRESS, INC.
LANHAM, MARYLAND, 2000

intellect™
EXETER, ENGLAND

Paperback edition first published in Great Britain by
Intellect Books, FAE, Earl Richards Road North, Exeter EX2 6AS, UK

Copyright ©2000 Intellect Ltd

ISBN 1-84150-029-1

A catalogue record for this book is available from the British Library

SCARECROW PRESS, INC.

Paperback edition published simultaneously in the United States of America by
Scarecrow Press, Inc., 4720 Boston Way, Lanham, Maryland 20706
http://www.scarecrowpress.com

ISBN 0-8108-3862-1

Library of Congress Cataloging-in-publication Data Available

329266

Consulting Editor:	Masoud Yazdani
Production Editor:	Robin Beecroft
Cover Design:	Michele Semenza
Copy Editor:	Wendi Momen

80 8 TON

Printed and bound in Great Britain by Cromwell Press, Wiltshire

Contents

Writing as a Visual Art

Foreword

Marvin Minsky
Toshiba Professor of Media Arts and Sciences, MIT

> *'Text is the self-portrait of human thought.'*
> —Ted Nelson

We all know how to listen and speak. We're all fairly good at conversing and we take it for granted that when people write, the readers will easily understand. Language involves remarkable skills — yet we rarely ask how such things work. Why are we able to read at all, when written words are mere physical marks — whereas thoughts and ideas are not things at all. Ignoring this, we simply declare that eloquent authors have talents or gifts — as though they either were born that way or were raised to those heights by some magical hand.

In truth, it's quite the opposite. Language skills don't come easily; they develop through years of trying to speak, from our earliest stages of childhood. We work at this both vocally and privately, inside our minds. Yet we never consider that conduct as work; instead we regard it as more like play — forgetting that play is our hardest work. This is the paradox of human psychology: the things that we find the most easy to do are often the ones the most hard to explain. Of course this isn't always true, but it makes an excellent story.

Consider those mental monologues that most of us experience. Few other kinds of mental work engage our brains so constantly. Vision, despite its complexity, appears to need no thought at all. It seems equally easy to stand or walk — yet these are also remarkable feats. We also do commonsense reasoning, and react to social stimuli, while scarcely aware that we're doing those things. How could such complex activities seem so simple and spontaneous? Perhaps because all that work is sealed off in separate systems of the brain, so that each one's enormous complexity does not disrupt the other ones. That could be why we're unaware of how we see, or hear, or think: none of those systems knows or cares how any of the others work.

> *'Be careful of reading health books; you may die of a misprint.'*
> – Mark Twain

Language is our most powerful way to tell other people about our ideas.

Yet although this is a wonderful thing, we know almost nothing of how it works. What really are those 'talents and gifts' that writers use to communicate? We almost never think about this because it all seems so natural. Nor do we have the faintest idea of how we choose words and make sentences. Yet every speaker knows many ways to describe and explain, to indicate and illustrate, to elaborate and reformulate. We're all fairly good at sentences. Less common are the skills one needs for writing (or reading) good paragraphs. And only a small minority are proficient at such larger forms as chapters, essays, or major reports.

Deficiencies in writing skills can leave a reader wondering, 'I can't figure out why they're telling me this.' But it isn't always the writer's fault when a paragraph is misunderstood; this also happens when readers are weak at reading the signs that writers use to indicate the functional roles that each of their statements is meant to serve.

We have already remarked that language skills are developed through years of hard work. This idea could be discouraging to those who seem less talented, for it seems to imply that any improvement would require too much exertion and pain. But although this is the prevalent view, perhaps our culture has exaggerated those differences, in the course of magnifying the virtues of our heroes. We don't know how to account for those prodigies of eloquence. But once we make ourselves recognise that we we're no better at explaining what common folk do, those differences seem less daunting.

To put some flesh on that argument, here's an arithmetical metaphor: suppose that a good explainer must be a master of precisely one thousand language skills. If so, then a person who lacked ten of those would be missing only one percent. Yet if that were enough to make something go wrong with one of every hundred words, then one such error will likely occur in almost every paragraph. Of course I don't mean this to be taken literally. We mathematicians explain things best by ultrasimplifying them. This 'example' is only intended to show how a very small deficiency could produce an effect that might appear to depend on a much larger factor.

There are people who are not so proficient with words, yet are brilliantly clear with diagrams. There are others whom we can understand only when they wave their hands. They use other forms of rhetoric that are usually not embodied in text — and perhaps those skills live in parts of their brains that are not directly concerned with words.

> *'I have never had a thought which I could not set down in words with even more distinctness than that which I conceived it.'*
> — Edgar Allen Poe

Socrates: Anyone who leaves behind him a written manual, and likewise one who takes it over from him, on the supposition that such writing will provide something reliable and permanent, must be exceedingly simple minded.

Author: But if something is written clearly enough, we can usually understand what it says.

Proust: That's what we think is happening, but each reader reads only what is already inside himself. A book is only a sort of optical instrument that the writer offers to let the reader discover in himself what he would not have found without the aid of the book.

Author: Well, I agree that a reader has to know what the separate words mean, but certainly you can say something new in how those words are arranged.

Socrates: Perhaps so, but remember that writing is really no better than painting: you can never be sure what will come from them. The products stand before us as though they were alive; but if you question them, they maintain a majestic silence. It is the same with written words: they seem to talk to you as though they were intelligent, but if you ask them anything about what they say, from a desire to be instructed, they go on telling you just the same thing forever! And once a thing is put in writing, the composition, whatever it may be, drifts all over the place, getting into the hands not only of those who understand it, but equally of those who have no business with it; it doesn't know how to address the right people and not address the wrong. And when it is ill-treated and unfairly abused it always needs its parent to come to its help, being unable to defend or help itself!

Author: But once the writing is well understood, the result inside the reader's mind is not like a passive document. Good language builds active structures in a listener's brain, and then those structures can interact with other things that the listener knows.

Critic: That's easy to say, but what does it mean? Given that texts are mere strings of words, how can they build, in readers' minds, structures that can interact. You have to say more on how structures are built, and more about how they are used.

Author: Presumably, we build them in much the same way that we build anything else. First we have to activate some units that already exist, somewhere inside the reader's brain. Then we must make new connections between them — and finally we can turn them on. That's how anything new is made, no matter whether it is composed of computer parts or animal cells.

Critic: That's really too general to be useful here, where we're speaking of language and what it means. Specifically, what are those units made of, and how do we connect them so they can work in meaningful ways?

Author: No one yet knows the answer to that. The most plausible current hypothesis is that the units are assemblies of nerve-cells, and these get interconnected by enhancing transmission through synapses.

Critic: That's too low a level to be useful to me. I'd like a higher level example of how a sentence could cause a listener's brain to build an appropriate structure.

Author: OK. 'John drove Mary from Boston to New York.' As soon as the sound of 'drove' was sent to the language centres of your brain, it was identified as a verb describing a certain form of transportation. This then activated an already existing structure that functions as a simple sort of story script. By itself, that script represents only the vague idea that someone will cause something to be moved from one place to another. But the other words are swiftly applied to replace those generalities by more specific substitutes. Now tell me where John's trip began.

Critic: Obviously, in Boston.

Author: How do you know that?

Critic: Because you said 'from' Boston.

Author: And where did it end?

Critic: In New York, because you said 'to' New York. We use prepositions like 'from' and 'to' to indicate which items should be attached to which vacancies in the story script.

Author: Who did the driving?

Critic: There was no preposition for that, but it had to be John because that name came just before the word 'drove'. We also use the order of words to indicate how to fill that slot.

Author: How did you know that John drove a car, rather than a truck or a bus? That wasn't among the words at all. In fact, the sentence said 'John drove Mary'.

Critic: It's a matter of everyday common sense that we rarely mention the obvious. We assume by default that John drove a car — and we never drive a person. (It would be a different story indeed if we knew that John's car was named 'Mary'.) As for him driving a truck or a bus, we'd expect the writer to mention it if the vehicle were very unusual.

Author: Precisely. Although this seemingly simple sentence expresses many relationships, no one has trouble connecting them. This is because we all are masters of using such story scripts. Each particular action-verb activates an already learned representation. In the case of transportation verbs, each script is composed of three descriptions: of how things were before the action, after the action, and the path or trajectory during the action. It is because we all learn the same rules for using such representations that we can all agree on how to assign which terms to which 'roles' in all three sub-descriptions.

'Words are only painted fire; a book is the fire itself.'
— Mark Twain

Critic: You're talking about what people call the 'rules of grammar'. But how do we know how to use them?

Author: It takes most children several years to learn to do it properly. Some researchers have maintained that some of these skills are built into our brains from birth. But I suspect that this seems so largely

because we learn these skills in those early years from which we have few memories.

Critic: But if grammar is learned and not innate, then why are all grammars so similar in all societies?

Author: Because the forms of the grammars are strongly constrained by the forms of the structures that people use for representing what we learn. I suspect that those structures are what is largely innate. For example, I'd be willing to bet that our brains are born with pre-wired hardware that makes it easy to represent actions as pairs of frames with trajectories. All cultures soon discover this and, consequently, all languages come to use such verbs, with somewhat similar grammar rules. And that, in turn, might be the reason why all cultures have sentences.

Feynman: A sociologist wrote a paper for all of us to read. I started to read the damn thing, and my eyes were popping: I couldn't make head or tail of it. Finally, I said to myself, 'I'm gonna stop and read one sentence slowly.' So I stopped at random — and read the next sentence very carefully. 'The individual member of the social community often receives his information via visual, symbolic channels.' I went back over it and translated. You know what it means? 'People read...'

Author: You can certainly make sentences hard to read by filling each slot with irrelevant stuff.

Critic: And using pretentious or obsolete terms like 'via' for trajectories. But where is all this going? Rules of grammar apply only to very small fragments of text.

Author: Precisely the subject of this book. Grammar constrains our sentences, but we do not have such neat constraints when it comes to larger spans of text. When what you want to describe does not fit into a single sentence, you may be able to say it in two or three sentences, but then you'll also have to indicate to your reader how to interconnect those two or three meanings.

Critic: And that's exactly what you just did. Your last sentence was composed of three separate sub-sentences, centred on the verbs 'does', 'say', and 'tell'. You connected them with the two conjunctions 'then', and 'but'.

Author: And see how we use that useful word 'but'. It tells you that there was something wrong with what you recently understood. It instructs you to go back and replace or augment some structure that you have assumed by default.

Critic: True, but now you're speaking psychologically. Ideas like that lie far outside the scope of traditional rules of grammar.

Author: Yet those are things we have to know in order to understand real text. In my opinion, the very concept of grammar is perverse because it suggests that we can understand what language is without any idea about how it works. I suspect that this is largely why we still know so little about how language conveys meaning.

Critic: I have to agree with much that you've said. Sentences are strongly
 constrained by rules of grammar, while paragraphs are a good deal
 more free. Then, when it comes to larger forms, there are scarcely any
 rules at all, but only individual styles. The problem is that so many
 writers have poor style.

'... As a child, I became aware, somehow, that what I put down on paper was —
 at least some of the time — exactly what I wanted to say.'
 —Jeremy Bernstein

'Writing as a Visual Art' asks why so many people can't write good text.
Their problems arise at every level, from filling each sentence with suitable
words, to choosing the name of a book. Few people have trouble
understanding simple explanations. But we all have trouble with both
writing and reading, when it comes to more complex texts. Let's look at
some problems at each level.

Selecting the right word can be troublesome, but most people know how
to use most of their words. Some people have unusually large vocabularies
and are more able to select 'just the right word'. But if that capacity
overgrows, it then can do more harm than good. A scholarly friend of mine
reads each new dictionary and prides himself on being able to find the
exactly appropriate words. Unfortunately, no one can understand his
books because no one has seen those words before.

Most people have little trouble arranging words into sentences.
However, a sentence that is grammatically 'correct' can still be difficult to
understand if the writer has tried to use it to combine too many different
kinds of ideas. In such a case, it's better to break up the argument into
several separate sentences, to form a paragraphic group. But that can lead
to trouble, too, unless we mark each sentence or phrase with some device
to indicate how it relates to other parts.

More serious problems are bound to arise with texts of larger size. When
a writer explains more complex things, how is the reader supposed to
know what each part of the text is trying to do? When writing or speaking,
we tend to lose sight of some of our current purposes. I often find while
I'm lecturing that some part of my mind is wondering if I'm repeating a
point for emphasis or trying to say something new. Am I attempting to
summarise, or starting to reformulate, or merely making a small
augmentation in something that came before? Am I clarifying, or
exemplifying, or describing evidence for a statement already made — or
am I preparing the case for a point to make subsequently. Frequently it is
none of these. Instead, writers often use other techniques to induce a
reader to favour some view without being explicitly told to. This can go so
far as to recount entertaining stories that have little to do with the
argument, but, by engaging the reader's sympathy or interest, make the
essay more pleasant to read.

Such tactics can be valuable — but only if the reader's mind knows what

to do with each fragment of text. When such devices fail to work, and therefore some of the readers get lost, we can't conclude that the writer has failed to communicate. It could be quite the opposite — if the writer's confusion is transferred directly across to the hapless reader's mind. Indeed, I fear I've done this now. I had intended, from the start, to focus on one clear idea — that the goal of good writing is finding good ways to copy things from one mind to another. Instead of clearly explaining this, I find myself rambling aimlessly. If I had taken Tonfoni's advice, we'd surely be finished by now.

> *If what we were discussing were a point of law or of the humanities,*
> *in which neither true nor false exists, one might trust in subtlety*
> *of mind and readiness of tongue and in the greater experience of the*
> *writers, and expect him who excelled in those things to make his*
> *reasoning more plausible, and one might judge it to be the best.*
> *But in the natural sciences, whose conclusions are true and necessary*
> *and have nothing to do with human will, one must take care not to*
> *place oneself in the defence of error; for here a thousand Demosthenes'*
> *and a thousand Aristotles would be left in the lurch by every mediocre*
> *wit who happened to hit upon the truth for himself.*
> - Galileo Galilei

Critic: And what, precisely, is her advice?

Author: That marvellous as writing is, it can be improved with visual aids.

Critic: You mean, messing up a manuscript with drawings and diagrams?

Author: Not really. Small changes can make large differences. A little can go a long way. We can do a lot with only a few graphic symbols.

Critic: Yet although publishers have long had such capabilities, most good writers don't seem to need them. You don't find any diagrams in the most popular novels.

Author: That's because in popular novels the reader already knows what's going to happen.

Critic: Nonsense. They're always full of surprises.

Author: Yes, in many minor respects. But in general literature, there are only a few basic large-scale plots, and every good reader knows all of them. When writers don't conform to them, their stories do not become popular.

Critic: I don't see anything wrong with that. Familiar forms make understanding easier. And inside those constraints, good writers can still do almost anything they want to do.

Author: That may be true, for conventional literature. But it works less well for describing things that do not conform to conventional plots. The structural schemes that work for stories don't always work for non-fiction. I have often spent many hours failing to understand a few pages of what appeared to be a well-written text — only to find that a few minutes' talk with an expert made everything clear. It is usually only a

matter of missing some critical relationship. The trouble comes, as
Socrates said, when the text won't answer your questions.

Critic: Then perhaps those pages were not so well written.

Author: That's often the case, but other times the trouble goes deeper than
that. When you have to explain something intricate, then writing,
without any visual aids, can simply be too linear. An author can make
any number of points, but sometimes the connections must cross one
another too many times. This isn't much of a problem in stories, because
time itself is linear. But when you're explaining a complex machine, or a
fragment of higher mathematics, or the workings of an organisation,
you need to be able to jump out of time so as not to get stuck on a single
track.

Critic: That makes sense, but I have another objection. The use of graphics
might bring more loss than gain. How often even a well-made film lacks
effects that were in the original book, because imposing definite images
constrains the viewer's imagination. After all, no writer knows all that
those readers may know. Therefore you want to leave plenty of room to
exploit the reader's knowledge and imagination.

Author: True, but Tonfoni is not proposing to augment books that already
serve well their purposes. She's trying to help us in other domains
where conventional methods don't work so well. And, yes, using these
methods might indeed constrain the reader's imagination — but that
isn't always a bad thing to do. When you have to explain a complex
thing, you may need to maintain more control.

Critic: Granted. But we often do that anyway. Even the writers of
unadorned text use graphic groupings in any case. We rarely see texts
that are not divided into headings, sections and other such shapes.

Author: True, but still those are essentially linear. Contrast such writing
with face-to-face conversation. Then you usually find yourself engaged
in many different activities, all at the same time. You use certain
gestures to put the other person at ease. You invent other gestures at
various points, to be later re-used as reminders. You modulate your
voice and animate your head and face; all these devices help guide the
listener to emphasise and reorganise internal structures and processes.

Critic: You can also use such gestures to distract the listener's attention, or,
by appearing friendly or conciliatory, you may be able to gain approval
of your proposals even when the arguments are weak. You can do
similar things with writing too — like inventing your own critic, so that
you can win all your arguments without regard to their merit.

Author: In any case, it really seems miraculous that linear writing can
work at all. This is because writers have been making stylistic
inventions for thousands of years. Still, many texts are simply too hard
to read, and the point is that we can make our meanings much clearer
by adding just a few graphical devices.

Critic: Fine — but what does meaning mean? That is a concept that the

finest philosophers have failed to clarify.

Author: That's mainly because of trying to describe what meanings are instead of how they are used. That's precisely the wrong way to go. We consider something to be meaningful, not when it happens to have certain particular characteristics, but when we find ourselves able to apply it to, or use it with, a variety of processes. When I say that an expression seems meaningful, I'm saying more about myself than about that expression.

Critic: That sounds too fuzzy to be useful.

An idea with a single sense can lead you along only one track. Then, if anything goes wrong, it just gets stuck, a thought that sits there in your mind with nowhere to go. That's why, when a person learns something 'by rote', that is, with no sensible connections, we say that they 'don't really understand'. Rich meaning-networks, however, give you many different ways to go: if you can't solve a problem one way, you can try another. True, too many indiscriminate connections will turn a mind to mush. But well-connected meaning-structures let you turn ideas around in your mind, to consider alternatives and envision things from many perspectives until you find one that works.
And that's what we mean by thinking!
— Marvin Minsky

Author: The meaning of a word or phrase depends first on how we represent it in our minds — and then on how we've connected that to all the other things we know. If we link it to only one other thing, then virtually nothing will be gained. That's why it's almost always wrong to seek the 'real meaning' of anything. A thing with only one meaning has scarcely any meaning at all.

Critic: Isn't there something wrong with that? It isn't enough just to make connections, so that every idea is based on several others. Don't you have to start somewhere, with more solid things? Unless your network of ideas is grounded on some concrete foundation, it will all float up in the clouds.

Author: There is nothing wrong with a group of thoughts in which each lends meaning to the rest — the way that each strand in a rope or a cloth keeps the others from falling apart.

Critic: Nice metaphor, but the rope won't work without those strands. Anyway, I wasn't looking for an endless philosophical argument. How does all of this connect with the subject of Tonfoni's book?

Author: Through the idea that meanings themselves are usually multi-media. For example, what happens in your mind when I say just the one word 'telephone'.

Critic: It leads me to think in several ways. Some of these are visual. I can think of a telephone's physical form, perhaps dumbbell shaped, with a wire attached, although most of the newer cordless ones are wireless, with more box-like shapes. I also have kinesthetic ideas about holding

the phone against my ear with the microphone close to my mouth. I can imagine holding it either with my hand or by clamping it between shoulder and chin. (Those newer phones don't do this well; they either fall off or my face presses buttons that make it beep.) Also, 'telephone' evokes social thoughts; a telephone is an instrument of spoken communication. I haven't called my mother lately. Economic thoughts, too. Last month came a huge long distance bill. Visual, kinesthetic, social, emotional, economic; isn't it amazing how a single word can engage so many different realms of thought. But how does all of this apply to texts as compared to telephones?

Author: Each of those realms requires you to use several different kinds of brain-representations. So your 'concept' of a telephone is likely to involve at least a dozen different types of networks in your brain. No one yet knows what those are like, but it seems plausible that some of them might resemble what computer scientists call semantic networks. Other brain centres might employ various forms of sequential scripts; others might use fuzzy pattern matching, while yet other brain mechanisms construct various sorts of symbolic-image representations. The point is that every reader of text must do many of these sorts of things, some of which may lead to problems.

Critic: What sorts of problems do you have in mind?

Author: When language builds things in a listener's mind, it is easy to indicate localised links. But when thoughts that a writer wants you to connect get further apart in the serial text, it gets hard to find words to connect them. Pronouns work well for nearby things, but are clumsy when skipping a paragraph.

Critic: You can get around that by naming something at one place and using that name at a later point.

Author: But when you do too much of that, it overloads your reader's verbal memory. You can add more links with less mental strain by using visual symbols and graphical links.

Critic: Are you saying that we have more visual than verbal memory?

Author: It isn't that either one is larger or better, but that they engage different kinds of machinery that we can use in different ways. It is very hard to understand a verbal description of a system or gadget with five or six parts — yet that's easy to do with a diagram. Why shouldn't it be just the same for exposing the structures of arguments?

Critic: Then why didn't Shakespeare need diagrams, or Molière, or Melville?

Author: Melville could have told us more about those nautical contrivances if the publisher had given him more latitude. Imagine how hard it would be to write about mathematics — or any other technical subject — if you couldn't use those special effects — symbols, equations and things like that.

Critic: If mathematicians gave those up, perhaps we ordinary folks could

understand what they're talking about.

Author: We could indeed, because then they'd have to leave out all their best ideas.

Critic: That was supposed to be a joke. Anyway, I think I see the central point. It isn't merely arguing that each particular subject could benefit from using its own special symbols. Tonfoni is proposing that a certain particular set of symbols could help us with texts in general. That could improve all sorts of writing, at only a single initial cost.

Preface

'Writers are made, not born', goes the old saying. It's abundantly clear, however, that not nearly enough writers are being made. A survey recently commissioned in the United States by the Oregon Progress Board revealed that a majority of the 2,000 Oregon residents randomly surveyed lacked the literacy skills needed to handle the ordinary tasks of daily life.

Even among the literate, writing is at best a difficult activity that frequently results in discouragement and ineffective communication. Although numerous books have heralded ways to improve writing skills, few, if any, have succeeded. Most books about writing fail to go beyond traditional methods that more often than not stifle the motivation for writing and effect little improvement in writing skills.

Technology too promises to improve writing skills. But even today's powerful personal computers with sophisticated word processing software seem to do little to effect better writing. Technology certainly does make writing easier, but it's having innovative ideas to undergird technological advances that will make a real difference.

This book offers some such ideas. It introduces you to a totally new, revolutionary approach to writing. It explores writing as a visual, multidimensional experience that is fun and common to your everyday experience. It examines how writing text is akin to creating a drawing or painting and designing a structure. Furthermore, it suggests intriguing concepts and visual tools such as 'shaping up text', 'textual objects' and 'textual machines' as aids to facilitate more natural, effective and creative writing.

These concepts and tools are the result of discoveries I've made during ten years of research in the fields of linguistics, cognitive science and artificial intelligence. I have used them with great success in numerous programmes for high school and university students in Italy and elsewhere in Europe, as well as in training workshops for various corporations in the United States. As you read this book, you too will learn a new way of writing. You will see that writing is a natural, enjoyable activity and you will find new tools to improve the effectiveness of your writing.

This Book is for You

You're a likely candidate to benefit from this book since some interest has moved you to set your eyes on these words. This book doesn't offer a sure-fire way to become a Pulitzer Prize-winning writer, but it does explore how you can make your writing more effective and creative. The conversational approach and illustrated content of this book are designed for anyone, regardless of age or background, who wants to experience a new way of writing. People who will benefit from the techniques presented in this book include:

- Anyone who writes letters, memos, reports, proposals, directives, legal documents and other business communications as a normal part of his working day.
- Journalists, writers, teachers, students and academics who write articles, stories, books, research papers and other documents.
- Would-be novelists, screenwriters, story-tellers and other people who write for enjoyment and self-expression.
- Everyone involved with designing friendly, effective human interfaces for interactive software systems.

The goal of this book is to help you discover the visual, physical realm of writing. To experience this new dimension of writing, all you need to do is to open your mind to the ideas presented here and then explore the possibilities they afford you.

How to Read/Use this Book

To use this book most effectively, first scan the table of contents to get an idea of its entire contents. Notice that there are six chapters and an anthology that collectively show many facets of my visual approach to writing. The chapters are arranged in a progressive order. The initial chapters are the most traditional and the least abstract, and you should read them first. As you read sequentially through the chapters, you will be increasingly challenged to think more abstractly and to focus more and more on visual, mental images. The chapters gradually lead you from your traditional, linear, flat experiences of writing to completely new experiences visually in three-dimensional space. The anthology included after the last chapter demonstrates some of the visual writing techniques and provides you with an exemplary summary of them.

After scanning the table of contents, next take a minute and quickly flip through the book for a visual impression. As you browse through the pages, you'll notice every chapter except the first one includes numerous illustrations. If you think the illustrations are a bit odd and wonder what they have to do with writing, that's great – you've just started on your journey to experiencing a new way of writing!

To add more substance to your initial verbal and visual impressions, here's a brief summary of the book's structure and content. The first chapter, 'The Physical Experience of Writing', provides a conceptual and

historical basis for the writing techniques introduced in this book. It sets forth three innovative concepts that radically challenge traditional attitudes and assumptions about writing. These concepts are: (1) a writer's purpose or intention deeply affects the style or type of writing; (2) writing and reading are intimately linked processes; and (3) creativity in writing concerns the visual, physical aspect of language and structuring text.

These three concepts are foundations of the Text Representation System (TRS) and Communicative Positioning Programme (CPP) – a methodology that I developed to integrate the verbal and visual aspects of language and make communicative intentions explicit. This books introduces you to the revolutionary visual, physical writing techniques that I invented in applying my TRS and CPP methodology. Over the last ten years these techniques have helped thousands of high school and university students and business people to achieve greater effectiveness and creativity in their writing.

After proposing a new way to think about writing, Chapter 1 then briefly gives historical evidence that shows how writing has always been a physical experience, intimately connected with the material used for writing. It points out how, from the earliest times, the material used for writing profoundly affected the way writing was conceived. The first chapter also proposes how the 'polittico' – a traditional style of painting consisting of partitioned elements – can serve as a strong visual metaphor for physically organising and structuring text.

Chapter 2, 'Writing as Drawing and Painting', leads you to experience writing in a new way – as an act of creating a drawing or painting. It expands the ideas presented in Chapter 1 by indicating that drawing and painting are ideal metaphors for writing because they are visual, fun endeavours that make use of material and techniques that have parallels in writing.

Most of Chapter 2 is devoted to presenting various 'canvases'. A canvas is simply a metaphorical visual aid that helps you reflect on and visualise certain cognitive processes important in writing. Each canvas represents a specific communicative purpose, such as brainstorming, conversing or negotiating, narrating, explaining and analysing. The first canvas, for instance, is the 'Word Explosion' for brainstorming and it enables you to free your mind from preconceived ideas about what you're going to write. Some of the canvas descriptions also include an exercise that explicitly tells you how to put the canvas to use both as a writer and a reader.

Chapter 3, 'Writing with Visual Symbols', discusses visual symbols that you can use to enhance the communication and cooperation between you and the readers of text you write. Visual symbols are like road signs that tell a driver what lies ahead, or the notation that directs a musician how to play a musical score. You place them beside or within text.

There are two kinds of visual symbols. The first kind characterises the style of the text, while the second kind facilitates an interaction between

you and your readers. The text-style symbols represent cognitive processes that take place all the time in ordinary communication. They each have a precise meaning, as reflected in their action-oriented names – 'Describe', 'Define', 'Narrate', 'Point Out', 'Explain', 'Regress', 'Reformulate', 'Inform' and 'Express'. There are also five interactive, or 'turn-taking' symbols that you can use to tell your readers exactly how you want them to interpret your text, and when you want them to take part in modifying it.

Chapter 4, 'Shaping and Organising Text in Space', challenges you to consider text as having a visual, physical attribute of shape that explicitly conveys the intention of text to readers. When you write text with a shape, the shape of the text itself is clear evidence of your communicative intention, and your readers will know it immediately when they see how you've 'shaped up' the text. Square-shaped text, for instance, carries a narrative intention. Round text, half-round text, triangular text and other geometric shapes of text all identify specific communicative intentions. To make this concept of textual shaping less abstract, Chapter 4 includes a simple example that shows exactly how to shape text.

Chapter 5, 'Building Textual Objects', carries the shaping of text from two to three dimensions. It explores how you can conceive of writing text as constructing three-dimensional objects in space. Through illustrations and detailed instructions, Chapter 5 teaches you how to write text represented by cubes, pyramids, miniatures, politticos, obelisks and cylinder/columns. Each of these textual objects carries with it evidence about its particular meaning. When you wrap up text to form a textual object, the object's shape exhibits exactly the right perception needed for reading the text.

To write a story, for instance, you conceive of the story as a textual cube. The cube consists of six flat, square faces containing text. Text with a square shape, as explained in Chapter 4, signifies a narrative intention. Each square face of the cube therefore represents a segment of the story told by the whole cube itself. To create a three-dimensional story, you simply write the text for each square, and then wrap up the six textual squares into a cube. Where you position each textual square and how you work out the relationships and interfaces among the square faces reflects the story's structure and your creativity in writing it.

The sixth and final chapter, 'Imagining Textual Machines', introduces you to the concept of textual machines. Textual machines, like the canvases presented in Chapter 2, represent some cognitive processes that occur during writing and reading text. They are different from the two-dimensional canvases, however, in that they model and animate these cognitive processes in a physical, mechanical way. Textual machines are revolutionary aids to help you reflect on and rethink the processes of writing and reading. Unlike textual objects, you don't construct these machines. Instead, you observe them perform in the virtual reality they inhabit. As a spectator in this virtual reality, you're given an opportunity

to experience and reflect on the processes that occur in your mind as you write. As you imagine, visualise and experience the physical motion of the textual machines, you gain understanding and insight into the complex, interconnected processes of writing and reading.

In order of increasing complexity Chapter 6 describes, illustrates and explains fourteen different textual machines. The 'Text Lens' is an example of one of the simpler machines, and it models how to focus directly on some information in a text, and then expand and enlighten it. Some of the more complex textual machines deal with such complicated processes as the selection and interpretation of information. Each textual machine is designed to stimulate and heighten your awareness of specific cognitive processes involved in writing. As you gain this self-awareness, you will have a clearer understanding of your writing purpose, and you will have a physical model to help you accomplish your purpose effectively.

An anthology follows the final chapter. The anthology reinforces some of the concepts and techniques presented in the preceding chapters. The first part of the anthology, which is named 'Text Origami', provides explicit examples of how text shaped into textual signs such as squares and triangles can be combined and transformed into textual objects such as cubes and pyramids. The textual objects that result from shaping text this way visually represent the text globally, so that the very shape of the text itself conveys a perception about the text as a whole. The second part of the anthology is 'Text Decoration'. Text decoration concerns visually representing text locally by using textual symbols to 'adorn' and embellish the text. The texts used in the examples of text decoration come directly from Chapter 3 and this Preface so that you can compare their linear version to an embellished version that includes symbols.

You may wonder why no bibliography follows the anthology. The reason is simple: this book presents visual techniques for writing that are totally new inventions, and the only way to learn more about them is to apply them yourself and explore the wonderful possibilities they open up. I cite a few books in the Acknowledgements that have been decisive in shaping my thinking. My physical experiences, however, have also been crucial. I've examined Egyptian sarcophagi, obelisks and other artifacts exhibiting writing in the British Museum. I've visited Etruscan ruins in my native Italy and have observed many ancient forms of writing. Throughout Tuscany, I've visually experienced hundreds of polittico paintings. These encounters with antiquity and art have been vital stimuli for my thoughts about the visual aspects of writing.

Now I want you to experience a new way of navigating *Writing as a Visual Art* (WAVA). Just pretend you are visiting the WAVA Gallery (opposite) following the suggested path. Each room represents a chapter and displays the content of it. Enjoy!

The visual techniques for writing presented in this book give you a new set of tools, and nothing should stop you from experimenting with them!

As you experiment, you may become a contributor to a future
bibliography. You might, for example, explain how you created a textual
origami that reflects your analysis and interpretation of some well-known
literary work, configured and connected some of the textual machines to
model a series of textual processes, or even how you invented a new
textual machine. Contributions like these have in fact occurred in Italy as
people discovered new ways to apply my visual writing techniques.

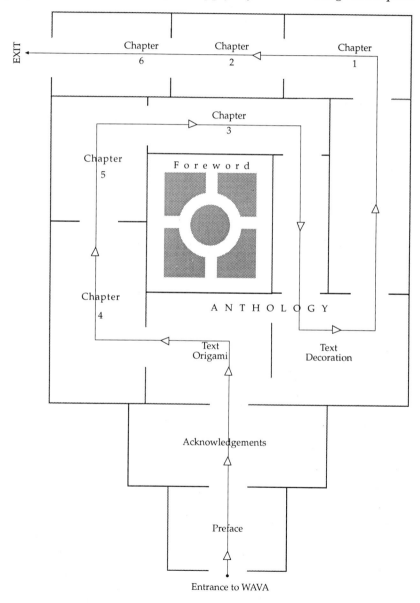

The purpose of this book is to lead you to experiencing a new way of thinking about and practising writing. As you allow yourself to have this experience, you'll discover how much fun writing is and how much more creatively and effectively you can write.

Acknowledgements

At the outset I must take full responsibility for the ideas presented in this book. I have developed them over several years of research and have formulated them into a methodology called the Communicative Positioning Programme (CPP). Whether you think my ideas are revolutionary, innovative or simply crazy, I accept the sole responsibility for their creation. I do, however, owe a debt of gratitude to many people who gave me the opportunity to explore new fields of knowledge, formulate my own ideas and present them in this book.

First of all, I want to thank Jim Richardson, who wrote this book with me. He followed my vision for it from the beginning, and throughout it all he remained available, friendly and responsive. During many hours of conversation as we worked chapter by chapter through the contents of the book, he was always open to my ideas. He expertly transformed those conversations into written text, accurately incorporated my comments, and carefully prepared the final manuscript.

The process of writing this book involved a considerable knowledge transfer. First, through phone conversations and correspondence, Jim and I worked out an outline of this book. Over the course of about three weeks as we met together, I then explained the concepts and details of the content to him. We taped those conversations, and they became a verbal draft of this book, from which Jim made a written draft. I read the written draft as Jim produced each part of it, and taped comments to sharpen and expand it. Jim then incorporated those comments into the final manuscript.

My gratitude to Professor Marvin Minsky of MIT is far ranging. I'm grateful to him for his interest in my research over many years. I have fond memories of his wonderful courses at MIT and how they stimulated my interest in artificial intelligence and opened my mind to ask the basic questions that lead to discovering new theories. I had the good fortune of seeing Professor Minsky develop his theory of agent-based intelligence, which he brilliantly presented in *The Society of Mind* (Simon & Schuster, 1986). I moreover had the rare privilege and pleasure of reading this important book even as he wrote it. His idea of each page of the mind visually representing one concept has influenced my own thoughts. I'm also indebted to Professor Minsky for numerous conversations with me about various aspects of my work and for commenting on a draft of this book. I thank him and his wife Gloria for their warm friendship over the years, and for allowing me to be a guest in their home in Brookline many times.

I also want to thank Professor Patrick Winston, director of the MIT

Artificial Intelligence Laboratory, for first introducing me to the concept of artificial intelligence. His courses in artificial intelligence at MIT caused me to begin thinking about how language and vision are very closely related. Some of what I've now worked out in the CPP flow from these early explorations in Professor Winston's courses. His book, *Artificial Intelligence* (Addison-Wesley, 1992), especially Part III on 'Vision and Language', has continued to enrich my own understanding.

I thank Professor Roger Schank of the Institute for the Learning Sciences at Northwestern University for his advice and friendship, and for all the scientific arguing and the theoretically friendly fights that we've had since we first met in Washington, D.C. many years ago. Through his book, *The Creative Attitude* (Macmillan, 1988), I gained insight into what it means to be creative and anti-dogmatic.

I also thank Dr Richard Doyle, Director of the Artificial Intelligence Group at the Jet Propulsion Laboratory, for supporting my idea of publishing my visual approach to writing in an English book. While we were working at the Artificial Intelligence Laboratory at MIT, Richard and I co-authored an article on textual theory entitled 'Understanding Text through Summarization and Analogy' (MIT Technical Report 716). Richard made it possible for me to meet Jim Richardson and begin the process of creating this book.

I'm also grateful to Professor Paolo Valesio for inviting me to present my ideas at Yale University and for having read my Italian books, which were precursors to this book. I'm grateful for his affirmation of the importance of my work and for calling my methodology 'a new visual rhetoric'. The discussions we've had and his encouragement have been invaluable.

Among those in Italy, I first of all want to thank Professor Marco Somalvico. From the beginning, he strongly believed in what I was doing. Even when my ideas were only beginning to take shape, and when I was encountering difficulty in their creation, he remained steadfast and continuous in his support. He helped me understand the importance of thoroughly explaining my ideas to people and continuing to forge ahead even when that was difficult.

And I also want to thank Dr Luigi Turrino, who has followed the different stages of my work and has been supportive during times of difficulty. From the beginning, he caught the real spirit of my work. He has given me valuable advice. He was also of tremendous assistance as I gathered material in museums. Moreover, he graciously applied his talents to redrawing the illustrations in Chapter 6.

I also thank my students, both graduate and undergraduate, in the CPP group at the University of Bologna, the teachers who work for me in various schools and specifically Paolo Tosolini who has helped me work out the hypertext (hyperCPP) which you may get after buying the book. Each of these people has contributed in vital ways to help disseminate my ideas through workshops and/or software. John Diamond also provided

support by retaining my scientific records in his office.

Finally, I would like to thank Masoud Yazdani at Intellect Books. He patiently waited for the manuscript, made valuable suggestions about the final form of the book and ensured its timely and expert publication. His personal endeavours and oversight were indispensable, and I greatly appreciate them. Andrew Healey and Mary Millner lent their expertise to the marketing and publicity of the book.

Graziella Tonfoni
May 1993

1

The Physical Experience of Writing

Writing is organising and packaging information and knowledge for readers.

But writing is more than a cerebral, verbal activity. It's actually an adventurous physical experience that has material, visual and spatial aspects. To participate in this adventure as a writer, discard your old notions and instead think of yourself as a drawer, painter and an architect.

Drawing, painting and architecture are appropriate, powerful metaphors for writing, as you will soon see. As you read this book, you will be guided into experiencing text in a physical, visual way. You'll see how you can plan texts so that they extend beyond a strictly linear dimension and instead exhibit definite physical shape in space.

A Revolutionary Way of Thinking about Writing

Whether or not you're consciously aware of it, you have certain attitudes and assumptions about writing. Many of these attitudes and assumptions may be traced back to your childhood when, as a schoolchild, you were taught about written language. Your first encounter with writing was probably learning to print letters on paper with a pencil. At that point in your life, writing was a structured form of drawing. As you grew older, you learned about putting letters together to make words, and words together to make simple sentences. From childhood to adolescence, you became more sophisticated in writing and constructed more complex sentences, paragraphs and texts. You gained skill in selecting and focusing on specific elements of knowledge in your writing, and you began to understand what things are implicit to readers.

Your thoughts about writing have probably changed very little since adolescence. Occasionally or frequently, a teacher or manager might have asked you to rewrite something you wrote to make it 'better'. You undoubtedly complied with the request, but were somewhat puzzled about what to do. Sometimes your rewriting satisfied your critic, other times it didn't. Why you succeeded on some occasions and not others may still be a mystery to you, as may what it means to 'write better'.

You continue to write today because writing is an important requirement of your daily life. You may even be motivated to write because you get personal satisfaction from it or because it's a means of self-expression. Whenever you write, however, you may feel that you're not as effective or creative as you want to be.

During all the decades that you've been a writer, you probably never really challenged your attitudes and assumptions about writing. Well, now is a good time to start! What follows are some concepts that will radically change your attitudes and assumptions about writing. These concepts are supported by the carefully worked-out writing aids and techniques detailed in this book.

Types of Writing

If someone asked you what type of writing you do, what would you say? You might say:

'Oh, I write reports at work.'

'I write term papers for my school classes.'

'I write proposals mostly, but I also write letters to my friends.'

'I write sales brochures and ad copy.'

'I do creative writing. I'm a screenplay writer.'

'As an engineer, I do little writing – mostly design specifications.'

'I'm constantly writing memos and legal documents as a lawyer.'

There are countless things that can be written – from advice columns to zoological surveys. Everything that's written, however, has a particular purpose or intention. This purpose or intention deeply affects the type or style of writing. To understand this, consider that a potter shapes a coffee cup differently from a vase. The two objects are made from the same material, but their shape is affected by the specific purpose of the object. Similarly, even though language is the material of all writing, 'defining' in a technical sense is different from 'describing' or 'explaining'. When you 'define', you provide the relevant details about something. When you 'describe', you give details about it, but without too much concern about selecting particular ones. When you 'explain', you supply the causes and effects of something so that you provide some understanding of it.

Defining, describing, and explaining are just a few of the various types of writing. You can also write with the purpose of narrating, pointing out, regressing, reformulating, synthesising, analysing or expressing. Each of these types of writing conveys a particular intention, perspective and point of view about something. These types of writing are the result of different processes that shape language, the material of writing.

Type or style in writing is like style in painting. Cubism, for example, exhibits a way of painting that's distinctly different from Surrealism or Impressionism. A Cubist painter intends to prioritise shapes, lines and forms in a way that exhibits a rational interpretation of objects. A Surrealist painter, on the other hand, wants to dream about what he's

seeing, and he mixes reality and dream together in his painting. An Impressionist painter is mostly concerned with reproducing light and light effects. Cubist, Surrealist and Impressionist painters all create paintings, but with radically different styles and perspectives about how they 'see things'.

Instead of categorising what you write according to its function, you can think about it in terms of your intention and point of view. So, for example, if you write a report, you may actually be writing with several different intentions and styles. You may begin the report by *describing* a situation. You may then *point out* something in particular, continue on by *analysing* that specific point, and finally *express* your own opinion about it. Thus during the course of the report, you adopt four different perspectives as a writer. You can tell your readers what perspective you're using by explicitly writing something such as, 'Now I'm going to analyse this situation', or you can 'shape' your text in a way that conveys what you're doing. When you take either action, you're giving information about what you intend to do and you create an appropriate expectation for the reader.

Creativity is not limited to particular categories of writing, such as poetry or novels. Creativity is always connected with effectiveness in fulfilling the intention or the purpose of writing. This means that you can be just as creative in writing a technical report as you can be in writing a screenplay or any of the other so-called 'creative' categories of writing. Creativity in writing has to do with exploring new and different possibilities for effectively accomplishing your purpose in writing. Once you adopt this attitude, you'll discover any writing endeavour, no matter how mundane, is an opportunity for you to be creative.

Writing and Reading

Writing always implies reading. Even if you write only as a matter of self-expression, with no intention of showing what you've written to anyone, you necessarily become a reader of your own writing. Writing and reading are akin to giving and receiving. They're connected, inseparable processes, and are like the two faces of a coin.

Besides being closely linked, writing and reading have a distinctly physical dimension. The English verb *to write* is derived from words that originally meant to scratch, draw or inscribe – all very physical activities integral to ancient ways of writing.

Reading, moreover, was originally understood to be a physical, oral activity. Most of the ancient Greek words for reading mean 'reading aloud', not 'reading silently' as we usually mean today.[1] For example, the Greek verb 'hypokrinomai' conveys the notion of acting – orally performing a play on a stage. The verb 'anagignosthain' means to read something aloud in a public place.

Creativity in Writing

A writer becomes creative the same way a potter becomes creative. To be creative, the potter masters the materials, techniques, processes and tools of pottery-making. He learns about the physical properties and structural constraints of different clays so that he knows the possibilities each one allows. He learns how long he has to shape a particular type of clay before it becomes too dry and hard to work. He also learns what type of clay is best for making small, finely detailed pieces and what type is best for creating large, massive vessels.

In addition to learning about the physical properties of the materials, the potter also learns about the various techniques, processes and tools for making pottery. He practices various techniques for working and shaping clay. He studies the processes of drying, firing, glazing and finishing pottery. Through experience, he also acquires skill in using tools such as the potter's wheel.

The potter's creativity is not diminished by the fact that he knows the physical constraints of the material, understands the processes of pottery-making, and has acquired considerable skill in using various tools. On the contrary, it's his physical experience of working the materials and his mastery of the techniques, processes and tools of pottery-making that enables him to explore new possibilities and to be truly creative.

Moreover, the potter's creativity isn't lessened when he makes an object that has a specific use or function. Simply because an object has an intended function doesn't preclude it from being made creatively. The potter can be just as creative in fashioning a coffee cup as he can in making an objet d'art. Instead of negating creativity, the function of the object complements creativity.

To be creative as a writer, you must learn about the materials, processes and tools of writing. The material of writing is language. To write intelligibly, you must master grammar and syntax, the verbal part of language. In addition to the verbal part of language, however, there's another substantive part – its visual, physical aspect – that it is important for you to learn about. In this book, you will encounter this aspect of language in a powerful way. You will be led through experiences that help you explore how the visual and verbal aspects of language come together in ways that facilitate your creativity in writing. From these experiences, you will begin to see new possibilities for conceiving and practising writing.

As a writer you must also experience the processes manifestly at work in using language to write. These processes – the so-called 'cognitive processes' – concern the ways you organise knowledge in your mind. You experience reality, perceive and represent it, organise it and store it in your memory in such a way that you're able to retrieve it at will. By being aware of these processes, you start to understand how to write better so that what you write achieves the effects you want it to have on readers.

Your memory is the end result of an intelligent, accurate and complex set of processes. Without memory, your mind would be like a roomful of books piled randomly from floor to ceiling – it would be virtually impossible to find any particular book, let alone specific information in it. But with the marvellous memory that you do have, you can retrieve information more rapidly, and in more interesting ways, than the most technologically advanced library.

The cognitive processes that shape and engage your memory are the following:

- Selecting – choosing some specific elements from a particular information set and ignoring the remaining elements.
- Focusing – concentrating your attention on certain, selected elements.
- Organising – placing the selected elements in some order.
- Storing – filing information in your memory according to some criteria.
- Retrieving – recovering elements stored in your memory by the use of keywords that trigger some elements and not others.

These processes are the foundation for the various types of writing (defining, describing and so on). When you define something, for instance, you select some of its elements and focus on them. When you describe something, you freely retrieve some of its elements from your memory. You make use of these cognitive processes all the time, but you're probably not aware of them. The exercises and techniques provided in this book, however, will help you experience and become aware of these processes so that you can activate them appropriately as you write.

The tools for writing you've had to work with up to this point have been limited. Without question, the computer with word-processing software is a powerful tool that makes writing easier. But in a fundamental sense, this tool has not deeply affected writing. Ineffectively written texts continue to be produced even with the use of computers. The chapters of this book present you with tools that can revolutionise writing. These tools, which are called 'canvases' and 'textual objects', integrate the verbal and visual aspects of language in a way never before possible. They enable you to experience visually the cognitive processes.

Once you experience the visual dimension of language, become aware of the processes underlying the various types or styles of writing, and utilise the visual tools for writing, you'll be able to write more creatively and effectively. For instance, you can create 'square' text for a story or 'triangular' text for your memories. By shaping text in a consistent way, you'll also become more aware of your own intentions and of the expectations you're creating for your readers. You may also invite your readers to cooperate with you so that you write in space together. As you put textual shapes together, you can create geometrical structures and

objects for writing. All of this will be a new way of writing for you, and you'll find the journey that leads to it a rewarding adventure.

A Revolution in Writing

The visual tools and concepts presented in this book profoundly affect writing. To foresee their significance, consider as an example the revolution of Impressionism in painting. There's no question that Impressionism produced a totally new way of painting. To be sure the genius of Claude Monet and a cadre of other French painters contributed to this revolution. But even more than that, the nineteenth century produced some major changes in artists' materials that deeply affected the practice of painting:

- The development of flat brushes, coupled with the introduction of metal ferrules, permitted a different kind of brush stroke – the broad and flat one – that precisely characterised Impressionistic painting.
- The discovery of new colours, as well as the discoveries of new theories of colours, such as the 'complementary theory' by Chevreul, who in 1864 divided the colour circle into 72 sectors.
- The invention of the colour tube, which facilitated outdoor painting. Prior to this invention, painters were restricted to studios because it was impossible to transport colours, since creating and mixing them required elaborate procedures.

As a consequence of these three structural changes, outdoor 'open-air' painting became possible, and a whole new way of seeing things was experienced by artists. This new perception of reality was captured by the Impressionist painter Berthe Monsot when he said, 'Everything sways, there is an infernal lapping of water, one has the sun and the wind to cope with, the boats change position every minute'.

The visual tools and concepts in the chapters that follow are, in a metaphorical sense, the flat brush, a new theory of colours, and the colour tube. These new tools and concepts enable you to experience a new way of writing that radically alters your very perception of writing itself. They prepare you to participate a revolution in writing that in many ways parallels the revolution of Impressionism in painting.

Where Does All of This Come From?

This century has produced some major changes that deeply affect the practice of writing. The advent of the computer has made it clear that a new way of writing is possible. Apart from word-processing technology, which makes correcting and modifying texts easier, the concepts of hypertext and delinearised ways of writing and reading were conceived. In addition, the endeavours of artificial intelligence and cognitive science provide possibilities for modelling the human mind.

The advance of word-processing technology led me to think about the possibilities of moving text outside the flat space of a computer screen. The development of hypertext, with its concepts of levels or layers of text,

further motivated my exploration of a physical, three-dimensional concept of text. The progress in artificial intelligence and cognitive science further prompted me to think about textual processes in visual, physical ways. Word-processing technology, hypertext, artificial intelligence and cognitive science laid the groundwork for my development of the Text Representation System (TRS) and Communicative Positioning Programme (CPP), which are the basis of the revolutionary ideas in this book.

Text Representationism opens up new possibilities of conceiving of text. It looks at hypertext technology not as a substitute, but as a challenge. Text Representationism proposes the idea of 'hyperspace' to move writing out of the realm of the computer screen into a real, three-dimensional world. In hyperspace, you can shape text into geometrical forms, objects and structures that exist in the same space that you live in, much as the ancient Egyptians did with their pyramids, obelisks and stelae. In so doing, you design and construct physical, creative expressions of text in space. These textual creations aren't confined to the computer screen – they can actually exist in your own living environment, where you can touch them and continually shape them.

Text representations may hang on the wall, rotate on hinges and unfold, like politticos, according to their reading directions. As physical shapes and objects, they may be stationary so that you move around them to read their text, or they may rotate so that you can read them while standing still. They may rotate as quickly or as slowly as you, their creator, decide – or at a speed determined by the reader's desire. As a creator of textual shapes and objects, you can determine writing and reading directions such as vertical, round or other directions that follow a novel route.

Your texts may turn into objects and your objects may turn into texts. You may place poems, for example, in your poem cases and stories in your story boxes. You may store your own poems and stories – or others you like – in these containers and carry them around with you.

The textual objects you create can also consist of a combination of different objects like pinnacles and altars in Gothic architecture, or they can exhibit a repeated object, such as in the structure of a pagoda. Your objects may represent different types of texts, but they can all fit together in the overall scheme of the TRS.

The basic idea of CPP is that any time you write, talk or otherwise communicate, you're positioning yourself in a certain way that reflects your intention and point of view. This means that anything you write can be written in different ways, if you change perspectives. To understand the relativity of communicative positioning, consider how two people might look at a table. The first person is interested in buying a table for a particular room. This person is mostly concerned about the size of the table, how well it goes with the decor of the room and the table's price. The second person is a furniture maker. What interests this person is whether the table is made with solid wood or veneer, the quality of its joinery and

the smoothness of its finish. Although both people look at the same table, each one sees it from a different perspective. So it is with writing. Your perspective affects how you perceive what you're writing about and how you 'package' it in text.

When you write using the TRS and CPP methodology as implemented in this book, you're designing text from a specific perspective in a visual, physical way. You plan your text so that it has shape in space. Your text then has its own physical structure so that its shape visually and materially enhances the perception and meaning of the text it contains.

Over the last ten years, I have successfully used the TRS and CPP methodology in writing laboratories at the University of Bologna. I have also employed my methodology in schools and universities in Italy and elsewhere in Europe to teach students to write effectively. It is also the basis for group-writing workshops that I have conducted in various corporations.

Evidence from the Past

When you think about writing, you probably think about writing on paper or with a computer in a page-oriented, linear fashion. This notion of writing, however, is just one of many in human history. Practice has changed over the ages, according to the materials used and the different civilisations using them.

Writing, as a particular form of communication, is a way of representing knowledge with language. Even without language, knowledge was represented in different ways by ancient peoples. We know that from the earliest of times, knowledge was represented visually by drawings of humans, animals, plants, objects and so on. Knowledge was also represented by abstractions such as geometrical patterns, designs and ornamental motifs. These abstractions were usually symbols of important events or concepts.

Objects additionally could represent certain kinds of knowledge. For example, Australian Aborigines used sticks to convey messages. In other cultures, warnings were communicated by objects with a particular shape. Objects could also serve as memory aids to remind generations of some significant fact or event. For instance, in ancient Rome stories about important battles and victories were written on obelisks, some of which are still standing today.

Drawings were the very first representation of knowledge, but as history progressed, drawings were increasingly combined with some form of language. It's interesting to note, for instance, that cartoons were common in ancient Egyptian life. As a mixture of pictures, a visual code and language, a linguistic code, they effectively communicated knowledge to the masses, who for the most part were illiterate and had little facility with language alone.

Throughout the ages, there have been many materials used for writing. You probably know that writing was done on parchment and papyrus before paper became widely used. But a variety of materials including stones, tortoise shells, bones, ivory, wood, bamboo, palm leaves, clay, metals, animal skins, leather and silk were also used to write on.

Needless to say, the physical properties of each writing material directly affected how writing was conceived, accomplished and organised. Some writing materials were perishable and others were imperishable. Important things were usually written on imperishable materials, such as stones or bones, while mundane things were mostly written on perishable materials such as leaves or animal skins. The choice of the material for writing was never a neutral decision. It always influenced writing in physical ways in terms of its appearance and direction – and in some cases, it even controlled the position writers assumed while writing.

There's speculation that ordinary leaves were the earliest writing material. It's difficult to prove this theory, however, because untreated leaves disintegrate easily, and anything written on them would not have survived from antiquity. Treated palm leaves with writing on them have been found, however, and there's clear evidence that this material was widely used for writing in India and the countries of Southeast Asia. The process used to make palm leaves suitable for writing was a simple one: each leaf was separated from its central rib, soaked, boiled, dried and then rubbed smooth.

The shape and texture of the processed palm leaf had a decisive influence upon writing. Ancient Indian manuscripts written on palm leaves retained the leaf's characteristic oblong shape. The texture of the palm leaf also affected characteristics of the script used in writing. It's interesting to note, for instance, that in Sanskrit, which was the classical language of India, all the words of a sentence were connected by a long horizontal line. This worked well in northern India, where scribes used a pen and ink; but in southern India, where scribes used a sharp metal stylus to incise characters, it proved disastrous. When the sharp stylus was used to make a long horizontal stroke, it invariably split the palm-leaf material because its fibres also ran horizontally. As a consequence, in southern India the writing script became more rounded and no horizontal connecting strokes were used.

Tortoise shells, bones and ivory are examples of some of the imperishable materials used for writing. Tortoise shells were considered to be rare and precious and were mainly used for writing in China and some areas of Southeast Asia. Animal bones were widely used in many parts of Asia and North Africa. Even today in East Africa, the shoulder blades of camels are used in teaching children the alphabet. Ivory was used in areas inhabited by elephants, although ivory was expensive and required greater skill to write on.

Bamboo was another material that was widely used for writing in ancient

China. It was readily available, and bamboo canes can be easily cut up and split vertically. Some scholars believe that the shape of bamboo itself is responsible for the vertical direction of Chinese script. Originally bamboo was used for administrative writing, such as the compilation of population lists, but its use was later extended to literary and religious writings. Bamboo 'books' were often constructed of whole or split canes, tied together with a silken cord. They were cumbersome to handle and posed particular problems for travelling writers and scholars.

In India birch bark was another material used for writing. It required only a moderate amount of preparation and could be easily cut into sheets and folded into folios. Because of its fragility, birch bark needed to be handled carefully while writing. Other types of wood bark were also used in the Mayan and Aztec civilisations in Central America.

Animal skin, leather and textiles such as silk, cotton and linen were also used as writing materials at various times. The use of animal skins for writing probably dates back to the beginning of human history. Without tanning, animal skins tend to deteriorate quickly. But once the process was developed, the leather produced by it was well suited to writing. The earliest surviving examples of leather writing come from Egypt and were produced about 3500 BC. Perhaps the most famous ancient leather manuscripts are the Dead Sea Scrolls, which were found around the middle of this century in the Judean desert.

In terms of textiles, silk was used for writing in China, cotton in India and linen in Egypt. Other materials for writing were often chosen because of their permanence. Because of their malleability, copper and lead, for example, could be pounded into thin sheets. Gold and silver were other soft metals that were sometimes used for writing. However, because of their expense, these were primarily used for writing important texts or for transmitting messages to high-ranking people.

Materials such as clay, parchment, papyrus and paper were specifically developed for writing. Clay tablets were in fact the first reliable type of writing material. Initially, clay tablets were produced in Mesopotamia. Signs were generally written on the wet clay with a reed stylus and then the tablets were dried in the sun, or if the text was sufficiently important, they were baked in a kiln. The texture of the wet clay definitely influenced the characteristics of the script. Since the wet clay was not particularly suited for retaining soft lines, circles and curves of pictographic signs, writing on the clay tablets gradually changed into a wedge-shaped script called cuneiform.

Attempts to improve leather as a writing material eventually lead to the invention of parchment. The making of parchment required an animal skin, in addition to being treated, to be stretched so as to produce a thinner material than leather. Parchments were first produced in Pergamum in Asia Minor as early as the second century BC. In Europe, parchment was used as a writing material up through the late Middle Ages.

Papyrus and paper are perhaps the most familiar of the ancient writing materials. The earliest surviving examples of papyrus writing come from Egypt and date from about 3300 BC. Papyrus was significantly superior to other writing materials concurrently in use. It could be made easily and cheaply. Pieces from the inner stems of the papyrus plant were beaten together in sheets and dried in the sun. The sheets were pasted together with an adhesive to form a long scroll. In codex form, a papyrus could be written on both sides.

Paper was a Chinese invention. It was produced by a process similar to the one used today, in which a pulp mixture is made and then spread on a frame to dry. After its first use in China, it was nearly a thousand years before paper reached Europe. It was initially introduced in Spain and Sicily by Arabs around the twelfth century and soon became the mainstay of writing. The influence of paper on Western civilisation since then has been immense. Among other things, paper facilitated the developments of printing and public education.

Writing has always been physically related to the material used for writing. The physical qualities of the writing material – such as its shape, texture, hardness and permanence – significantly influenced the way writing was conceived and accomplished. Historically, writing has always been a physical activity, intimately connected with some sort of material.

Polittico as a Metaphor for Organising Text

The polittico is a particular style of painting widely used in Italy and elsewhere in Europe. When creating a polittico, the painter divides a large canvas into sections and paints a scene in each section. When the polittico is finished, the individual scenes together form a coherent painting. The scenes depicted in a polittico are traditionally based on a story in the Bible, and are organised in such a way that illiterate people can look at them and easily understand the story as a whole.

The main feature of a polittico is the one central image with less important images close to it. The less important images can be on either side of the central image or below it. The image partitions may have different shapes, such as rectangles or more complicated forms, but their arrangement clearly demonstrates the intention of each part. How each partition relates to the overall coherency of the painting is also clear from the visual arrangement.

The term 'polittico' is derived from the Greek word *polyoptigon*, which means to allow different ways of looking at something or to be able to view it from multiple perspectives. The multiple perspectives of a polittico are possible because of the way the painter partitions it into different elements. The way the elements are organised – and their particular shapes – enable you to see at first glance the main focus of the painting, and how the other elements relate to it. This first-glance property of a polittico is significant

because it allows you to receive information appropriately, since each part of the polittico visually indicates its particular communicative function.

As in a polittico painting, you can shape, partition and organise text to help readers visually understand its main focus. You can put textual elements together so that the arrangement itself emphasises what is central and what is peripheral – that is, what is most important and what is less important, but still relevant. If you have many elements, you may include arrows or numbers in the text to help readers navigate through them. The different shapes of the textual elements can, moreover, provide multiple views of the text as a whole to enable readers to comprehend it in all its complexity, and the possibility to choose and substitute other texts.

The partitioning of text that takes place in polittico writing is not unlike the partitioning of information that occurs in the forms that everyone fills out at some time or other. However, polittico writing is a much more active way of organising information. Not only do you determine what to write, you also decide how to organise and shape information so as to facilitate the writing and reading of it.

Notes
[1] I have written three books in Italian about the methodology on which this book is based. One of these books was written to be 'read aloud', while the others were written to be navigated.

2

Writing as Drawing and Painting

This chapter concerns the visual representation of those cognitive processes that are connected to writing. These cognitive processes have to do with various attitudes that a writer can have toward creating text. There is no such thing as a general writing attitude, but there is the writing of different kinds of texts for different communicative purposes.

The predominate metaphor used in the chapter is taken from drawing and painting. This metaphor is the canvas. For an artist, a canvas is an important initial consideration and choice because of its physical property of texture. As illustrated in Figure 2-1, a canvas can be fine and smooth or coarse and rough, depending on the tightness or looseness of its weave. An artist chooses a canvas in part because of the particular characteristics of its texture. A finely textured canvas is appropriate for a detailed, precisely drawn or painted picture, but a coarse canvas is what the artist needs to create a painting using a thick, bold application of paint.

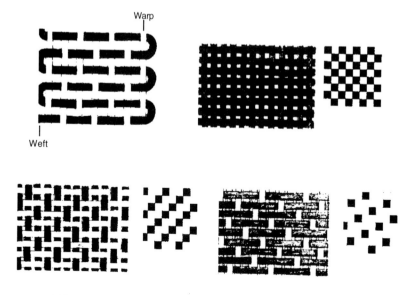

Figure 2-1. *Like a canvas, text also has a texture that is more or less dense*

Just as an artist chooses a canvas with an appropriate texture, a writer needs to decide how much 'texture' the text will have. The texture of text has to do with the density of information conveyed by it. Depending on the particular communicative purpose of the text, what the writer intends to achieve and what the text is actually for, the texture of the text may be more or less dense.

Not only does the metaphor of canvas carry the property of texture, it also implies a visual context for the process of writing. After choosing a canvas with the right texture, an artist prepares to draw or paint by organising the space on the canvas. The artist establishes a perspective, point of view, focus and possibly a cliché for the drawing or painting. The perspective identifies how the artist is looking at things, the point of view shows what the artist selects as most relevant, the focus indicates what is central and the cliché (format) displays how the artist deals with organising space.

The writer also prepares to write. Before actually writing, a writer must think about text as an open possibility. Text can be written from a multitude of perspectives and points of view, with many different focuses, intentions and organisational considerations. Each way of writing text enables a different viewing of it and is a continuous invitation for the writer to 'redraw' it. If the writer changes the idea for the text at any point, the writer can always modify it.

The canvases presented in this chapter visually represent some of the specific ways of drawing and painting text. They picture how you can capture and organise your thoughts into texts that have specific communicative purposes. These canvases are visual aids, schemes and stimuli to help you reflect on and visualise what you're doing as you get ready to write and participate in the process of writing.

The canvases are presented progressively – starting with those that visually represent simple concepts related to words and sentences. These canvases include those that concern the processes of brainstorming, word chaining and creating metaphors. Additional canvases explore more complex processes such as those for planning and organising narrative texts, analogous stories, explanatory texts and hypertexts. The last two canvases concern collective writing.

An 'exercise' is provided at the end of some of the canvases. These exercises give you the opportunity to explore the canvas as a visual stimulus for writing. They provide explicit instructions for experiencing the canvas from both a writer's and a reader's perspective. It's important to consider both perspectives because writing is not an isolated act of producing text, but rather is intimately connected with the reading of the text. The way the text is organised visually and linguistically deeply affects the way the reader reads and perceives it.

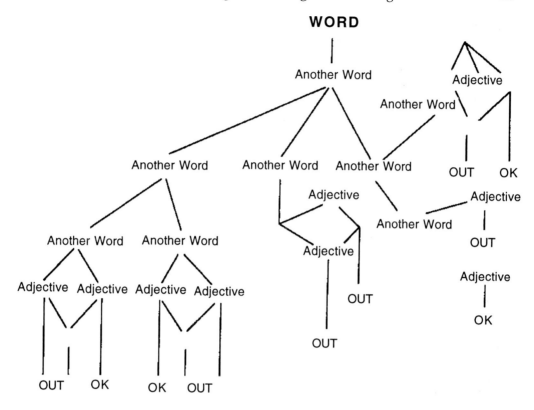

Figure 2-2. *Canvas for word explosion*

Word Explosion

The canvas in Figure 2-2 is for brainstorming. You can use this particular canvas right at the beginning of the writing process to free your mind from preconceived ideas of what you're going to write about. It will help you tap into the creativity that is uniquely yours and to think about what you're writing in more explicit ways.

The canvas in Figure 2-2 facilitates the cognitive process of free association, in which you allow yourself to think freely about a particular word or concept. The idea here is that you start with one word or concept and then let your mind go. As you proceed, you trigger additional words and adjectives that give texture and specificity to your thinking and writing.

Figure 2-2 illustrates how a word or concept explodes like fireworks in the night sky. The initial word or concept triggers a cascade of other words and meanings. At the first level, the word explodes into others which are immediately associated with it. These additional words in turn trigger in

your mind many adjectives and attributes (some of which may be contradictory). As in fireworks, some 'firewords' quickly fall away, while others persist.

After you explode a word on a canvas such as Figure 2-2, you can go back to it and discover more about what you're thinking. As you do this, you may cross out some of the words that came into your mind as being off the track or contradictory. (These excluded words are marked 'OUT' in Figure 2-2; the persisting words are marked 'OK'.) Once you go through this process, you not only discover the free associations that the word or concept has for you, but you also focus on some of those relationships that are important to you.

As an example of how the word explosion canvas works, consider the word 'house' as the initial, starting word. At the first level, you may think of other words associated with 'house'. These other words may include 'doors', 'windows', 'kitchen', 'garden' and 'fireplace'. As you continue freely associating, attributes and adjectives – such as 'big', 'light', 'dark', 'warm' – may also come to mind. You can take the free associations as far as you want and then when you're done select those words (such as 'light' and 'warm') that you like.

Word Chaining

The canvas in Figure 2-3 builds on the processes of free association and word selection represented by the word explosion canvas (Figure 2-2). This second canvas shows how you can put together a group of words from a word explosion so that they form a logical, linear chain. The word chain that results from this process can be a group of sentences, paragraphs or even larger parts of a text.

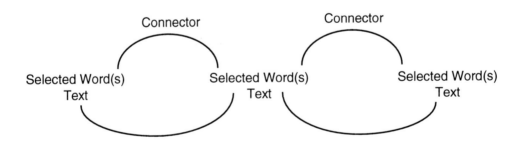

Figure 2-3. *Canvas for word chaining*

After exploding a word into a cascade of other words, adjectives, attributes and properties, you select those you want to keep. The selection process

removes inconsistencies and helps focus your thinking and writing. The selection process by itself, however, doesn't result in much more than a group of related – but still unconnected – words. The selected words are like points that an artist locates while sketching and they await connection when the artist explicitly draws lines through them.

Word chaining, as depicted in Figure 2-3, connects up the words selected from a word explosion. It adds verbs and connectors so that a linear, articulated text results. The connectors are prepositions (such as 'before' or 'after') and conjunctions (such as 'and' or 'but') that you add to link words or concepts together in a logical, linear way that reflects your thought processes. Connectors facilitate the readers of your text by guiding them from one word or concept to another – much like the lines in a sketch draw your eyes from point to point.

As an illustration of word chaining, consider again an explosion of the word 'house' that results in the selection of some set of words such as 'house, 'windows', 'bright', 'garden' and so on. You link the selected words together by adding verbs and connectors so that you end up with sentences. For example, you might end up with this word chain: 'My house has a lot of windows. I always open the drapes on the living room windows because I like this room to be bright and I also like to look out at my garden'.

Exercise

The following exercise refers to the process of both word explosion and word chaining.

The Writer's Perspective

1. Create a text starting from a single word/concept and proceeding toward the possible associations.
2. Use the attributes and properties that you relate to the word/concept you choose.
3. Select the same attributes and properties. You are now creating your own perspective in exploring the text.
4. Create other texts, expand them and link them together. Use connectors (prepositions and conjunctions) to move around and navigate through texts. See the possibilities you opened up and 'draw' your text according to the texture you created.

The Reader's Perspective

1. Take a word/concept out of a text and explore the associations made by the writer. Examine the attributes and properties and the connectors the writer used. By understanding what the writer did, you will gain insight into the writer's process.
2. Become actively involved in the text. For instance, try rewriting a sentence: add adjectives that you like, substitute words and become a writer yourself. By becoming actively involved, you can 'redraw' the text and have it exhibit other possible textures.

3. See if you can find one more word/concept or additional attributes and properties that are not in the text, then expand the text yourself to accommodate them. Whenever you read/interpret a text, you're either doing text-completion or text restoration; you're acting upon the text and are really becoming a writer.

Metaphor Creation

A metaphor uses one word in place of another to suggest a likeness between the two words. The two words are usually unrelated and distant from each other, although they may share some property or attribute. The meaning of a metaphorical word is not the literal one, but one that is transferred from a particular property or an attribute of another word. Metaphors are important because they add meaning and significance to words that extend beyond their literal sense. They enable language to exhibit greater imagination, novelty and flexibility.

Whether you're aware of it or not, you use metaphors all the time. Some metaphors, such as 'chair leg' and 'bottleneck' are used so much that you probably don't even recognise them as metaphors. Most metaphors, however, are easy to recognise. For example, if someone told you that John just won the lottery and is 'drowning in money', you certainly wouldn't rush out to call the paramedics. You would understand the metaphor 'drowning in money ' to mean that John has so much money that it's as if he's engulfed by it.

You can explore the possibilities afforded by metaphors through the canvas shown in Figure 2-4. This canvas illustrates that a metaphor begins with two word explosions, one for the source word and one for the target word. The source word is simply one word (or concept) that you start with. The target word (or concept) is the one you choose in transferring a new meaning to the source word. You explode both the source and target words into other words and attributes, properties and adjectives.

You then select one or more of these attributes, properties and adjectives from each word explosion and draw a 'bridge' between them. The bridge spans the distance between the words and connects their common feature. When you link the words by establishing the bridge, you create a metaphor.

Let's make the process of creating a metaphor more explicit by giving an example. Suppose you begin with 'John' as the source word and 'lion' as the target word. Exploding the word 'John' results in other words that include 'male', 'human being' and 'adult'. It also results in attributes about John that include 'intelligent', 'stubborn' and 'proud'. Exploding the word 'lion' gives different results. At the first level, the other words freely associated with 'lion' include 'king of the forest', 'carnivore' and 'four-footed beast'. At the attribute level, they include 'proud', 'violent' and 'mangy'.

You select 'proud' as a common attribute between 'John' and 'lion'

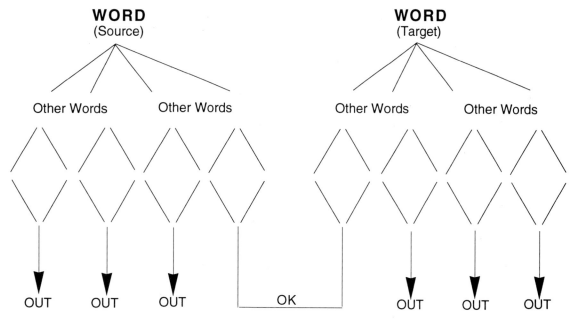

Figure 2-4. *Canvas for creating a metaphor*

and exclude all the others in both word explosions by crossing them out. When you use 'proud' to draw a bridge between 'John' and 'lion', you've created a metaphor. Then when you say 'John is a lion', what you mean is that John is proud. You don't mean that John has four legs, is mangy or anything else because you excluded these attributes and instead focused on 'proud' as a common link.

Exercise
The Writer's Perspective
1. Begin word explosions for your source word and target word.
2. Fill out both word explosions respectively with attributes, properties or adjectives.
3. Select the one/ones you want to be the bridge that relates the two exploded words and link them together.
4. Write down the metaphor you created.

The Reader's Perspective
1. Write down some metaphor you know or have read.
2. Recreate the source word and target word.
3. Fill out both word explosions with possible attributes, properties or adjectives and focus on the one/ones you can foresee as the bridge for possible links.
4. Read the metaphor again and – if you can – expand and enrich it by finding other links.

Figure 2-5. *Analogous patterns*

Pattern Recognition and Analogies in Stories

Take a look at the four patterns in Figure 2-5. Do you see their similarities?

The motifs that make up the four patterns are obviously different. The motif in the upper-left pattern, for example, consists of four small squares and an inscribed circle, while the motif in the upper-right pattern has four small squares that each contain an inscribed triangle. Although the motifs are different, they are repeated in exactly the same way in the four patterns so as to replicate the same basic structure. Because they replicate the same basic structure, they are analogous patterns.

If you now apply how you recognise analogous patterns to how you look at the structure of stories, you can make some important discoveries. Look at Aesop's famous story and see what you can discover:

> Let T be a story. T is a story about a fox and a vineyard. The vineyard has grapes. The fox likes grapes. The fox wants to pick the grapes. The fox cannot reach the grapes because there is a gate. The fox is angry and says that he doesn't like grapes at all.

This story can be represented visually as shown in Figure 2-6.

The canvas represents the logical structure of the story by focusing on certain words and parts that link it together. The linking words appear on the left side of the canvas. The arrows on the right side point to the objects of the linking words.

In addition to discovering the logical structure of the story, you can also judge what the story is about. Depending on your perspective (how you're thinking about the story), these are some of the things you could think the

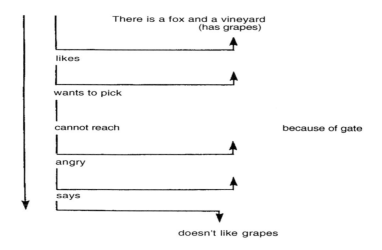

Figure 2-6. *Canvas representing this story about a fox and a vineyard*

story is about:

 Let T be a story: T is a story about a fox
 Let T be a story: T is a story about a vineyard
 Let T be a story: T is a story about grapes
 Let T be a story: T is a story about a gate
 Let T be a story: T is a story about liking grapes
 Let T be a story: T is a story about disliking grapes

The first two assessments are the most likely: the story is about the fox or about the vineyard. The next four assessments, which are preceded by an asterisk, are possible, but are progressively further from the central focus of the story as you go down the list. The last one – that the story is about disliking grapes – is so far off the mark that it misses the point of the story entirely.

 This shows you that once you see the logical structure of a story, you can create a series of stories analogous to it by substituting different plots into the structure. For example, the stories below are analogous to the story of the fox and the grapes as represented in Figure 2-6:

 There is a woman and a ring. The ring is beautiful. The woman likes the ring. The woman wants to buy the ring. The woman cannot afford it, because she doesn't have any money. The woman is angry and declares that she doesn't like the ring at all.

 There is a human being and an object. The object is nice. The human being likes it. The human being wants to have it. The human being cannot have it because there are some difficulties. The human being is angry and says he doesn't like the object at all.

 There is a very ambitious man and an open position at IBM. The

position is a very high level one and pays a lot of money. The (very ambitious) man wants to have it (because he is ambitious and wants the money). The man cannot have it because somebody else is preferred to him. (People at IBM prefer somebody else). The ambitious man is angry and explicitly declares (he doesn't want that position because) he doesn't like it at all.

There is an A and a B. B has C. A likes C. A wants C. A cannot have C because of D. A is angry. A says A doesn't like C.

Sometimes stories will seem to have similar plots but will not be analogous because the logical structures of the stories are not the same. The following two stories, for example, are not analogous to the original story of the fox and the grapes because they have a different (if not confusing) logical order.

There is a fox and a vineyard. The fox is angry and says he doesn't like grapes at all. The vineyard has grapes. The fox cannot reach them because there is a gate. The fox wants to pick the grapes. The fox likes the grapes.

There is a fox and a vineyard. The fox is angry and says he doesn't like grapes at all. The fox likes the grapes. The fox wants to pick the grapes. The vineyard has grapes. The fox cannot reach them because there is a gate.

It's not enough that these two stories have the same sentences as the original story; they must also have the correct logical structure to be analogous to it.

Exercise

The Writer's Perspective

1. Create your own plot and your own story.
2. Create your perspective by setting priorities and goals for what is important; you may want to point out something like a specific event or a concept that is most relevant.
3. Now create a premise (title), which is a device for building up the reader's perspective according to what you wish (focusing).

The Reader's Perspective

1. Create your own summary of the story with a simplified texture that shows the relevant concept you discovered through exploring the plot according to the writer's premise.
2. Next create new stories by keeping the same texture and the same premise and just changing the plot (cliché).
3. Create new premises by keeping the same texture and the same plot (refocusing).

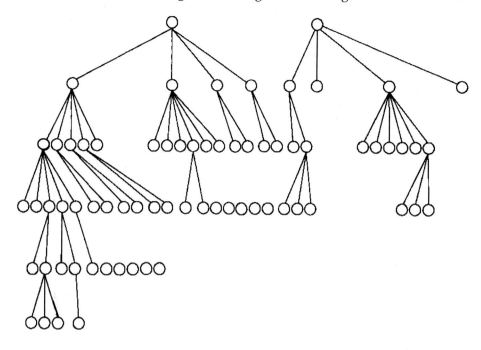

Figure 2-7. *Canvas for the overall drawing of narrative text*

Global Narrative Text Planning

The canvas in Figure 2-7 represents a visual scheme for globally planning narrative text. A canvas such as this enables you to sketch out a long story that may encompass a number of events, protagonists and possible outcomes. It opens up the possibility of developing the story in many different ways and it helps you check its coherence.

The small circles in Figure 2-7 represent narrative concepts, which are ideas or abstractions that affect how a story develops. These narrative concepts are turning points or nodes from which alternative progressions of the story branch out. The following list identifies some narrative concepts that affect how a narrative text may develop:

Motivation	Problem
Failure	Resolution
Success	Change of mind
Perseverance	Complex negative event
Loss	Complex positive event
Enablement	Competition
Negative trade-off	Cooperation
Positive trade-off	Agreement
Hidden blessing	Disagreement
Mixed blessing	Conflict

You can expand or modify this list of narrative concepts as you wish to accommodate your own narrative text-writing purposes. The important point to remember, however, is that narrative concepts are not events, but abstractions that support what occurs in a story. They are open positions to be filled up.

As an example of how the canvas in Figure 2-7 can facilitate planning a story, consider again the simple story of John wanting a bike. You could begin the story by deciding to state John's motivation or desire: 'John wanted to buy a bike'. This narrative concept would be represented by a small circle at the top of the canvas.

From the narrative concept of motivation or desire, you could branch out into many different story options. For instance, you could provide an option for immediate success – John could simply purchase a bike as an outcome of his desire. You could also provide for another possibility that would result in a postponement of success: John could purchase a bike but have to wait to get it because it was on order. As a third possibility, John could encounter a problem; he couldn't buy the bike because he didn't have enough money. Each of these options would also be represented by small circles connected by lines to the starting circle.

If you then develop the story line from the option of John's problem, you again have more possibilities, each of which branch out from it. John, for example, might resolve his problem by: (1) borrowing money from his aunt; (2) charging the bike on a credit card; (3) stealing the bike; or (4) any other plausible option.

As you're planning a story by sketching it out on a canvas, you can keep a whole set of options open and develop each of them. By doing this, you're providing yourself many paths for the story that you can then consider when you write the story. You can trace through each path, reflect on it and see if it tells a coherent story consistent with the choices you made. You can keep the story open until you decide what you really want to do. You may, for instance, create a conflict and then check it and decide if that's how you want to develop the story.

At some point after sketching out the possibilities for a story, you may select one path as the story you want to write. For example, you may want to select a path that tells this story: 'John wanted to buy a bike. He didn't have enough money. He won the lottery. He was able to buy the bike and was happy'.

Local Narrative Text Planning

Figure 2-8 shows a five-part canvas to help you plan and analyse the details of a narrative text. The canvas presented in the preceding section is a visual scheme for planning a narrative text at a global or macro-level. If you're having problems after globally structuring a narrative text, you can use the canvas in Figure 2-8 to work out the textual details at a local or micro-level. The idea here is that by using the visual schemes in Figure 2-8

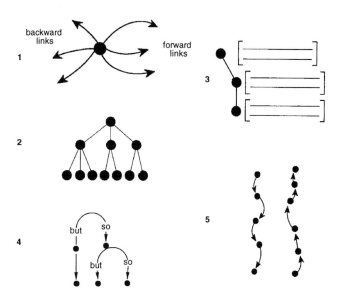

Figure 2-8. *Canvas for planning narrative text details*

you can examine, reposition, refine or expand the branches drawn in your global narrative text plan (Figure 2-7). You can use these schemes to work out details that now come to mind, but were initially left out in your global planning.

The first illustration in Figure 2-8 shows that any narrative concept represented by the black circle in your global text scheme is linked with what comes before it and what comes after it. The reason for this is that for a story to be coherent, the narrative concepts must relate to each other in predictable ways so that the reader won't lose track of the main story.

For instance, if during the course of a story one of the protagonists encounters a problem, you would expect him to search back in his mind for the cause of the problem; afterward, you would expect the protagonist to look for a solution. To make this notion more concrete, consider the story of John and the bike. John says he wants a bike, but he doesn't have enough money to buy it. When you read this, you naturally tend to ask why John doesn't have enough money – you think 'backward' to see if you can find a link that points to the cause of John's money problem. When you learn that John desires to have a bike, what do you expect to come after an expression of his desire? You expect his efforts to obtain the bike. This is the link forward.

Examining the links that point backward and forward from a narrative concept helps you work out the details of a narrative text in two ways. First, since there is predictability in the backward and forward links, you

can check these links to see if a detail of your narrative is coherent. For example, if you write: 'John wanted to buy a bike. He didn't have money and was happy', examining the links indicates an incoherence – the reason why John was happy is missing and the reader will have a problem jumping to this conclusion. It's just like a hole in the canvas of a painting – the missing element leaves the reader confused.

Examining the backward and forward links also helps you position a narrative concept within the text. If you have an idea, but you're not sure where to place it in your narrative, you can put it somewhere and look at how it links up with what comes before and after it. You may have to move it around until you find a place where it fits coherently.

Illustration 2 shows that if you take any narrative concept in a story, you can evolve the story from it in different ways. This is similar to planning out a narrative text globally, but at a much more detailed level. From the narrative concept you've chosen to examine, you branch out various plot options to evolve before you actually decide to go one way or another.

Returning to the example of the story of John wanting a bike but not having enough money, you could evolve the story differently by considering several ways for him to obtain the needed money. For instance, John could borrow the money from his uncle, earn the money by working, rob a bank and so on. As you evolve the story from each option, you explore new possibilities for how the concept you started with could link up with the rest of your narrative text.

If you have a narrative concept clear in your mind, illustration 3 suggests that there is a whole set of ways to express it. By exploring different ways to express a narrative concept, you have greater freedom in choosing the one you wish to evolve. You can keep each set going in parallel with the other sets before coming to a decision.

The initial narrative concept in the story about John and the bike, for example, concerns wanting or desiring: 'John wanted to buy a bike'. You can take this narrative concept and express it in many different, but equivalent ways. For instance, you could consider stories about John wanting to buy a house, John wanting to win a marathon and John wishing to marry Jane. All these options are equivalent at a conceptual level because they are all expressions of a desire or wish. They are radically different, though, in terms of what John desires.

Illustration 4 shows that you can also examine the relationships among narrative concepts by analysing and enlightening the links between them. You link together narrative concepts by using connectors. The connectors establish either a temporal or a causal relationship. Some commonly used connectors are as follows:

Temporal Connectors	Causal Connectors
since	and
while	but
before	so

afterwards	instead of
meanwhile	rather
whenever	though

You can choose a connector that conveys the kind of relationship you want to establish. If you want a narrative sequence to have a smooth, continuous flow, you can use the 'and' or 'so' connector. ('John wanted to buy a bike and he then went to the bank to withdraw enough cash to purchase it'.) On the other hand, if you want to create tension in the narrative, you could use a connector such as 'but' or 'rather'. ('John wanted to buy a bike, but he didn't have enough money'.) Unlike the 'and' or 'so' connector, the 'but' or 'rather' connector interrupts the flow of the text and tells the reader that there is a change of direction, a pause for revision or some suspended evaluation.

The final technique for examining and working out the details of a narrative text is represented in illustration 5. This illustration shows that you can create a text by linking narrative concepts together from cause to effects or vice versa. You don't always have to go one way. You can go in both directions if you use the right connectors to establish the links between the narrative concepts. You can even scramble the sequence to vary the way you construct the narrative.

To see the possibilities for reconstructing a narrative text, think again about the story of John and the bike. A construction of the story from cause to effect is: 'John wanted to buy a bike. He didn't have money. He won the lottery. He bought the bike and was happy'. To reconstruct the story from the effect to cause, you could write: 'John was finally happy because he won the lottery and got the money he needed to buy the bike he wanted'. A scrambled reconstruction is: 'John was happy because in spite of the fact that last week he didn't have enough money to buy the bike he wanted, yesterday he won the lottery and purchased the bike'.

Analogous Story Planning

The canvas in Figure 2-9 also helps you to think about narrative text visually. But unlike the preceding canvas (Figure 2-8), this canvas is a visual aid for planning or finding other stories that are analogous to a particular story. Figure 2-9 indicates the ways that two stories can be analogous. Two stories can be partially analogous – they are either initially, intermediately or finally analogous – or they can be totally or globally analogous.

Each group of connected circles in the illustrations in Figure 2-9 represents a story. The small white circles represent narrative concepts that are the same in the two side-by-side stories. The small black circles represent narrative concepts that are different. Where the line connecting the narrative concepts in the two stories parallel each other, the stories are analogous. Where the lines are not parallel, the stories are not analogous. To show the various ways two stories can be analogous, consider the

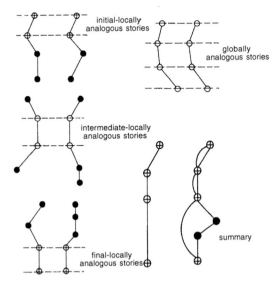

initial-locally
analogous stories

globally
analogous stories

intermediate-locally
analogous stories

summary

final-locally
analogous stories

Figure 2-9. *Canvas for planning or finding analogies in stories*

familiar story of John wanting a bike as the original story. Table 2.1 lists
the four ways another story can be analogous to it and gives an example of
each type of analogous story.

The first story listed after the original story is an initial-locally analogous
story. In this kind of analogous story, which is illustrated in the upper-left
part of Figure 2-9, the initial part of the story is conceptually the same as in
the original story, but then the stories differ. Both stories start with the
protagonist's motivation or desire. Both protagonists also encounter a
problem. John succeeds in satisfying his desire, but Mary doesn't.

The next kind of story is one that is analogous in the middle. This type of
story is depicted in the left, centre part of Figure 2-9. It differs conceptually
from the original story at the beginning and the end, but is the same
conceptually in the middle. In the middle of the story, Mary encounters a
problem, just as John does. But whereas John's story begins with a
statement of his motivation, Mary's story begins with a loss – being
scheduled to go on vacation but not wanting to go because of being ill.
John's story, moreover, ends with success, while Mary's ends with failure.

In a final locally-analogous story (illustrated at the bottom left of Figure
2-9), both stories differ in their narrative concepts except at the end. John's
story progresses from motivation to problem to success. Mary's story
moves from a mixed blessing to resolution to success. The stories
conceptually come together only at the end.

The last kind of story is one that is globally or totally analogous. This
type of analogous story is represented at the top, right in Figure 2-9. All
parts of a globally analogous story parallel the original story. John's story,

Original Story	John wanted to buy a bike. He didn't have enough money. He won the lottery. He bought the bike and was happy.
Initial Locally Analogous Story	Mary wanted to go on vacation. She didn't have her boss's permission to go on vacation. She gave up and was very unhappy.
Intermediate Locally Analogous Story	Mary was scheduled to go on vacation. She was ill and didn't want to go on vacation. She couldn't convinced her boss to reschedule her vacation time so she spent her vacation at home ill.
Final Locally Analogous Story	Mary was scheduled to go on vacation. She was ill so her boss offered to reschedule her vacation until after she was well. After she was well, she went to Bermuda and was happy.
Globally Analogous Story	Mary wanted to go on vacation. She didn't have her boss's permission. She finally convinced her boss to let her go on vacation. She went to Bermuda and was happy.

Table 2.1 *Examples of analogous stories*

as noted before, conceptually moves from motivation to problem to success. Mary's story also goes from motivation to problem to success. Both stories are completely analogous. They convey exactly the same concept, but by using different plots.

In addition to the four types of analogous stories, the lower-right part of Figure 2-9 shows a visual representation of a summary. A summary is a special kind of analogous story in that it conveys the same concept as the original story, except that it leaves out irrelevant information. The following example shows an original story and a summary of it:

Original Story	John wanted to buy a bike. He didn't have enough money. He decided to play the lottery because his friend Paul told him that he knew someone who had just won ten million dollars. John thought it would be best to buy his lottery ticket at the same store that Paul's friend did. John won the lottery. He bought the bike and was happy.
Summary	John wanted to buy a bike. He didn't have enough money. He won the lottery. He bought the bike and was happy.

In the original story, the sentence about Paul's friend and the sentence about where John bought his lottery ticket are irrelevant to the concept

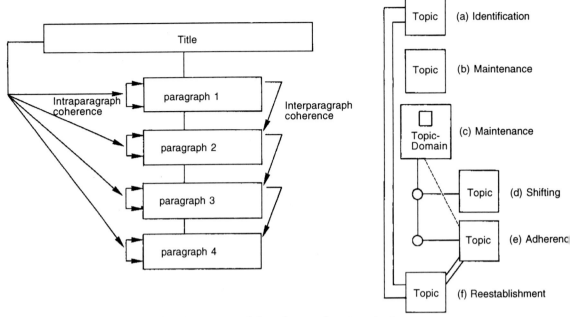

Figure 2-10. *Canvas for planning and drawing explanatory texts*

conveyed by the story. These sentences are therefore excluded from the summary.

Explanatory Text Drawing

Explanatory text intends either to teach the reader about some topic or to show the reader how to do something such as how to operate a particular device or machine. The canvas presented in this section specifically concerns the first kind of explanatory text – text that teaches the reader about a topic. The canvas that addresses the kind of explanatory text that deals with 'how to' information is presented in Figure 2-10.

Explanatory text that teaches the reader about a topic typically exhibits a logical progression or some development that is causal or temporal. History or geography texts are good examples of this kind of explanatory text. They are organised in such a way that the reader can remember – that is, store and retrieve – the causal or temporal relationships they explain.

Figure 2-10 shows the canvas that represents visual schemes for planning and organising explanatory texts.

This canvas has two parts. The first part, which resembles a traditional outline, shows the logical progression of the text, starting with a title and flowing down through the division and development of a set of paragraphs. In visualising an explanatory text, it's important to fill in the space for the title. The title identifies the topic addressed by the text and prepares the reader to expect the information presented in the text.

From the title, visualise dividing the text into paragraphs. The paragraphs are complete units that elucidate the topic in particular ways. As an individual unit, each paragraph must have an internal coherence. Together they must also have a coherence that enlightens the topic.

The right side of Figure 2-10 shows another way to visualise and plan an explanatory text. This scheme provides an alternative to a strictly logical progression of paragraphs. Instead, it focuses on identifying and maintaining the topic and developing text that more readily keeps the reader's attention.

In this visualisation you identify the topic in (a) to make sure the reader knows what it is. You maintain the topic in (b) and (c), but expand on it in (c) by adding more data or more details. To keep the interest of the reader, you then may decide to shift the focus of the text in (d) to other details that are related to the topic but digress from it. In (e) you adhere to the topic again, but from your shifted position. Finally in (f) you go back to the topic.

The difference between the first and second visual schemes is similar to the difference between drawing and painting. The scheme on the left, like drawing, is more structured. The scheme on the right, like painting, adds the dimensions of colour, texture, mixtures and tonalities.

Dialogue-Conversation

Before initiating an important conversation, such as one that focuses on some cooperative effort or negotiation, you may want to plan it. While actually engaged in such a conversation you may also sketch out its dynamics and conclusions so that you can reconstruct the conversation later or capture it in writing.

For example, for a business meeting with another individual you may want to keep track not only of the outcome of the meeting, but also the details about how you and your meeting partner arrived at that outcome. Planning the interaction you anticipate with the other individual before the meeting actually occurs may also be important in facilitating an effective dialogue. In your planning you focus on why your meeting partner is the best person to talk with and what steps you need to take to prepare yourself for the meeting. You also think about your partner's point of view, how the meeting could evolve and how to steer the conversation toward your concerns.

A visual scheme like the one shown in Figure 2-11 helps you plan a conversation, record its rhythm and track its evolution.

Figure 2-11 is divided by a vertical line into two spaces. The left space is for recording the contributions of the initiator of the conversation. The right space is for drawing those of the addressee. The lines flowing down through the initiator's and addressee's spaces trace the dynamics of the dialogue as it progresses.

The configuration of the lines in Figure 2-11 represent a typical

Figure 2-11. *Canvas for tracing a conversation*

conversation, in which the initiator convinces the addressee to cooperate with him in some work effort. The canvas traces activity on the initiator's side first. These initial lines represent planning that the initiator does in his mind before getting started. The initiator evaluates alternatives and determines his goals and objectives. He identifies who he needs to talk with and checks to see if that person is available. All of these activities are represented by the branching lines sketched at the top of the initiator's side of the canvas.

At some point, the initiator actually starts talking with the person. This is shown in the canvas by the first line that crosses over from the initiator's side to the addressee's side. Upon talking with the addressee, some problems surface that need to be worked out. The working out of these problems appears on the canvas as branching lines and lines bridging both sides of the canvas. When the initiator and the addressee solve their problems, they begin talking 'in sync' with each other. This final part of the conversation is represented at the bottom of the canvas by parallel lines transversing the initiator's and addressee's sides.

You can also annotate a canvas that traces the dynamics of a conversation. You may write on the canvas key words, concepts or statements made by the initiator and the addressee. To track who said what and when it was said, be sure to make your annotations on the appropriate side of the canvas and at the location or line that represents the correct point in time. For example, if you as an initiator commit yourself to complete a task by a particular date, note the task and the completion date on your side of the canvas at the appropriate spot in the flow of the conversation.

By drawing an important conversation on a canvas like the one in Figure

2-11, you can keep track of its outcome. The process of planning and drawing a conversation on the canvas also has the effect of slowing it down so that it stays focused and is directed toward some goal. If necessary, you can also reconstruct the conversation in detail from the canvas, since it shows what you and the other person said and how the conversation evolved over time.

Collective Text Perception

The visual schemes presented in Figure 2-12 illustrate a collective perception experienced by a small group of people writing or reading the same text.

The first illustration in Figure 2-12 helps you visualise a particular type of collective writing called collage writing. Collage writing may be done by a group of up to five people that collectively endeavours to create a story, explanatory text or any other text by piecing together their individual written contributions.

Initially the group gets together to discuss the goal of the text, its style and the quantity of information they want it to contain. The members of the group then divide up the work. They discuss who is going to write what part of the text and how all the parts fit together. This initial planning process is similar to what a group of architects do when planning the design of a house: the group decides who is responsible for designing the details of each room and they make sure that there's an overall plan so that the rooms fit together into one, unified structure.

Once the members of the group produce their individually written texts, they meet to put these pieces together into a single text. This process is

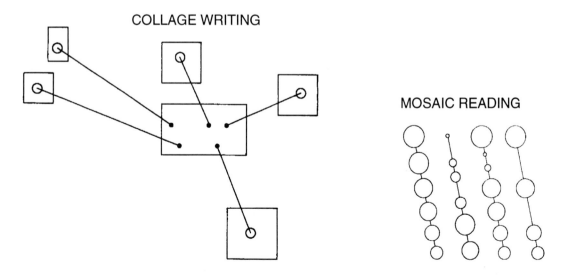

Figure 2-12. *Canvas for collective text perception*

visually represented by the left illustration in Figure 2-12. The five smaller squares and rectangles surrounding the central, larger rectangle represent the text contributions of the individual members of the group. The central rectangle represents the text collectively written by the group.

The group writes the text from the texts contributed by the members. As in constructing a collage from various materials, the group cuts pieces of the texts provided by the members and pastes them into the new text they're creating. They may do this in somewhat of an unstructured way. For example, as the group members read and review John's text, they may decide to take his first sentence and place it in the new text after a sentence that Mary wrote. They may also reshape the text so that it exhibits a flowing, consistent style.

The group thus creates the collectively written text from pieces of the individual texts of the members. This is illustrated in Figure 2-12 by the lines drawn from peripheral squares and rectangles to the central rectangle. The small circles within the peripheral squares and rectangles indicate that a piece of this text is cut. The point at which a line terminates within the central rectangle represents the place in the collectively written text where the cut text is pasted. After the whole text is pasted together, the group then collectively reshapes it.

The illustration on the right side of Figure 2-12 represents mosaic reading. Mosaic reading shows how different readers can read the same text in different ways. In mosaic reading, a small group of people summarise the same text and then compare how their summaries differ. In the illustration, the line of connected circles at the far left represents the initial text that the group members read and summarise. The circles depict parts of the text, such as paragraphs. The sizes of the circles represent the relative importance or quantity of information as intended and presented by the writer.

The three connected lines of circles to the right indicate how three different readers summarise the initial text. As in the representation of the initial text, the size of the circles indicates the relative importance that the reader gives to that part of the text in the summary. For example, the first reader's summary is represented by the second line of connected circles. In this reader's summary, the first paragraph of the initial text was far less important than the last two paragraphs, as shown by the relative sizes of the corresponding circles. The other two readers, however, gave much greater importance to the first paragraph in their summaries.

You're undoubtedly aware that if you read a story in a group, no one will summarise the story the same way. You also know that if you summarise the same story on two different occasions, your summaries won't be identical. Similarly, reading the same book twice is not repetitive since it may lead to a different understanding. When you reread a book, you see new information and details because you change the focus of your reading as well as your perception of the text.

The two illustrations in Figure 2-12 visually emphasise that a group of people perceive the same text differently. In collage writing, the collective perception of text is different from any individual's perception of it. In mosaic reading, different readers perceive the same text in different ways. Because of these differences in text perception, when you write you may want to be more directive. You may want to offer guidance to help the reader perceive things as you perceive them. For instance, you may suggest that part of your text is less important than another part or offer other perceptual cues to the reader.

Text Rotation

Up to this point the predominate visual metaphor for writing has been drawing. The next two visual schemes carry the metaphor further, into the realm of painting where colour, tonalities and mixtures are important. These schemes include considerations such as gradation, balancing and so on that help you colour your text more or less vividly according to your communicative intention and what you want your text to look like.

Rotating text is concerned with writing texts that carry the 'same' message to readers that have differing information needs and backgrounds. For instance, you may 'rotate' a letter, resume or sales brochure to accommodate the particular perspectives and expectations of different readers. When you rotate text, you concentrate on presenting information in ways that take account of the reader's viewpoint and facilitate the reception of your message.

You can visualise text rotation by considering the illustrations in Figure 2-13.

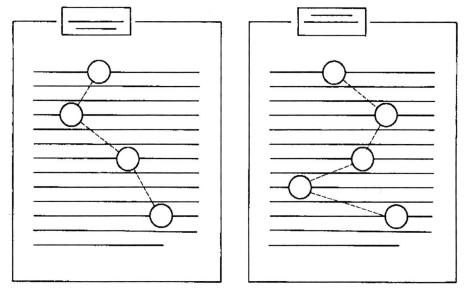

Figure 2-13. *Canvas for text rotation*

Figure 2-13 represents texts that convey the same message to two readers that require different amounts of information. The text, for example, could be a letter inviting the addressee to a professional meeting. The letter on the left is addressed to someone who is already aware of the purpose and importance of the meeting, but who needs details about its time and location. The letter on the right is for someone who has no previous knowledge of the meeting. This person needs to understand the purpose of the meeting, why it's important to attend, as well as where and when the meeting will take place. There may also be some difference in the amount of detail in the directions given to each person. One person may simply need the address, while the other may need precise instructions for getting there.

Both letters convey the same message to the recipient, but in very different ways. The rectangles at the top of each illustration in Figure 2-13 represent how the topic of the letter is expressed. The expressions are different, as you can see by the configuration of the lines in the rectangles. The circles depict specific bits of information; the dashed lines connecting the circles and the position of the circles indicate how all the bits of information are organised and presented.

The letter on the left contains four circles, while the one on the right has five. This is because the left letter includes less information than the right. The positions of the circles and thus the way they're connected, are also different to point out differences in the way information in letters is organised and presented. These differences each demonstrate how a letter can be rotated to accommodate the readers' points of view.

There are several ways to rotate text to facilitate the reception of the same message by different people. While writing, think about how you need to define, describe, explain, repeat, expand, gradate, balance or exaggerate certain words or concepts in your text so that the reader can easily apprehend your message.

You can define a word or concept that is unknown to the reader or one to which you give a particular meaning. When you define a word or concept, you are identifying for the reader what is relevant for understanding the word or concept's specific meaning. You may also want to describe things in the text that are unfamiliar to the reader. Describing means giving details or 'writing about' something. You may also need to explain something to the reader. An explanation gives the reader an understanding of how some events are related in terms of their cause and effect. (These verbal categories of define, describe and explain are discussed in detail in Chapter 3.)

You can also repeat information. Repeating information in different ways emphasises it to the reader and draws his or her attention to it. In addition, you may expand words, phrases or concepts to help the reader. Expanding means adding information, such as through an appositive construction or a relative clause, so that the reader is able to make a connection to what

you're writing.

As in painting, you can also rotate text by gradating, balancing and exaggerating. You can gradate your text by careful use of adjectives. For one reader you may use no adjectives, for another you may include many informal ones and for yet another, you may use only a few formal adjectives.

You may also need to balance parts of your text in specific ways for different readers. When you balance text, you even it out, just as an artist balances bright or opaque colours in a painting. If your text is matter-of-fact here but passionate there, you may decide to tone down the passion for a particular reader. On the other hand, you may want to exaggerate some parts. Exaggerating is the opposite of balancing. In painting, it's the use of sharp contrast between colours; in writing, it's an extreme use of adjectives to persuade a reader or argue against something. Knowing your reader's expectations and needs helps you decide when to balance or exaggerate text.

When you use these techniques, you're rotating text – you're giving a different perspective to it. You're not copying the text, since that keeps the same perspective. Instead, you're creating a different focus and perspective within it.

Exercise

The Writer's Perspective

1. Whenever you want to write a message to different readers, plan to give more or less information according to what you think or expect each of them will know.
2. Then model the text in different ways according to what you may want to define, describe, explain, repeat, expand, gradate, balance or exaggerate.

The Reader's Perspective

1. Whenever you read your message and know that it has been extended to other readers as well, look at what is defined, described, explained, repeated, expanded, gradated, balanced or exaggerated.
2. You may find you know enough now or that you need to know more.

Hypertext

Hypertext is particularly suited for 'hands-on' explanatory texts such as instruction manuals or procedural guides. It is a nonlinear text that is intended to be read and accessed at different levels according to the reader's needs. When you create hypertext you're providing a structure that enables readers to find the level of detail or explanation that they need to understand the information you're conveying.

Hypertext provides readers with different ways of reading or accessing the same text. Readers with differing information needs can choose to read

the text in a way that most directly meets their particular needs. A reader may also choose to read a hypertext a number of times in different ways to obtain greater understanding or details. Hypertext reinforces the learning process because it enables readers to check their understanding. If they find they don't understand what they're reading, they can always go back and read the text in a different way.

Unlike the traditional way of writing explanatory text (visualised in Figure 2-10) that implicitly requires linear reading, hypertext writing allows readers to have a totally different attitude. As illustrated in Figure 2-14, readers of hypertext can do spot reading, and jump and move reading.

THE READER'S PERSPECTIVE THE WRITER'S PERSPECTIVE

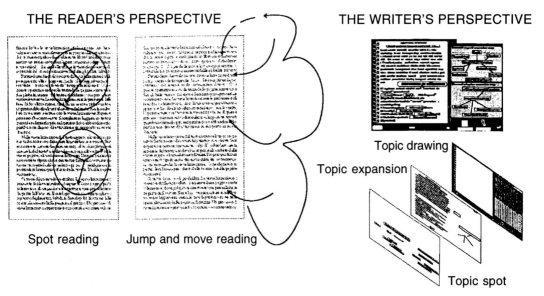

Spot reading Jump and move reading

Topic drawing

Topic expansion

Topic spot

Figure 2-14. *Canvas for hypertext*

In spot reading, readers focus on finding a particular word and then read around it. Readers of hypertext also do jump and move reading, which is skipping back and forth through the text in pursuit of needed information. In both ways of hypertext reading, only the relevant parts of the text are read. The complete hypertext is rarely read by anyone.

When you write hypertext, you assume your readers come to the text with various degrees of knowledge of the topic about which you're writing about. You also assume your writing will be discontinuous and nonlinear so as to facilitate learning.

To write a hypertext according to the model illustrated on the right side of Figure 2-14 , you start with particular words, concepts or topics. You place these in topic spots on the first, most abbreviated part of the hypertext. You then telescope the topic spots backwards to other levels or

layers of hypertext that contain increasing details and explanations. If the hypertext has three levels, the intermediate level could contain topic expansions, while the third level could include topic drawings, which provide the most detail and explanation.

Readers who are experts can then quickly obtain needed information by doing spot reading around certain topic spots in the hypertext. Less experienced readers may need to delve deeper into the levels or layers of the hypertext to find out what they need to know. Novices can actively do jump and move reading throughout all levels of the hypertext to satisfy their information needs.

Although hypertext can most easily be created on a computer, you can also write hypertext on paper. For instance, suppose you want to write a recipe for making pasta with ricotta pesto sauce. You want the recipe to be written as a hypertext so that gourmet, average and totally inexperienced cooks can all read it effectively and find just the information they need to make the pasta.

To write this hypertext recipe, you might begin by structuring it so that it is presented in three columns. In the first column, you present the recipe in the most abbreviated form: you simply list the ingredients and their quantities and then give concise instructions for putting them together. You italicise ingredients such as basil, fettuccine and ricotta cheese that may be unknown to average (and certainly inexperienced) cooks. You also boldface all cooking procedures indicated in the recipe including such words as mince, blend and steam. In the second column you list a description of each of the ingredients italicised in the first column. In the third column you explain each of the boldfaced procedures in the first column.

When written in this way, the recipe is a hypertext. A gourmet cook spot reads the first column to find out how to make the pasta. An average cook may need to jump around among the first, second and even third columns to understand what ingredients are needed and how put them together. An inexperienced cook will need to do the most reading of the hypertext to learn exactly what to do.

There are many other examples of hypertexts that can be created on paper. The important point in writing hypertext is to adopt a hypertext mentality, which appreciates the differences in the expertise of readers. With this attitude, you then strive to structure your writing so that each reader finds the information needed.

Fresco Talking

The last two parts of this chapter deal with group-working activities. In particular, they concern collective conversation and collective writing. As before, these final parts present visual metaphors as a means of reflecting on, understanding and facilitating collective talking and writing.

Fresco is the metaphor for collective conversation, whereas tapestry is

the metaphor for collective writing. Both metaphors are represented by visual schemes or canvases. They are also both related to the collective perception of text, as visualised by the canvas depicting collage writing and mosaic reading (Figure 2-12).

Even though fresco and tapestry are related metaphors, they represent different processes. Fresco has to do with group-working conversations and oral interactions that occur in meetings. Tapestry, on the other hand, is primarily concerned with collective writing and creating collectively written text. Because fresco deals with conversation, it reflects quickness and spontaneity. As a metaphor for collective writing, tapestry – as you will see in the last part of this chapter – is more structured, deliberate and specific.

Fresco is a technique used for creating paintings on wet lime plaster freshly spread on ceiling and walls. During the Renaissance many talented Italian painters adorned churches, buildings and residences with frescoes. The ceiling of the Sistine Chapel, which was created by Michelangelo in the sixteenth century, is perhaps the most famous fresco ever painted.

There are specific reasons why fresco is an appropriate visual metaphor for group conversations. Most frescoes are large and required the work of a group of painters. Frescoes also required quick work. Painting could be done only while the wet plaster surface remained moist; once the surface hardened, it was too late to paint. Because of the large size of frescoes and the time constraints imposed by the materials, fresco painting was a highly cooperative activity.

The oral dimension of collective communication exhibits the same characteristics as noted for fresco painting. What has to be done verbally is constrained by time. For example, suppose you attend a meeting at work with a few other people. You have exactly one hour for the meeting and during that time you must discuss many aspects of a particular issue and make a decision about it. Like fresco painters, to accomplish your task, all the group members must interact effectively and cooperate in achieving the common goal.

A canvas, such as the one shown in Figure 2-15, can be a visual stimulus to organising and controlling a group conversation.

Figure 2-15 probably looks to you more like an abstract drawing than a scheme for organising a group discussion. To be sure, it's a free-form illustration, but it contains certain explicitly defined symbols that serve as aids in coordinating and guiding a group conversation. One of these symbols is the spiral with an arrow in the top, lefthand part of Figure 2-15. There are several others. The zigzag and curving motifs around the outside of the illustration not only have an aesthetic purpose, but they also visually represent the flow and movement of conversation.

The symbols interspersed with the motifs identify specific verbal categories. The spiral with an arrow, for example, symbolises the verbal category 'describe'. The other symbols in the illustration (reading from left

Figure 2-15. *Canvas for fresco talking*

to right, top to bottom) correspond to these verbal categories: explain, express, analyse, inform, reformulate, define, narrate, synthesise, point out and regress. Each of these verbal categories has a precise meaning that is related to a particular cognitive process. These verbal categories and symbols are fully presented in Chapter 3.

The idea of fresco talking is that you use a visual stimulus, such as the one in Figure 2-15, while engaging in a group conversation. The visual stimulus should contain all of the verbal symbols so that the members of the group can refer to them as they talk. During the course of the conversation, speakers can point to a symbol to identify to themselves and to the group what they're doing. For example, someone may begin talking and point to the symbol for explain. The group then immediately understands that what is being said is an explanation, not a judgemental statement or a personal feeling. Someone else may then jump into the conversation, indicating a regression or a reformulation of what the previous speaker said.

There are, however, no hard and fast rules for using a visual stimulus for fresco talking. Speakers don't necessarily need to point to a symbol before speaking. They can simply preface a remark by saying something like 'Now I'm going to analyse . . . ' and use the visual stimulus as an aid for identifying what they're doing. Alternatively, as people talk, a group leader could point to one of the symbols to show the group what is occurring. The leader might also ask someone to speak and point to a symbol to indicate the kind of communication desired.

However used, the value of the visual stimulus or canvas is that it creates an environment for fresco talking. Its visual impact significantly enhances communication. Speakers and listeners alike can refer to it to recognise what is being said and what part of the symbol space the conversation is moving in. The group itself can discover how much conversation is related to certain kinds of communication. For instance, the group might conclude that too much time is being spent on describing something and not enough time on analysing it. A group leader, moreover, can use the canvas to control conversation so that specific goals are realised within the time allocated.

If a group conversation begins to get bogged down, by simply drawing a symbol the group leader can indicate how the individuals in the group should converse. Pointing to the symbol, the group leader can say something like: 'You all gave your opinions in your own way, now let's get down to the real business at hand by using this communicative style'. The symbol would then serve as a traffic sign to control the conversation, unify it and direct it toward some conclusion.

Tapestry Writing

Tapestry is a visual metaphor for collective writing. Tapestry is used here in a broad sense – it refers to both woven hangings (such as those that you might find in medieval castles) as well as the vast variety of oriental and Persian carpets. Collective writing refers to any group activity that results in some written output. For example, a group of people could collectively write a paper presenting the result of their work, a proposal for acquiring new business or many other kinds of written texts.

Tapestry is a rich metaphor because it visually carries certain characteristics akin to collective writing. The weaving in tapestries exhibits a range of densities – from fine to coarse. Some tapestries, for instance, are made with more than a hundred threads per inch, while others are sparsely woven. The creators of a tapestry must decide the density of the weave before actually weaving.

The density of a tapestry corresponds to quantity of a collectively written text. Before writing, a group must consider how much it needs to write. Sometimes the quantity of writing is externally imposed (such as specific page limit for a proposal), while other times the quantity is decided by the group.

Tapestries also exhibit a complexity of design. The design can be a pictorial of animals, humans and nature or an abstract geometric or floral motif. Some tapestries commingle a structured design with a free-flowing design. Whatever the design, all tapestries have to be planned in advance and the plan must be sufficiently detailed to facilitate weaving.

Collective writing is complex too and must be planned. Some written products of a group effort are systematic and structured, while others are more open-ended and unstructured. Collective writing always requires decision-making about who is going to take care of what and how the collectively written text is going to come together. Collective writing also requires a cooperation among the group members to produce a shared product.

Tapestries, as used for writing, may contain selected words that give examples of the main topic, trigger some expectations, allow brainstorming or focus on the most relevant items. There are four visual models of tapestries that facilitate group interactions for collective writing. Each visual model shows a different approach or attitude toward collective writing. The differences in these approaches are indicated visually by the way each model divides and defines space. A group may choose to mirror the visual imagery suggested by one or more of the models as a means of enhancing its interactions for collective writing.

The first two models are shown in Figures 2-16 and 2-17. These models both concern a central text and peripheral, smaller texts. They differ, however, in their approach. The remaining two models are illustrated in Figures 2-18 and 2-19. These models represent differing approaches to the turn-taking in collective writing.

Look now at Figure 2-16, the first model for tapestry writing.

The model shown in Figure 2-16 addresses how a group can expand or revise an existing collectively written text. The existing text can be something like a report that needs to be updated. This existing text is represented by the large square in the middle. Arrows point outward from the central square to smaller squares around it. The smaller squares represent the new texts that result from the group's activity. The individuals in the group write these texts as a result of dividing the work and reflecting on or reacting to the existing text.

The model is called centrifugal because the group starts from the central text and expands outward to texts written by the group members. This, of course, doesn't just happen. It must be planned so that the group members know what roles they have in the collective-writing process. The group decides how the work will be divided up and who is responsible for writing what text.

As an example of how this model can be applied, suppose a small company is under consideration for acquisition by a larger company. A proposal for the acquisition is submitted by the larger company and a group within the smaller company is appointed to write a position paper

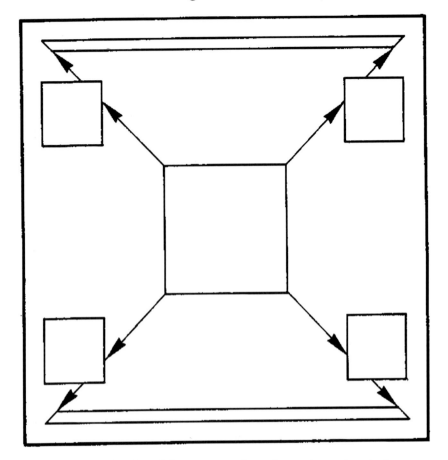

Figure 2-16. *Centrifugal model – you start from the centre and go to the periphery*

in response. The centrifugal model can be used as an approach for collectively writing the position paper.

The acquisition proposal is the central, existing text. In a group meeting the group members are then asked to write their reactions or opinions about the proposal. There is a limited time for the meeting, so the length of the members written responses is restricted to one or two pages. Once every member has finished writing, the group exchanges the texts for reading. In this model, these texts are the peripheral texts emanating from the central text.

The reverse of the centrifugal model is the centripetal model in Figure 2-17.

Centripetal means that the process of collective writing flows from the outside parts to the middle. In this model, the smaller squares around the outside represent existing texts. These texts could be a set of individually

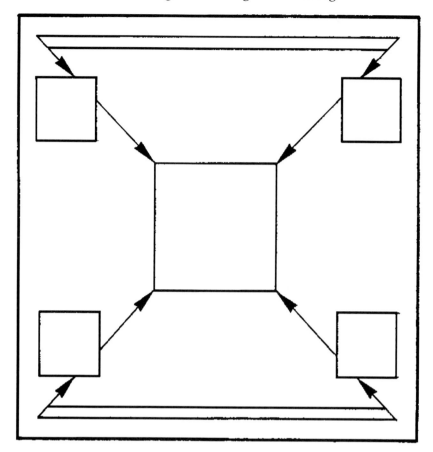

Figure 2-17. *Centripetal model – you start from the periphery and go to the centre*

prepared notes or memos about a certain topic. The group's job is to consider this material and integrate it into a collectively written text, which is represented by the large central square. As in the centrifugal model, the group plans how to integrate the material and makes decisions about the division of work among the group members.

What is interesting to notice in both the centrifugal and centripetal models is that they preserve a record of the process of creating the collective text. In the centrifugal model, the existing central text remains with the individual texts triggered by it. Likewise in the centripetal model, the existing texts are kept with the resulting integrated text.

This preservation of the process of collective writing is important because it enables you to retain two things. First, you can always see the individual contributions – they don't get lost in the collective process. Second, you can see what the collective writing process included and what

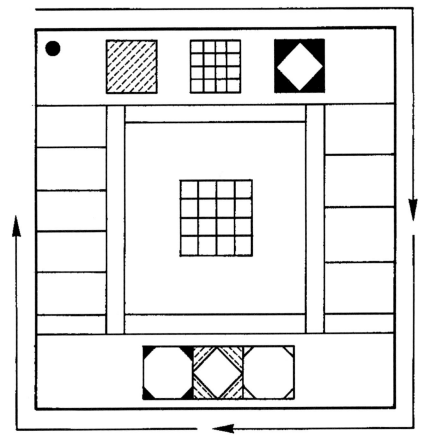

Figure 2-18. *Linear rotation model – you start from the upper left and proceed around the periphery clockwise*

it eliminated from the existing text. Knowing this helps you understand what was modified and why.

The next two models represent a different approach to collective writing. Figure 2-18 illustrates the linear rotation model.

In the linear rotation model, the group is concerned with writing a text that deals with a particular topic. Each group member decides to write about the topic from the perspective of a particular communicative intention or point of view. For example, one member of the group may decide to write a descriptive text, while another may want to write an analytical one and give more detailed explanation. Other members may choose to write about the topic from the perspective of their particular roles in the group or their viewpoints. What the group is doing at this point in a visual sense is deciding how to partition the space for writing.

When the members finish their written contributions, they are passed around and read. These written contributions are represented by the small

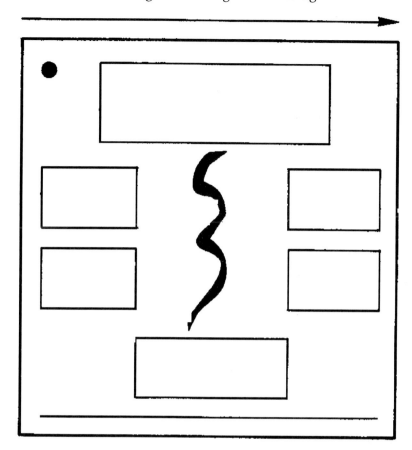

Figure 2-19. *Linear sequential model – you start from the upper left and proceed across from left to right and then down*

patterned squares around the outer part of Figure 2-18. The patterns in the squares are all different because they represent the unique contributions of the members. Each contribution presents a particular kind of writing or a specific point of view about the topic. The specific points of view may be related to the different roles the members have or to the differences in their individual perspectives or feelings.

The group then proceeds to consider each text in a linear fashion, in order around the square space of the visual model, as shown by the arrows. At some point, the group decides which text seems the most relevant, important or crucial. The chosen text is considered the final written output of the group or serves as a trigger for additional writing. This text is placed in the middle of the visual model as a representation of its importance.

An example of how this model can be used, consider a group writing about employees being laid off as a possible result of losing a large

contract. The members of the group might each decide to write something based on a particular way of looking at the problem. One member might focus on explaining why the contract was lost, another on pointing out a possible benefit to losing the contract and another on expressing his feelings about the prospects of being laid off. One by one the written texts are discussed by the group. The one that appears most to the point is then determined and may trigger additional writing. The linear rotation model, like all the models, is a snapshot in time. The process of collective writing may continue. The model itself serves as an image that helps track the process. It also helps to prevent the differing perspectives and points of view of the members from being lost.

Figure 2-19 shows the linear sequential model of collective writing.

In this model the members of the group are not so much representing themselves as they are representing some collective thought. For instance, they could be department managers. The group writes a collective text. The texts contributed by the group members are represented by the rectangles in Figure 2-19. These texts, as in the linear rotation model, are read and discussed by the group. In this case, however, the order is linear sequential, going from left to right, top to bottom, as you do when you read a page. Because the texts are the result of some other group process, they contain systematic, well-defined and accepted material.

As the group discusses these texts, however, controversial issues may surface. Common concerns left undefined or that remain controversial are noted in the spiral motif by a word or short sentence. The group can then view them as questions, problems or issues needing resolution. They may then become topics for further discussion.

3

Writing with Visual Symbols

Musical notation uses a set of visual symbols to convey the composer's intentions and wishes to those performing or executing the composition. Even though music is fundamentally to do with sound, it's conveyed through visual symbols. These symbols include, for instance, a clef to indicate pitch, a time signature to show the rhythm and scales to identify the key. The musical symbols are essentially visual drawings or icons whose meaning the musician needs to know to execute a musical piece properly. The symbols communicate to the musician what the notes written on the staff alone cannot.

Text, in a sense, is like a musical composition. Words are like notes. They have meaning in writing, but the words alone are not enough to convey the writer's intention fully. When words and sentences are spoken, however, the speaker's intonation helps the listener understand the intention. For instance, depending on your intonation, you may have different intentions when you say, 'The window is open'. Saying it flatly may simply describe the state of the window to a listener. Saying it with anguish, on the other hand, may convey to the listener that you're cold and want the window closed.

Unfortunately, the equivalent of intonation is missing in written text. But by using visual symbols, you can convey your communicative intention when writing text, just as a composer does when writing a musical composition. Visual symbols establish a level of communication and harmony between the writer (composer) and the reader (the musician). The reader 'plays' a text, just as a musician executes a composition. A text consisting of words alone may be ambiguous to a reader, just as a musical score without symbols might confuse a musician. The notes in the musical score have little meaning by themselves unless the composer includes symbols that tell the musician exactly how to interpret them.

This chapter presents several visual symbols that you can use when writing to enhance the communication and cooperation between you and your readers. These symbols raise the semantics of text by making its meaning explicit. By using these symbols you will make more apparent to yourself and to your readers what you're doing in the text you write. You will become more aware of how your writing style deeply affects the way your readers react to what you've written.

Two kinds of visual symbols are presented. Each kind of symbol has its own particular use, just as various kinds of symbols do in a musical score. The first kind of symbol characterises the style or type of text. There are eleven of these symbols with the following names; describe, define, narrate, point out, explain, regress, reformulate, inform, synthesise, analyse and express. The name of each of these symbols has a technical meaning that relates to a cognitive process and identifies a specific intention of text.

These symbols are designed so that they intuitively convey the intention of text. They're dissimilar so that you won't confuse them. Their names are all verbs whose precise meanings are based on ancient Latin words. These Latin words carry in their original meaning a strong suggestion about the cognitive process that each symbol represents.

The second kind of symbol facilitates the interaction between you as a writer and your readers. These symbols – called turn-taking symbols – enable readers to interpret text more explicitly and they also indicate when and how you want them to interact with it. You can use these symbols to direct the turn-taking among readers of a text, much as a composer uses notation in a composition to direct the actions of orchestra members.

The symbols presented in this chapter are important aids in writing in two respects. First, they help you become self-reflective as a writer. By thinking about the symbols related to cognitive processes and styles of writing and using them to sketch out text, you're making your intention explicit to yourself. Once you're aware of your specific intention, you can examine the text you've written to see how well it conveys that intention.

For your readers the symbols are also aids because they make the meaning of the text more apparent. By including symbols in your text, you're explicitly declaring your intentions to readers. The symbols also give readers hints about how you want them to interpret the text and they invite them to interact with it.

You can use the visual symbols presented in this chapter rigidly or flexibly. How many symbols you use is up to you – the quantity doesn't matter. What's important to remember, however, is that any time you use visual symbols in writing text, you're creating a particular frame of mind for readers. You're providing the possibility for readers to play the text, to interpret it according to your wishes and to become actively involved with it. When you use visual symbols, you increase the power of your writing because you're giving more information and explicitly declaring your communicative attitude.

Describe

'Describe' comes from the Latin word 'describo', which means to write about or write around.

You can write a description in a free, unconstrained manner. You can provide as much or as little information as you choose. You can order the

information in a description as you want – you don't need to put it in a logical or chronological order.

For example, in describing a room, you could start with what strikes you as the most dominant part – a fireplace. You could write all about the fireplace, including details about its size, construction and design. You could then characterise the rest of the room in relation to the fireplace, giving details only about particular parts that interest you. Alternatively, you could describe the same room by focusing first on its size and orientation. Next you might itemise the furniture in the room and then end with some details about the lighting. Both approaches are equally descriptive of the room.

As another example, consider the story of John wanting to buy a bike. Written descriptively, this story could be as follows: 'John, who has dark hair and is very tall and slim, wanted to buy a new mountain bike to go biking every weekend on the trails by his house. He bought a lottery ticket at the train station one afternoon just to try his luck. He ended up winning and was able to buy the bike he wanted'.

The symbol for describe is a spiral (Figure 3-1). This symbol conveys the free, unconstrained characteristics of a description. The point at the centre of the spiral is the starting point for your description. You begin there and write your way around the spiral as you present more and more information. The more information you give, the larger the spiral becomes. The size of the spiral may be small or large, depending on how much information you choose to present.

Figure 3-1. *Describe*

Define

'Define' comes from the Latin word 'definio', which means to put limits on. Originally 'define' meant to mark off the boundaries of a territory or

parcel of property. A definition is similar to a description, except that instead of being open and unconstrained, it's restricted to the selection of relevant information.

When you define something, you provide just the relevant information about it. A dictionary, for instance, gives only specifically selected information that conveys the general, usual meaning of a particular word. It doesn't include every nuance of meaning. The story of John and the bike written in a defining style, for example, could go something like this: 'John, who is my uncle, wanted to buy an ATX 780 mountain bike. He was able to buy it because he won the California Lotto drawing last week'.

Figure 3-2 shows the symbol for defining. This symbol conveys the idea of putting limits on what you're defining. What you're defining is represented by the small circle in the centre of the symbol. It's enclosed on all sides by boundaries that constrain and confine it. The oblique parallel lines between the boundaries and the small circle indicate that you fill up a definition with information chosen to be relevant.

Figure 3-2. *Define*

Narrate

'Narrate' comes from the Latin word 'narro', which means to talk about facts and events in a given order, to tell a story.

Narrating is concerned with writing about a set of facts and events in some sort of order. Narration is common in novels, newspapers, magazines and other texts that tell a story. When you write a narration, you can use connectors, as explained in Chapter 2, to vary its structure. Connectors are an extremely important resource of language that allow you to scramble the order of events. If you use connectors properly, you don't need to write

a narration in a strictly logical or chronological order.

 In fact, most narratives exhibit a scrambled order to keep the readers' attention and prevent them from becoming bored with the monotony of one event told in sequence after another. Flashbacks in movies, for instance, break the consecutive chain of events by moving abruptly from some present event to one in the past. Instead of telling the story of John and the bike in consecutive order as 'John wanted to buy a bike. He didn't have money. He won the lottery. He bought the bike and was happy', you could write it more interestingly this way: 'John was happy because despite the fact that last week he didn't have enough money to buy the bike he wanted, yesterday he won the lottery and purchased it'.

 Figure 3-3 is the symbol for narrate. The symbol represents a set of events or facts chained together in a particular order. The events or facts are represented by points. The arrows connecting the points show the chronological flow of the narration, while the arcs represent its logical connection. As a story becomes longer and more articulated, more points are added and the narration line becomes longer and longer.

Figure 3-3. *Narrate*

Point Out

'Point out' means to take a point (specific event or fact) out of a narrative, focus on it and add more information about it. When you point out something, it doesn't mean that the other events in the narration are irrelevant. It just means that you're turning your attention for a while to one specific thing and amplifying it. This is what you may do unconsciously anyway, according to your interests, preferences and attitude. However, when you deliberately include a visual symbol in your writing you become aware when you are pointing something out.

 In writing the story of John and the bike, you could point out, for example, why John didn't have enough money. You could write: 'John wanted to buy a bike, but he didn't have enough money. Let me point out to you why this is so. He always spends his money on frivolous things. He charges them on his credit card and is barely able to make his monthly interest payment'.

 Figure 3-4 shows the symbol for point out. This symbol represents the

specific point in a narrative that is selected from the chain of facts and events and then expanded. When you point something out, what you're pointing out is enlarged because you give additional information and details about it.

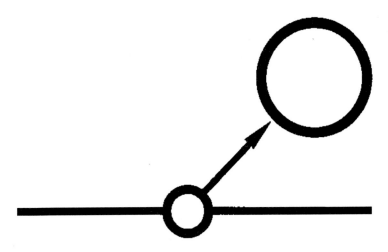

Figure 3-4. *Point out*

Explain

'Explain' is derived from the Latin word 'explano', which means to unwrap or open up.

When you explain something, you present facts in a cause and effect order. You may start from the original cause and move downward progressively to a set of effects or, alternatively, proceed from the effects and move upward toward the original cause.

Explanations are common in texts such as manuals or instruction books. They are also found in stories and narratives in places where the writer takes a more active role. Instead of just delineating the facts for the reader, the writer may interpret them and show how they're related and connected. In explaining the story of John wanting to buy a bike, for example, you could write: 'John won the lottery. Therefore he was very happy because he was finally able to buy the bike he wanted'.

Figure 3-5 is the symbol for explain. This symbol is a graphic representation of a procedural description. The symbol shows that you can go in two directions: from the top downward (from cause to effect) and from bottom upward (from effect to cause). Explanations frequently use connectors (because, since, therefore and so on) to help the reader move through the text and understand the logical relationships within it.

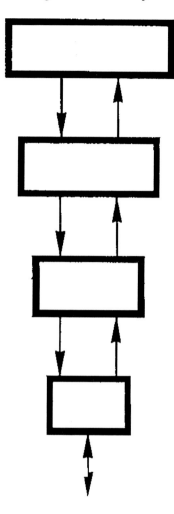

Figure 3-5. *Explain*

Regress

'Regress' comes from the Latin word 'regredior', which means to go back.

When you regress, you give more information about a certain item within a chain of information. The regression provides a context for the item so that readers can understand it from a less informed or different viewpoint. You may want to regress at a particular point when you think your readers' perspectives, expectations or knowledge are different from yours. When you regress, you provide enough additional information to be understood, but not so much that you bore readers with the obvious.

One example of a regression is: 'John Smith is president of Infogenics, a small consulting company in northern California'. The appositive 'a small

consulting company in northern California' tells readers what Infogenics is, something about its size and where it's located. A regression that gives a context for a geographic location is: 'John lives in Novato, which is in Marin County north of San Francisco in California, one of the western states'. Of course, if the writer thinks the reader already knows some things, he shouldn't include them in a regression so as not to labour the point. But if the writer is unsure of what the reader knows, he may provide a broad regression just to be safe.

The symbol that visually represents a regression is shown in Figure 3-6. This symbol has two parts because it represents a two-step process. The lower part of the symbol represents a set of words, sentences or paragraphs. You identify the word, sentence or paragraph where you want to regress, then you focus on it (the rectangle with a point inside), take it out of the text chain and then zoom out from it. The rectangles expanding out from the item taken out of the text chain symbolise a larger and larger context for it. They represent more and more information that the writer thinks is important and relevant in understanding the item chosen for a regression.

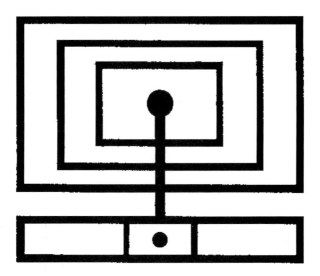

Figure 3-6. *Regress*

Reformulate

'Reformulate' comes from the Latin words 'reformo', 'reformulo', which mean to change shape and to shape again.

To reformulate text, you reposition yourself with a different attitude to your writing. You change your writing by switching from one style to

another. For instance, you can reformulate a description into a definition. Similarly, when writing a narrative, you may stop and reformulate part of it to point out or explain something.

Certain writing styles are closely linked so that reformulating text from one style to another is natural. Describing and defining are closely linked styles, as are narrating and pointing out analysing and synthesising. Switching from one of the linked styles to the other means that you approach writing the same text with a different attitude and emphasis.

The symbol for reformulate is shown in Figure 3-7. It conveys the idea of making a transition or switching from one style to another.

Figure 3-7. *Reformulate*

Inform

'Inform' comes from the Latin word 'informo', which means to put into shape or to shape up.

The symbol for inform is shown in Figure 3-8. This symbol consists of two lines that converge on a point and then depart from it. The point represents some specific information. Informing – in the sense of shaping up information – is a broad concept that encompasses the other symbols as well. It's an umbrella term that covers all aspects of shaping up information. As such, the symbol for inform is too general and vague to be used alone. It becomes more specific, however, when you consider the direction from which you shape up information.

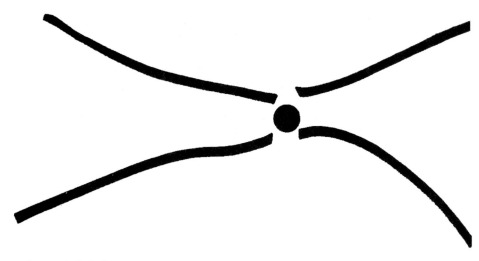

Figure 3-8. *Inform*

When you split the inform symbol at the point of convergence and divergence, you create two other symbols that more explicitly represent how you inform or shape up information. These two symbols are shown in Figure 3-9.

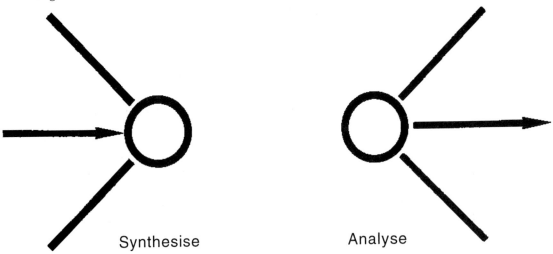

Synthesise Analyse

Figure 3-9. *Synthesise and Analyse*

The first symbol, which depicts the convergence of information to a point, represents the concept of synthesis. 'Synthesise' is derived from the Greek word 'synistemi', which means to put together or collect. You synthesise when you shape up information from a broad or undefined domain to a

specific point. As the arrow in the symbol shows, you inform synthetically when you shape up information from a large, open realm into a small, tight kernel.

The second symbol depicts the divergence of information from a central point and represents the concept of analysis. 'Analyse' comes from the Greek word 'analyein', which means to dissolve, loosen or unfasten. As the arrow shows, you expand from a small, tight central kernel of information outward. You inform analytically as you break apart, unloosen and unfasten a kernel of information.

Because 'informing' is such a vague concept, you make your intention in writing more precise by considering an attitude of either informing synthetically or informing analytically. You usually use the symbols for synthesise and analyse in combination with the other symbols. For example, you could explain something analytically or explain it synthetically. By using synthesise and analyse with another symbol, you're showing the reader more specifically what you intend to do.

Express

'Express' comes from the Latin word 'exprimo', which means to push out, to press out.

To express means to give personal and emotional opinions about facts. Expressing is the most subjective style of writing. It's bound to your personal experiences, likes and feelings. In telling the story of John buying a bike, you might express part of it as follows: 'I never really liked John, who is an undeserving, lucky man. This time he won the lottery. I really can't stand that'.

As you begin to consider expressing as a style, you may become more aware of your personal feelings and how they affect the way you write – and of course, the way readers perceive what you write. In some cases, expressing yourself when you write is appropriate; in other cases, it's inappropriate. For example, when you write a diary or something else that exhibits your personal feelings, you want what you write to have an expressive style in the technical sense. On the other hand, if you write an evaluation of a project for a client, you don't want your personal feelings about various people involved in the project to be apparent – rather, you want to control your personal feelings and stick close to the facts.

The symbol for express is shown in Figure 3-10. This symbol represents a visual territory that is subject to modification according to personal opinions. Unlike the symbol for define, which has distinct boundaries, the boundaries of the express symbol are open and enclose an amorphous amoeba-like shape, which represents your constantly changing subjective feelings, mood and state of mind.

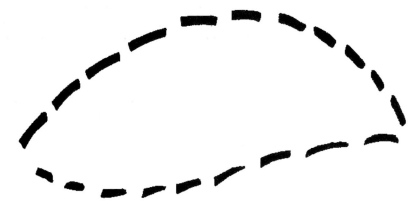

Figure 3-10. *Express*

Examples of Text Styles

The following examples show the differences among the various text styles. Each text is written in a particular style that exhibits the writer's communicative intention, attitude or position in replying to the query, 'What happened to you yesterday?'

Text Style	Symbol	What happened to you yesterday?
Describe		My father and I were watching a televised debate among the presidential candidates. After the debate, we had an argument about politics. It became heated and I left the house. I actually raised my voice and he did the same before I finally walked out of the door.
Define		I had a fight with my father about politics.
Narrate		I asked my father what he thought about the presidential candidates. He replied that he was going to vote for the most conservative candidate. I told him that I thought that candidate would ruin the country and set

civil rights back fifty years. After more discussion, he then said to me, 'You're young and inexperienced and you will soon learn'. I became furious and left the house without saying another word.

Point out

My father and I had a fight about politics. Affirmative action is one of the political issues on which we vehemently disagree. He takes a typical, backward conservative approach, while I support an enlightened, liberal one.

Explain

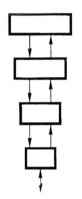

My father doesn't have an open mind when it comes to politics. When I tell him my opinion, he never listens. This happened yesterday and as usual I got angry, he insulted me and we had a real fight.

Regress

My father – who has voted for every conservative candidate since 1964 – and I had a fight about politics.

Reformulate

I told you exactly what happened when my father and I had a fight. I want to point out to you, however, that it wasn't my fault. He kept pushing his point, even after I acknowledged his right to his opinion.

Synthesise

My father and I had a fight about politics. Politics, however, was just the occasion of the fight. We often fight over issues of authority and personal freedom.

Analyse

My father and I had a fight about affirmative action. He takes a conservative approach and I suppose that's because he feels he has succeeded by his own efforts, without preferential treatment. I just don't think he really understands that some people can't succeed like he has because of institutionalised discrimination.

Express

It really bothers me when my father and I have a fight. We say things to each other that we really don't mean. I believe my father is a good person, but I just wish he was more tolerant of my opinions.

Turn-Taking Symbols

In addition to symbols that identify the style of text, there are also five symbols that you can place within text to facilitate a dialogue between you and the readers of text you write. These symbols, like musical notation, help readers play the text the way you want them to. They explicitly tell readers how you want them to interpret what you've written and when it's their turn to get into the text and modify it. They enhance the cooperation between you and your readers so that your readers receive and understand what you intend to convey. They also direct your readers to parts of the text that you want them to actively take part in interpreting.

 These turn-taking symbols always appear in text in pairs. If you use them, make sure that the first symbol of the pair marks the beginning of a portion of text, while the second marks its end. The pair of symbols when used this way enclose a specific portion of text that you want to draw readers' attention to. The turn-taking symbols are the following:

Major scale

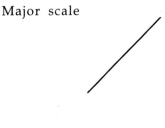

signals readers at the point of its appearance in text that what follows should be read exactly as written. When you include this symbol to mark off a portion of text, you're telling your readers to interpret that text as it stands. You don't want readers to change the text in any way.

Minor scale

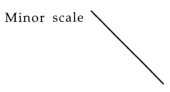

signals a request for the intervention of readers. When you include this symbol to mark off a portion of text, you're telling readers that what you've marked off is written from your perspective, but you

would like them to change it according to their own different points of view. This symbol invites readers to modify this portion of the text. You welcome changes of adjectives, the reformulation of sentences or the modification of the marked-off text in any other way that seems appropriate.

The symbols of major and minor scale enable you to convey to readers the 'key' for interpreting the 'notes' on the text. There are also two symbols that signal the 'rhythm' of the text.

Open or unsaturated rhythm

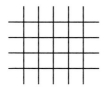

indicates to readers that you consider the text enclosed between the symbol to be incomplete. For example, if you're writing about history, you might include this symbol to indicate that your information at that point is sparse. The symbol invites readers to get into that portion of text and add more information if they can.

Tight or saturated rhythm

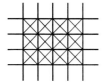

indicates to readers that you consider the text to be complete. When you include this symbol to mark off a portion of text, you indicate to readers that as far as you're concerned, the text is comprehensive, accurate and finished. You want them to accept the text as it is and not add anything to it.

You can also use a v-like insertion symbol to direct the attention of readers to a particular portion of text. You may use the insertion symbol in combination with any of the other symbols, as the following examples show:

The insertion symbols when used in combination with the describe symbol explicitly identify the portion of text between them as a description. You're explicitly telling readers you want them to interpret this very specific part of text as a description. The text that precedes or follows it, however, may exhibit a different style.

The explain symbol (which is just an example here – it could be any other symbol) may be included in the margin or at the beginning of a section of text to tell readers that the text is predominately an explanation. Within the explanation, however, you can also place insertion symbols with the analyse symbol to mark off a particular part of the explanation that is analytical.

Without changing the overall 'key' or 'rhythm' of the text, you can also use the insertion symbols with the unsaturated rhythm symbol to identify a particular portion of text that is less dense, more open and somewhat incomplete.

These examples are just some of the ways you can use turn-taking symbols in text. You can use them to be more or less directive to your readers. The greater the density of symbols you include in text, the more directive you will be toward your readers and the more control you will exert over their interpretation of the text. Whatever the density of symbols you decide to use, it's important to maintain consistency in the way you use them. If you begin including symbols to direct readers stage-by-stage, step-by-step through the text, you will need to follow through with that decision so that you won't mislead or confuse them.

 You can also experiment with various combinations of using the turn-taking symbols with the other symbols that identify the style of text. As you experiment with all the visual symbols, think about yourself as a composer who – by simply placing notes and symbols on a staff – is able to provide enough information for an orchestra to play and interpret a complex musical composition.

 You can use the symbols freely to facilitate your creativity and enhance the communication between you and your readers. Like music, text is always moving and fluid. Sometimes as you write, one particular style may emerge and you may want to use a symbol to alert your readers to it. Other times you may find it difficult to discern the style of the text. Several styles may come together, like a melody, so that it's not possible to characterise the text by any one style. If you encounter this fuzziness about your style, it may just mean that the text is exhibiting the free-flowing characteristic of language. In such cases, rather than trying to identify its style with a symbol or set of symbols, it's best to leave the interpretation open to your readers.

4

Shaping and Organising Text in Space

This chapter introduces you to a totally new way to think about text. Instead of considering text in a traditional page-oriented amorphous fashion, you're challenged to conceive of text as having shape. The specific shape given to text visually and explicitly conveys its communicative intention to readers. In this revolutionary way of thinking, text can be square, triangular, semicircular or some other shape. There's a syntax of textual shapes because each shape carries a specific communicative intention. Square-shaped text, for example, identifies the text as a story, triangular-shaped text tells you that the text embodies a memory and so on.

This syntax of shapes, which is agreed upon by both writer and reader, enables the construction of textual structures, as well as a cooperative completion of text. As a writer you can combine the various textual shapes together to create structures that resemble something like a textual origami. Readers may also have a turn in shaping up the text in their own ways and add to the structure you present to them. You'll see later on in this chapter, through a hands-on exercise of shaping up a simple story, the possibilities of using shapes to organise text in space.

Shaping text is like shaping pottery. You can shape up the same material into a coffee cup, bowl, dish or any number of other objects. How you shape the material depends on the function of the object you intend to create. You can also shape up text into various shapes according to the specific function of the text. All text is made of the same material, which is language, but its shape depends on the specific communicative function you intend it to have. The shape of the text itself is therefore an evidence of your intention and your readers will know your intention immediately when they see your text.

You use a set of two-dimensional geometric signs to shape text. These textual signs are like traffic signs whose specific shapes immediately and unambiguously alert you. When you see a round traffic sign, for instance, you know something is prohibited. Likewise, when you see a triangular traffic sign, you know that a potentially dangerous condition lies ahead. In

the same way, the shape of the textual signs makes readers immediately aware of the specific intention of text.

The textual signs give you additional possibilities for explicitly expressing your writing to readers. They tell readers on a global level what the text is about, even before they begin reading the language of the text. The textual signs are therefore more immediate, less abstract than the visual symbols presented in Chapter 3.

The geometric properties of the textual signs require some planning on your part to determine how to partition and shape your text. Depending on the kind and amount of information you have to convey, you may decide, for example, to put some paragraphs into a triangular shape and others into a square shape. Because they're geometric, you can also combine textual signs to shape and organise in space textual structures that are complex and changeable. In fact, these two-dimensional signs are the building blocks for the textual objects discussed in Chapter 5.

The first part of this chapter presents all of the geometric signs for shaping text. Each sign is defined and illustrated so that you understand its meaning in writing and reading text. The next part gives a hands-on exercise that shows you how to use the signs to shape text and how you can put them together to construct a kind of textual origami. By working through this exercise, you'll understand how to shape text with the textual signs.

Signs for Shaping Text

There's a set of geometric signs for shaping text. The shape of the text as conveyed by a geometric sign reinforces your communicative intention as you write and visually proclaims it to readers. Follow these guidelines as you write and read textual shapes.

The textual signs shown on pages 95 to 98 enable you to transform your thinking, writing and reading text from a verbal mode to a visual mode. You can let your imagination guide you as you use these signs in making this transformation. If you're apprehensive about moving too quickly from page-oriented text or if you write lengthy texts, simply put the appropriate sign at the beginning of the text. If you're more adventurous, cut a piece of paper into the shape of the kind of text you want to write, then fill it with text. Shape other types of text if you wish and then try putting the shapes together to create a textual origami.

Exercise for Shaping Text

The exercise that follows on page 99 gives you the opportunity to experience shaping text. In this exercise you'll shape up a simple story in various ways to explore different possibilities and you'll see how to use all of the textual signs. The illustrations that accompany the steps of the exercise include sample texts, but feel free to write and shape your own texts.

Square

When you want to write a *story*, which means a narrative text that has a set of events about some protagonists, use a

similarly, when you see a square, interpret the text you're reading as a *story*.

Square within Square

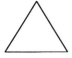

When you want to write a *summary*, which means a reduced version of a story that includes only those events you consider relevant to understand the story, use a

and similarly, when you see something like this, interpret the text as a *summary*.

Triangle

When you want to write a text that is related to a *memory*, which is a personal experience of an episode or a fact triggered by the reading of some initial text, use a

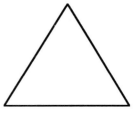

and similarly, when you see a triangle, understand that the text is about a *memory*.

Semicircle

When you want to write about an *idea* or a *particular concept* triggered by reading some initial text, use a

An idea or particular concept is an abstract consideration that you've identified in some text. When you see a semicircle, know that the text is about a *particular concept*.

Right Triangle

When you want to write a *comment*, a personal reaction or evaluation, related to a certain text, use a

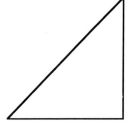

and similarly, when you see a right triangle, interpret the text as a *comment*.

Frame

When you want to write a text *analogous* to another, then frame it like this:

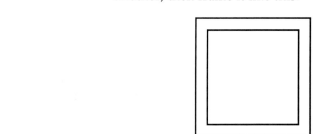

To be analogous, a text must express the same concept or series of concepts as the specific narrative text it references. Aesop's

fables, for example, are analogous. When you find a framed text, understand it to be *analogous* to the text that precedes it.

Grouped Semicircles

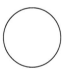

When you want to write additional *ideas* or *concepts* that emerge from the reading of a text, use a semicircle for each one and group them together like this

The grouped semicircles show the ideas or concepts that you've identified. They keep their individual identity but are grouped together. When you see a group of semicircles, interpret it as *concepts extracted* from the text.

Circle

When you want to write a unique *global idea* or a *general concept* that emerges from the text, use a

A global idea or general concept is the one – of all those that you've identified – that is the most important or significant. When you see a full circle, interpret it as a *general concept extracted* from the text.

Inscribed Arcs

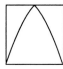

If you want to add an alternative development to a story you've written or if you want the reader to add a *new alternative* to it, draw two arcs like this

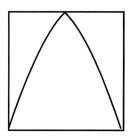

The two inscribed arcs can be a sign for turn-taking. You can either signal that you will be writing more or that you want the reader to take a turn and write more. When you see two arcs drawn on the text you're reading, interpret the text as being enriched with another *possible development* or as ready for you to add your own alternative to it.

Opened Text Space

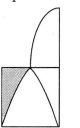

When you or a reader develop an alternative to part of the text, open up a new element in space for the new alternative. Attach the opened text space to the existing text, so that you can see both the old and new versions of the text.

The sign for the new alternative tells you where to provide an alternative development of the text. When you or the reader complete text for the alternative, fill up the empty text space with it and present it in this manner:

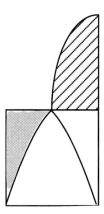

Exercise for Shaping Text
(from page 94)

John wanted to buy a bike. He had wanted to buy it for years, but never seemed to have enough money. He attempted to get a loan from the bank, but failed. As he was walking down the street one day, he saw a sign for the lottery. He decided to play. He won the lottery. He was able to buy the bike he had wanted for so long and was very happy.

1. Think about your text, which is a story, and write it in a square.

2. Write a brief summary of the text within the smaller square. The summary is just a short version of the main facts and events that are important and relevant in understanding the text.

John wanted to buy a bike. He didn't have enough money. He won the lottery and got the bike.

John wanted to buy a bike. He didn't have enough money. He won the lottery and got the bike.

John wanted to buy a bike. He had wanted to buy it for years, but never seemed to have enough money. He attempted to get a loan from the bank, but failed. As he was walking down the street one day, he saw a sign for the lottery. He decided to play. He won the lottery. He was able to buy the bike he had wanted for so long and was very happy.

3. This is how your text with its summary looks now.

You put the two pieces together and once they are together, you immediately know that the larger piece is the text and the smaller one the summary. The summary in the illustration is on the top, but it could also be on the bottom. Where you place it depends on how you want to the reader to navigate through the textual shapes.

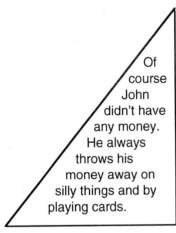

4. Add a comment about an event or a specific fact in your text in a triangle. You position this triangle close to the text that triggered the comment.

5. Your text with your comment now looks like this:

> John wanted to buy a bike. He didn't have enough money. He won the lottery and got the bike.

The text is in the middle since it is the most important, the summary is on top and the comment is to the left. The shape of the comment and its position next to the main text signals the reader that what is inside the triangle is a comment triggered by the text.

Of course John didn't have any money. He always throws his money away on silly things and by playing cards.

John wanted to buy a bike. He had wanted to buy it for years, but never seemed to have enough money. He attempted to get a loan from the bank, but failed. As he was walking down the street one day, he saw a sign for the lottery. He decided to play. He won the lottery. He was able to buy the bike he had wanted for so long and was very happy.

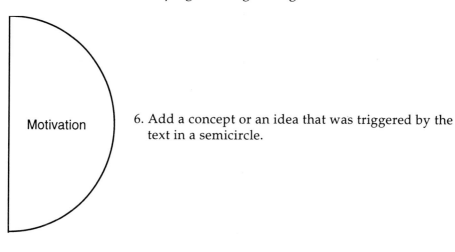

6. Add a concept or an idea that was triggered by the text in a semicircle.

7. Your text with the summary, comment and the idea looks like this now:

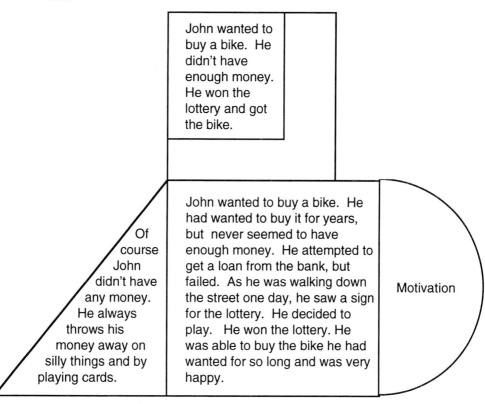

John wanted to buy a bike. He didn't have enough money. He won the lottery and got the bike.

Of course John didn't have any money. He always throws his money away on silly things and by playing cards.

John wanted to buy a bike. He had wanted to buy it for years, but never seemed to have enough money. He attempted to get a loan from the bank, but failed. As he was walking down the street one day, he saw a sign for the lottery. He decided to play. He won the lottery. He was able to buy the bike he had wanted for so long and was very happy.

Motivation

The configuration of the textual structure stays the same, but now the semicircle with a one-word concept appears on the right side of the text. The text stays in the middle since it's the most important.

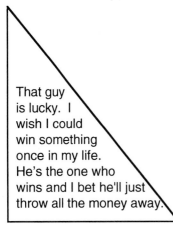

That guy
is lucky. I
wish I could
win something
once in my life.
He's the one who
wins and I bet he'll just
throw all the money away.

8. Now instead of including a concept or an idea, add another comment that is related to a different part of the text.

Put this comment within another triangle and place it on the other side of the text. Before you can place it there, you'll need to remove the semicircle that is currently on the right side of the text. Sometimes as you shape up text, you may need to move or remove some pieces that are less relevant than others. In this case, both comments are selected as more important to include than the concept.

9. Your text with the summary and both comments – but without the concept – looks like this.

John wanted to
buy a bike. He
didn't have
enough money.
He won the
lottery and got
the bike.

Of
course
John
didn't have
any money.
He always
throws his
money away on
silly things and by
playing cards.

John wanted to buy a bike. He
had wanted to buy it for years,
but never seemed to have
enough money. He attempted
to get a loan from the bank, but
failed. As he was walking down
the street one day, he saw a
sign for the lottery. He decided
to play. He won the lottery. He
was able to buy the bike he had
wanted for so long and was very
happy.

That guy
is lucky. I
wish I could
win something
once in my life.
He's the one who
wins and I bet he'll just
throw all the money away.

10. Think about other analogous stories and write them in frames, like this:

> Mary wanted to go on vacation. She couldn't convince her boss. She finally did convince him and went to the Bahamas.

> I wanted to buy a condominium a few years ago. I really didn't have enough money. I asked my mother to lend me some. She wouldn't loan me any. I borrowed money from my father and finally bought the condominium.

Now order them one after the other on the right side of the text.

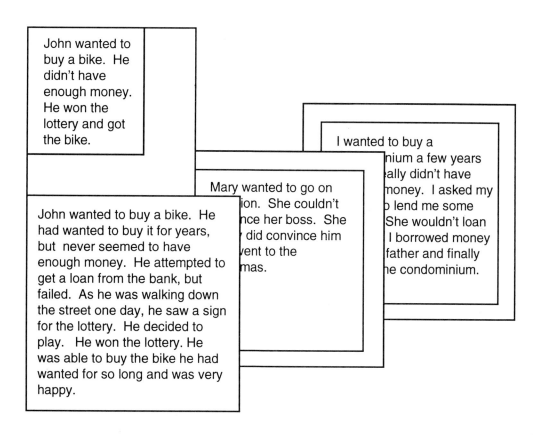

11. Now think about the whole text or any part of the text that reminds you of your own experiences. Write all of these memory stories in triangles like this:

This reminds me of when I wanted to go to New York. I didn't have the money, so I asked to go to a conference there related to my work. My request was approved and I went.

This reminds me of when I wanted to buy a new pair of shoes. I didn't have the money. My mother didn't want me to buy those shoes, so I borrowed money from a friend.

John wanted to buy a bike. He didn't have enough money. He won the lottery and got the bike.

John wanted to buy a bike. He had wanted to buy it for years, but never seemed to have enough money. He attempted to get a loan from the bank, but failed. As he was walking down the street one day, he saw a sign for the lottery. He decided to play. He won the lottery. He was able to buy the bike he had wanted for so long and was very happy.

Now order them one after the other below the text.

This reminds me of when I wanted to go to New York. I didn't have the money, so I asked to go to a conference there related to my work. My request was approved and I went.

This reminds me of when I wanted to buy a pair of shoes. I ve the money. didn't want me e shoes, so I from a friend.

12. Open up your text and add alternative things that you can foresee. These could be different events or new developments. Take away the summary and draw on your text two arc lines that meet in the centre of the opposite side of the square. Now open up alternative text spaces and add the alternatives you thought of. If you want readers to supply their own alternatives, leave one or both of the text spaces empty.

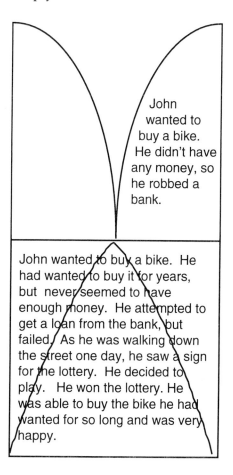

As you organise and shape up text as a writer, always keep the main text the most visible since it's the most important. In shaping up text, there's always some revision to it. During the revision process, you should adjust the structure if there are so many pieces that it's confusing to the reader. You're the one who decides how many pieces are in the textual structure and how complex it becomes.

13. Now think about what concepts the text triggers in you. The text
 will become just a word or a set of words that corresponds to those
 concepts and is positioned within one or more circles. This is a
 synthetical process. You're going here from the analytical part of
 the text, with all its information and language, into abstractions,
 which you put into round shapes. This is how the text becomes an
 abstraction expressed either as a word or a set of words.

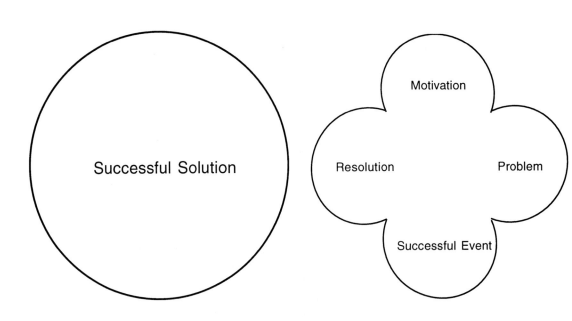

5

Building Textual Objects

One thing is sure: when we write sentences in English, they all follow a linear order and the writing goes in a left-to-right direction. This is a fact in our language. Japanese, however, is written in a right-to-left direction, but it's still linear. Language does imply some linearity and directionality – no doubt about that. But why should we always think of only one-dimensional writing? In other words, why should we *limit* ourselves to the constraints of a page or a computer screen?

Hypertext technology points out a very interesting idea – we can expand text on different levels so that it doesn't necessarily follow a sequential, linear order. Hypertext implies a delinearising of writing and creates the possibility of reading text at multiple levels. Hypertext reading is like using a geographic map: you navigate through it according to the information islands (spaces) you see.

What we present in this chapter is even more ambitious than hypertext. It deals with planning and building 'textual objects' with definite shapes in space. Up to now, we've thought about writing linearly in one dimension and in Chapter 4 we considered specific geometric shapes for writing. Now we're progressing one step forward – into a three-dimensional realm where we shape up and structure textual objects.

The textual objects presented in this chapter were carefully developed and selected. They all share the same fundamental feature – consistency and coherence between the space-organisation they imply and the specific kind of text they contain. In other words, they support text-space organisation and they create a hyperspace for writing.

We're already aware of some space indications in everyday life that we automatically know the meaning of and accept passively. The shapes of traffic signs, for instance, carry specific meanings that we know immediately. For example, round traffic signs carry prohibition messages. Thus when we see a round traffic sign as we drive, even before looking at the picture inside it, we immediately realise that we're not allowed to do something. We also know that triangular traffic signs carry 'beware' messages. So when we see a triangular sign, we're alerted to a dangerous situation ahead about which we need to be careful. How about applying this idea about message shapes – which are so immediate and effective for traffic signs – to the planning, delivering and structuring of text?

If we do this, our readers will know at first glance what we as writers would like them to do with our text. They will know this by simply recognising the shape and the structure of it. For instance, using the techniques provided in this book, if we want to write a story, we may plan to use a square space. If we want to write a memory text and receive comments on it, we may plan to use a triangular space. When we use a round space to write, we're telling readers that the round space contains a concept triggered by a text. We may also build a cubic story, a pyramid story or a polittico panel for discussion.

There are particular objects that you can use to explore the possibilities of this new way of writing. You may write on a:

Cube
Pyramid
Miniature
Polittico
Obelisk
Cylinder/Column/Papyrus

As you use these objects, you experience directly the shaping up of your own text. You can then pass your textual objects to your readers who you may invite actively to participate with you as a text architect. Some textual objects facilitate collective creative writing. In collective writing, a group organises itself so that everyone has a particular task that leads to the common, final result of collectively shaped text.

Does all this sound totally crazy? Perfect – crazy ideas are likely to be good!

Now let's explore these strange textual objects a little more. Each object is for a particular kind of text. All of the shape-space organisational textual objects and structures you'll meet in this chapter are based on the Text Representation System. They have two basic types of shapes:

(a) Squared shape-space organisation (cube, miniature, column). The cube and miniature are based on squares. The column is based on a rectangle, which forms the side of the column wrapped around the column's two circular bases. Even though the column side is rectangular, the column is categorised as a squared shape-space organisation since a square is simply a special case of a rectangle.

(b) Non-squared shape-space organisation (pyramid faces, polittico, obelisk faces). Pyramid faces are based on triangles. Politticos and obelisks are based on polygons that are not squares or rectangles.

There are fundamental semantics attributed to this difference, namely:

• Structures of type (a) contain text intended to be more 'objective' on the writer's side. Cubes are for narrative text. Miniatures are for texts that explain and give information. Columns are for texts that describe and give details.

• Structures of type (b) contain text greatly influenced by personal experience and individual 'positioning', and are thus more

'subjective' on the writer's side. Pyramid faces are for individually based reminding and memories. Politticos are for personal commenting and arguing. Obelisks are for collectively triggered reminding and memories.

The various structures in types (a) and (b) are conventions used in the Text Representation System and Communicative Positioning Programme methodologies on which this book is based. These conventions, as in any language system, are communal agreements that facilitate group-working interactions.

The distinction between subjective and objective simply refers to the writer's intention and to the communicative function the writer wants the text to have. This distinction is not an epistemological one, but rather a technical one that conveys the idea that the writer has to let the reader know what he intends to do and therefore how the reader should react to the text. What matters is the perspective the writer creates for the reader – the way the writer wants the text to be perceived. The perspective created by the writer results from his text-structuring and more precisely, from his own shape-space organisation. The shape-space organisation becomes an interpretation device that facilitates the reader's filtering and interpretation of the text.

Therefore when the writer uses a squared shape-space organisation [type (a)], he creates the following expectation, which is an attitude or state of mind, for the reader:

'This text is giving me information about an event or set of events or is giving me a description or some instructions to do something.'

On the other hand when the writer uses a non-squared shape-space organisation [type (b)], he creates the following expectation for the reader:

'This text is about some personal viewing, commenting or reminding.'

There is a different purpose or positioning, between giving information and personal viewing. The reader who becomes writer, once exposed to some triggering text, is aware of the consistency of shape-space organisation and communicative function of the text. If he reads a text on a squared shape-space basis, he has the first attitude; if he encounters a non-squared shape-space text organisation, he knows the second attitude is required.

All this is very simple and creates a high semantic context. You, as the initial writer, create the context for interpretation. Your reader or readers help you complete it and continue. Together you write collectively and creatively.

One more thing: once you complete a certain collective text, you may shape it up differently. This means that something planned as a squared shape-space structure may have a non-squared shape-space structure as well. A cubic story can also have a pyramid version next to it. That is, a story may be turned into a set of memories. You can go from the cube, an objective text, into a pyramid that contains a set of stories related to your

personal experience. What is important in all of this is the consistency between shape-space organisation, communicative intention and text function.

The sections that follow explain how you can use the textual objects to write various kinds of text. Each textual object is introduced to you by a brief statement of its purpose within the Text Representation System and Communicative Positioning Programme methodologies and by an illustration of its construction or structure. You will be lead toward the experience of writing with textual objects by instructions and advice for their use. These instructions and advice will also be shared by readers who will understand textual objects just as you do.

Some historical information about the object is then briefly provided. You should interpret this information as evidence that it's possible to write in different dimensions using different clichés. You may skip over this historical material if you wish, since it's not important or strictly relevant in building textual objects.

Following the boxed area, there are ten questions and answers that relate to constructing and using the textual object. These questions and answers focus your attention – in an interactive way – on the major aspects, details and features of the textual object.

Cube

A cube is for creative individual and collective text-shape-space-organisation for story writing. You create the reading perspective and decide on the length of your text. You may also ask others to write and add more cubes to yours according to the rules you state. Figure 5-1 shows how you construct a cube from six squares.

Writing on a cube structure can be found in ancient Assyrian sculptures. In the Egyptian tradition, there are also numerous examples of tri- or quad-faced writing. In the Black Schist Sarcophagus, for example, there is writing externally and internally on four faces of an object. This writing is mostly religious texts or narratives of historical events.

The ancient Egyptian way of writing exhibits a co-presence of images and text. Egyptians were experts at including detailed and accurate descriptions in drawings. As their ancient cartoons show, they liked to present events in a logical sequence. But they also liked the dichotomy of completeness/complexity – they believed an idea and its contrary were inseparable.

Considering this, some Egyptian drawings have a surprising aspect in that by superimposing several points of view on a single image, they seem to contradict a logical/sequential ordering. For example, one drawing shows a falcon hovering over the king. The drawing represents several moments of flight at one time by showing one wing as is appears when seen from above and the other wing and the falcon's tail as seen from

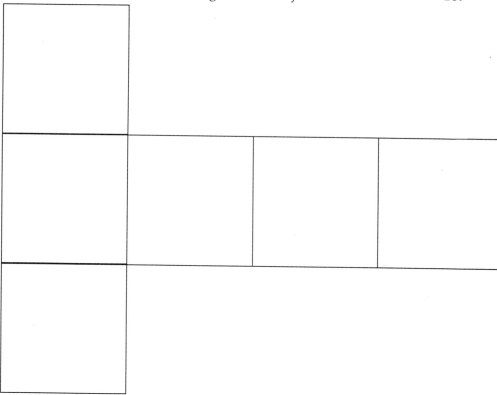

Figure 5-1. *Construction of a cube*

below. In consistency with the dichotomy of complexity/completeness, the Egyptian calendar system is not based solely on the stars, the sun or the seasons, but rather is based on a combination them.

The same attitude is also manifested in Egyptian myths. There are many symbolic aspects and images and they come together simultaneously so that there isn't just a single line or single interpretation. Unity and multiplicity also go together, as well as the notion of eternity as a constant and ceaseless state of becoming that has no beginning and no end. All these views fit well with the idea of writing in cubic space (and also in shaping up pyramids).

(1) Why should I use a cube for writing?
A cubic structure is especially useful for writing a story that you plan to divide into paragraphs or chapters. Each paragraph or chapter fills a face of the cube. If you have fewer than six paragraphs or chapters, you may leave some of the faces blank; if you have more than six, you may add more cubes. The size of the cubic structure can vary according to the length of the paragraphs or chapters of your story.

(2) When should I use a cube to write a story?
When you plan to write the plot and you also want to give the title and the summary a special place inside the cube. The title and the summary create the reading perspective for the reader.

(3) How should I use a cube to write the story?
First make sure you know the progression of the paragraphs or chapters of the story. Then pick one face and start writing. Use arrows or numbers to direct readers in rotating the cube from one face to another as they read progressively through the paragraphs or chapters of the story. Once you complete writing on the faces of the cube, use another square to write a title and summary for the story. Place the square with the title and the summary inside the cube. You may orient this square anyway you want to, as long as you place it inside the cube. (See Figure 5-2.)

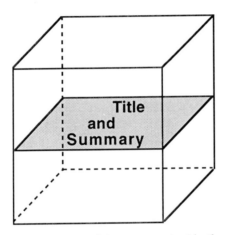

Figure 5-2. *The title and summary of the story go inside the cube*

(4) What kind of story is good to write on a cube?
Think of a story that's your own and how you want to deliver it. Your readers will understand it exactly the way you shape and plan it! The cubic structure allows linearity in writing the story since each face is like a page that you fill up. The cubic structure also lends itself to easy reading because arrows or numbers lead readers sequentially through the faces of the cube. By using a cube to write, you're presenting to readers your own text-space organisation as well as how you want them to rotate it.

(5) How can I use a cubic structure to create a whole set of stories?
You write a group of stories or a long story that requires more than the six faces of a single cube by working out a puzzle-like configuration of squares on a flat, two-dimensional plane. This puzzle-like configuration results in a structure of cubes when you wrap up the square faces. (See Figure 5-3.)

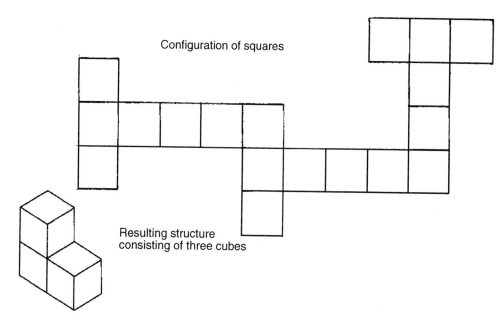

Figure 5-3. *Puzzle-like configuration of squares that wraps up into a group of cubes (polimini)*

You can combine a set of open cubic structures according to your needs and preferences. You write on the faces of the open structure to create a 'small book of stories' or a very long story. You then wrap up the configuration of faces into a group of cubes, called a *polimini*.

Make sure you always determine the reading/rotating order of the cubic structure by including arrows or numbers that point or direct you from one face to the next. If you create complex cubic structures, check to make sure readers can easily find their way around them. Figure 5-4 (overleaf) illustrates a few polimini structures.

(6) What should I do if I want to go back to a totally linear order?
Unwrap the cubic structure and order the cube faces in a way that is consistent with the arrows or numbers, which point out the reading order of the text and the rotation of the cube. You may then create differing text paths and puzzle shapes by reordering and reorganising the cubic faces.

(7) What should I do if I want the reader to take some initiative?
You may ask the reader to write more story-cubes by following the rules already described, thereby creating a collective library of stories. You may actually have an incrementally collective library. This is like an open library where new readers come in to use and add books. It's also like a computer file that people can access to read other peoples' contributions or add their own.

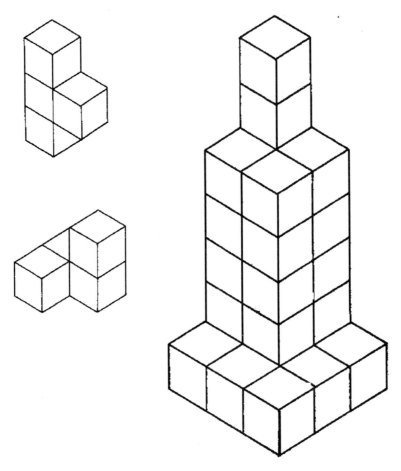

Figure 5-4. *Other polimini structures*

(8) In a polimini structure, how should faces touch?

Faces may touch on the initial faces of cubes if the cubes contain different stories; if a cube contains the continuation of the same story, its final face should touch the initial face of the next cube containing that story.

(9) What are the main features of the cubic structure?

All the square faces are equal. You determine how large they should be according to how long your story is. The rotational order is free – you determine it by using arrows or numbers. There is no *a priori* focal point; you can start writing wherever you want. Your departing face constitutes the first face to be read. Cubic structures are easy to combine into polimini and you set the rules for combining them. Once open, cubic structures behave just like pages of a book and you can easily chain them together in a linear order.

(10) If I got it right, I should use cubic structures for shaping up and delivering my own story and maybe even my own story book.

Yes, and you may add more and more stories in space to create a huge polimini structure, which appears like a text-sculpture based on different stories. A cubic structure also facilitates your readers too, since they may cooperate by adding their own stories to your text sculpture according to the space definition you determined.

Pyramid

A pyramid enables creative individual and collective text-shape-space organisation for story writing. You present a story that reminds you of other stories that you may then add to the initial one. The same story may remind your readers of other analogous stories as well and they may add and organise them in space too. The pyramid is different from a cube since it contains personal memories related to a story instead of just a story itself. The pyramid consists of triangles, which are non-square spaces, that are intended to be filled with a subjective kind of writing related to your personal feelings and impressions. Figure 5-5 shows how to construct a pyramid from a square base and four triangles.

Pyramids represent the ideas of synchronicity (the four faces reach the top together) and diversity (they look in different directions). They also represent perfection in combining a flat form (the desert region they were built in) and height (the sky they reach).

The ancient Egyptians believed that the life after death was more important than life itself. This is why they prepared for death while still alive. A pharaoh would often go to see his pyramid while it was being built. He would regard it as a place for safeguarding his body and his eternal life.

(1) Why should I use a pyramid for writing?

A pyramid has a base part – a square – and four triangle faces, which extend away from it. The triangle faces are supported by the square base and meet at the vertex, which is a common departing point for each of them. The square base on which the four triangle faces rest has its own autonomy. It corresponds to the starting point for writing.

A pyramid is an interesting combination of different geometric shapes in space. There is both autonomy and connectedness between and among them. The perspectives you may choose for looking at a pyramid are the following:

(a) You can start from the square base, look up and then rotate the pyramid to see each of the triangle faces.

(b) You can begin at the vertex of the triangles, rotate the pyramid on an axis through the vertex and the centre of the square base to see

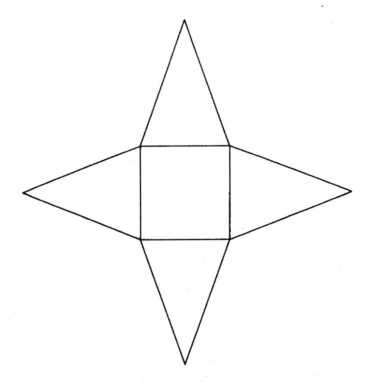

Figure 5-5. *Construction of a pyramid*

each of the triangular faces and then look down afterwards to view the square base.

(2) When should I use a pyramid for writing?

A pyramid, which here is considered to have four-triangular faces and a square base, is especially useful when you want to write a short story about something that happened to you or about something that you heard. You write the story, called the 'base story' on the square base. The plot of this base story may trigger some of your memories that are analogous to it ('it reminds me of this other story') or it may trigger the readers' memories. The concept that triggers these memories is the starting point for filling up one analogous story on each of the triangle faces. You explicitly write this concept at the vertex of a triangle face before writing each memory-triggered story.

(3) How should I use a pyramid for writing?

By using the (a) perspective as noted in the answer to question (1), you write the *basic* story and then you fill up one or more of the triangle faces with other stories that relate to it, according to the principle, 'it reminds me of this other story'. By using the (b) perspective, you pass the pyramid to others who, after reading your story, may fill up the triangle faces

according to the same principle. Once you complete the pyramid, you can read the triangle faces and then check back to your original base story to see if they all make sense.

(4) What kind of story is good to write on a pyramid?
The best kind of story is one that you've experienced yourself. This kind of story may be about a *script*, which may be a wedding, birthday or some other personal experience. It can also be about some *plot unit*, which may include a problem and resolution, change of mind and so on. In other words, the story should be about something that happens at different times in everybody's life. The story is therefore about a shared experience. A shared experience means everyone knows what you're talking about. Someone may say, 'It happened to me once, in this way.' Someone else may say, 'Oh yes, the same thing happened to me too, but in this other way.'

(5) How can I use a pyramid structure to create a whole set of stories?
You write the basic story and fill up the triangle faces according to the 'it reminds me of...' principle. Once you fill up the pyramid, pass it to your readers and have them fill up new triangles, still departing from the same base story. This way you can have double pyramid structures rotating in space like the ones show in Figure 5-6. The double pyramid structures contain the additional stories that are all triggered by the same base story. They therefore appear as isomorphic texts rotating in space.

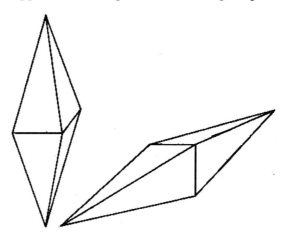

Figure 5-6. *Double pyramid structures*

(6) What should I do if I want to go back to a two-dimensional order?
Just unwrap the pyramid or pyramids, as shown in Figure 5-7 (overleaf). A single pyramid will look like a four-faced star when you unwrap it. In the case of a double-pyramid, you will have two four-faced stars, which have the same size square base and two triangle faces that touch at the vertex.

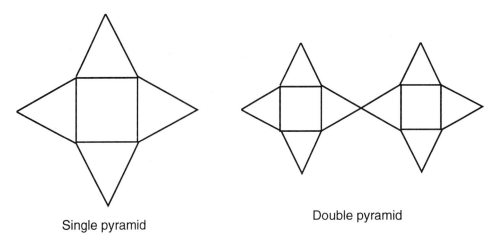

Single pyramid

Double pyramid

Figure 5-7. *Unwrapping pyramids*

(7) What should I do if I want the reader to take the initiative?
Ask the reader to create new triangle faces, as explained and illustrated in the answers to questions (5) and (6).

(8) In a double pyramid, how should faces touch?
All the triangle faces rest on the square base, which contains the base story and corresponds to the common plot you depart from.

(9) What are the main features of the pyramid structure?
All the triangle faces are equal and each of them depart from the same point and touch at the vertex. You determine how long and large they should be according to how long you want your stories to be. You have two rotational possibilities, (a) and (b), as identified in the answer to question (1). You decide which possibility you want according to how you want your pyramid text to be written and read.

Your focusing starts from the base story and goes up to the vertex. From the base story, you then rotate the pyramid the way you want. You can leave the rotation order totally free – it doesn't matter which triangle story is read first, since the stories aren't sequentially ordered and they all depend on the base story equally.

The square face is like a page – it defines the base story. The triangle faces explicitly show that they are derived from the same base story. They're generated after the base story and are triggered in memory by it.

(10) If I understand, I should use pyramid structures for triggering and writing memories that come out of a story or for allowing readers to add memories according to the plot I've proposed.
Yes, and feel free to experience as many possibilities as you wish.

Miniature

A miniature is for creative individual and collective text-shape-space organisation for writing, delivering, expanding and completing news. A miniature could be used, for example, in an electronic mail system to circulate news among a group of people who need to know about certain facts, but at different levels according to individual needs. You present some news and give more information that you think readers may wish to know. You can also add figures to represent visually what you've written. You may also plan empty spaces to be completed by your readers according to what you ask them to do. Figure 5-8 (overleaf) shows the structure of a miniature.

Ornamental writing came about during the first centuries of our era, when scrolls were replaced by leaved books and a new element was introduced – the page, which enabled framed pictures and richly decorated titles to be included. But the real development of ornamental writing – illumination in text – and text miniaturing came in the seventh century when the centre of European culture shifted north of the Alps and text miniaturing became popular. The term 'miniature' is derived from minium, a red-orange lead pigment often used in medieval ornamental lettering.

 When the monks produced their books, they used ornaments in conjunction with written text. They regarded this decoration as a way of impressing readers with the value and importance of a book. Text miniaturing was frequently used to decorate a difficult text and to make the reading of it more pleasant. To facilitate reading, miniaturists had to know the content of the book, create drawings and ornaments consistent with the content and suitably partition the text itself.

(1) Why should I organise my text-space as a miniature?
Miniatures were used during the Middle Ages to make the reading of certain texts more pleasant. The aesthetic aspect of miniatures also enhanced their communication effectiveness. By using different styles of calligraphy and by separating different parts of the text, you give the text different values and functions. If the text has a rich content, alternating the text with drawings and motifs may facilitate the reading process. According to the methods and techniques presented in this book, information 'islands' (partitions) in text may also point out different communicative functions such as descriptions, definitions, explanations and comments.

(2) When should I plan to text-miniature?
Whenever you plan to deliver your text to different readers who may have different information, needs and expectations. In other words, you may need to write the same plot, but expand it in different ways according to the knowledge and background of each individual reader. The base text

Figure 5-8. *Miniature structure*

may be essentially the same on the content level, but it may need to be refined in different ways to correspond to the experience and expectations of your readers.

A good application for text-miniaturing is in sending an electronic mail message to multiple receivers. The message is collective, but you originate it alone and disseminate it to several receivers. The purpose of the message is usually to circulate news or information that you think is relevant (even if at different levels and in different ways) about something that concerns specific individuals. For example, the message could be personal news or media news that you transfer more or less literally from newspapers, TV, reviews or other sources. You may think the message is important for different readers for different reasons.

(3) How should I plan to miniature a text?
You should draw a text-partitioning map on the text-space in a page or a computer screen. The text-partitioning map defines text 'islands' that contain different kinds of information. (See Figure 5-8.)

The main part of the text-space contains what the writer thinks is the common and shared part of the text. What goes in the main part of the text-space is the writer's choice. Other parts of the text-space have different communicative functions. The upper part contains the title and the reader's name and constitutes the perspective you're suggesting to the reader. The title island may also contain your specific request for completion. You may ask the reader to add more information (if that's possible) or just to confirm that the message was received. You may add a simple drawing or a picture related to the main text in the figure space. You may additionally include a short summary of the text.

You may highlight some parts of the main text, so that the receiver focuses on them. Once highlighted, you may transfer, repeat and headline a word or a sentence on a side-island note space. The note space, which adds to or expands on the information in the main text, should appear on the right side of the main text since you want it read *after* the main text. When you write something in the note space you're adding notes or information that you think is useful in expanding the information in the main text.

You may also transfer, repeat and headline a highlighted word or sentence on another side-island, which is called the explanation space. The explanation space provides more information in the form of causal explanations including the reason something happened, an additional justification or some background information. This space should appear on the left side of the main text because you want the reader to read it before the main text. It adds reasons and facts that make it easier for the reader to understand what comes after it in the main text.

The summary space is located at the bottom of the main text. It contains a short summary of the main points or facts of the text. The glossa space completes the text-organisation space and appears below the summary space. It contains comments by the writer, but it may also be completed by the reader.

The communicative interaction obtained by text miniaturing is one-to-one and is directed and controlled by the sender, similar to what happens in a traffic control system. This means that the sender receives completed messages back from each of the respective receivers. The receivers fill up different spaces according to what the writer explicitly requests them to do or by knowing what they can do themselves. The receivers, however, don't necessarily know about each others' responses.

(4) Which kind of text should be miniatured?

As already noted, news that has to circulate to various people is most appropriate for miniaturing. Although text miniaturing entails a collective-writing dimension, it is controlled and directed by the sender according to the following scheme:

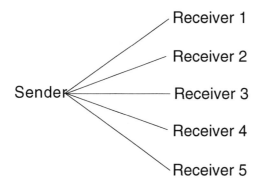

There is privacy and uniqueness in the interaction between the sender and each of the receivers, because the receivers don't communicate between or among themselves. In fact, they don't even necessarily know about each other. They respond to the sender's explicit request or by knowing the system of communication and by positioning themselves appropriately with regard to the main text.

(5) How can I use text-miniaturing to expand my text?
Let any individual receiver know what kind of information you're expecting and then allow the receiver to complete the text. For example, one of your receivers may have an explanation for some part of the news you sent and you may then highlight the empty explanation space to let that receiver know you expect him to provide it.

Another one of your receivers may have more details to add, so you then highlight the empty note space to let that receiver know precisely what you're expecting from him. You are the one who assigns the communicative terms and roles. If the receiver is not able to complete your request, he can return your message anyway to let you know that he can't help. He may also refer you to another person who can.

(6) What should I do if I want to go back to a totally linear order?
Incorporate all those explanations, notes and comments you think are important to the main text. The text with these additions then becomes an expanded and enriched version, which is collectively completed but individually organised. The text is collectively completed because the information it contains comes from multiple individuals who each react individually; it is also individually organised because the original sender is the one who decided what should be added and deleted. Once you incorporate the explanations, notes and comments you want, the text has only a title (with no receivers' names), the main part of the text and possibly some figures or pictures. You may compile separately a list of contributors to the text, like the list of credits at the end of a movie. If you

choose to compile this list, don't include it with the miniature, but keep it separate.

(7) *What should I do if I want a receiver to take some initiative?*
You can make a direct and explicit request to the receiver in the title space. You can then highlight those empty parts of the text-space that you expect the receiver to act upon by adding information. Before making a request to the receiver, determine exactly what you expect from him. To determine this, try to answer the following questions:

Why am I sending this text to this specific person?

What do I expect the receiver to know?

What support do I think the receiver can give me?

Should the receiver add something? If not, is it okay if the receiver just confirms that he got the message? If I want the receiver to add something, I need to make explicit my expectations – do I want him to add an explanation, notes, comments or simply refer me to someone else or some other situation?

Always keep in mind that you, as a writer, are the one who took the initiative and that you're still in control of the situation.

(8) *In collective text-miniaturing do texts have to merge?*
Refer to the answers to questions (6) and (7). It's your choice to reformulate a collectively completed text that you're organising individually. You're in charge of what is kept, added or deleted and thrown out. You're the text-miniaturing-organiser. Everything that comes back to you is under your control and you can decide whether or not to keep it.

(9) *What are the main features of a text-miniature?*
The text-space is open – you define space islands and create space limits according to those communicative functions you give priority to within the text. The focal point in reading is determined by you. You decide what is more important for your receivers and then lead them through the reading process. You set these criteria by both using space definitions and highlighting some of them to signal your priorities and expectations.

Miniatures are easy to modify. Although the differing space islands may be filled up by different receivers, they keep the same format (cliché) and position. They carry a consistent meaning and organisation. Space islands can also disappear when you revert a miniature back to 'normal' linear text space.

Miniatures also allow text partitioning and highlighting as a device for keeping and focusing the receiver's attention. They may include mixtures of text and figures or pictures. The figures or pictures confirm the text by visually representing its content and facilitating the focusing process. They also make reading more pleasant by providing visual relaxation and an aesthetic quality.

(10) If I've got it right, I should use text-miniaturing as a medium for delivering a message or information that I want to pass on to different receivers.

Yes, and make sure you want to be the one who is in charge. If you want to raise a topic for discussion or if you only want to contribute to the discussion, then use the next kind of text-organisation, which is polittico writing.

Polittico

A polittico is used for creative text-space organisation in raising and discussing a topic. You raise a topic and ask your readers to comment and write their opinion and then you circulate the expanded text. The open discussion on the topic you raised can be expanded so that more and more readers are put on the panel. The polittico is different from the miniature because all the people participating know about each others' views and reactions to the topic. Moreover, all the parts of the polittico are filled up at a predetermined time so that you see all the views and writing together. On the other hand, in text miniaturing, there is a relationship between the sender and each individual receiver, but not among the receivers themselves. Figures 5-9 illustrates a trittico, a simplified version of a polittico. Figures 5-10 and 5-11 show a multipart polittico with its panels moved in various positions.

A polittico is a picture made of a set of panels that are usually hinged so that they fold like doors in front of the main scene. When there are three panels it is called a trittico. When there are more than three panels, which is usually the case, it is called a polittico. This form of painting was widely used for religious scenes or stories and its structure is architecture-like. During the gothic period, politticos were highly complex, resembling pinnacles on church facades. The golden background colour in politticos has its origin in the Byzantine tradition. An example of one of the most complex and sophisticated politticos is the Ascensione di Giovanni Evangelista con Santi by Giovanni del Ponte (National Gallery n 580). Polittico paintings were mostly used as altar paintings depicting religious subjects.

(1) Why should I use a polittico for writing?
A polittico has a central space that contains the main subject of the painting and a set of complementary parts. The complementary parts are like doors that can open, called *ante*. They include paintings of subjects or scenes that are both autonomous and related to the central painting, which is the focus of attention.

The simplified form of a polittico has three parts – the central, main part and two lateral ones – and is called a *trittico*. Polittico structures may also have more lateral parts, as shown in Figure 5-10.

Figure 5-9. *Trittico*

Figure 5-10. *Polittico*

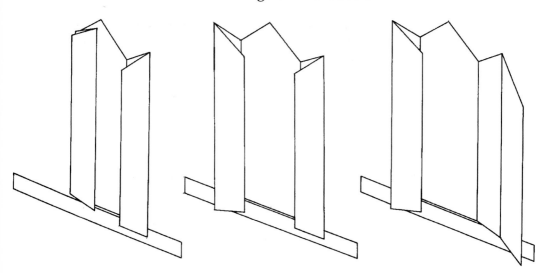

Figure 5-11. *Polittico shown in Figure 5-10 with its panels moved to different positions*

What is strictly required in a polittico is symmetry and isomorphism. There must be the same number of lateral parts on the left and right side of the central part and they must have the same shape. The main central part must also be larger than the lateral parts, being the most relevant, and it's viewed first. The lateral parts rotate so that they can be completely opened and expanded linearly, one next to the other. The lateral parts also close up so that they touch. A base at the bottom of the polittico may cover the entire length of the structure. This base part doesn't move or rotate and is usually painted. In the written polittico structure, it contains a summary.

A polittico is a good structure for expanding a text and juxtaposing differing viewpoints or opinions about a controversial topic or issue.

(2) When should I use a polittico for writing a text?

Use a polittico structure whenever you plan to raise a controversial topic for discussion and you want different opinions and points of view about it. You initiate a conferencing session, choose a certain number of panellists, assign turns and establish a deadline so that all the panels of the polittico are completed and viewed at the same time. You should be recognised as the one who raised the topic, but you don't want to be the only one receiving comments back, as is the case in text-miniaturing, Rather, you want the panellists to know about each other, read each other's comments, communicate with each other and be aware of each other's respective opinions and perspectives.

Polittico writing is ideal for electronic conferencing among a defined number of panellists. A panel director assigns turns to the panellists and asks each of them to comment on a certain topic once. The panellists know

that they have only one turn and are entitled to only one comment on the specific topic. All of the panellists' comments appear on the lateral sides of the polittico painting – none of them is omitted.

(3) How should I plan to organise a polittico-writing session?
First of all, write down a topic you want comments about in the central main part. Since you're the initiator, in the central part also provide facts about the topic and add comments that make your perspective explicit so that the panellists know exactly what you think.

Then open up a lateral part in the structure for each panellist discussing the topic and assign each one a lateral space. You may add a note in the lateral space about the deadline for the panellist to fill up the space so that the other panellists can view it. Make sure that all the panellists know that they're supposed to comment once on the central text during their turn.

The panellists also need to know that you're the one who takes into account their opinion and draws final conclusions about the panel session. Your job is to write down a summary and place it within the bottom part of the structure. The summary is understood as a *collectively directed* summary, even though you write it. Before beginning, make sure the panellists accept your conditions (deadlines and the size of their writing space) and that they're committed to return their text on schedule.

You may also let each panellist know who else is on the panel. The text of each panellist should represent an individual opinion. If two panellists decide to join together and write a common text, they should let you know. If a panellist is unable to fulfil his commitment, he should inform you so that you can ask someone else to take his place on the panel.

(4) What kind of text is good to organise in a polittico-writing structure?
A suitable text is about a controversial topic. The topic may be about making some decision, solving a problem or asking for opinions about a philosophical, political or ethical issue.

What is needed are panellists who are willing to take a position and make a contribution by stating their individual perspectives. If the panellists would rather debate the issue among themselves, then a polittico-structure is not the most suitable form. Panellists need to be aware that their own text is to be a reaction or answer to some triggering issue. They then have to devote time for thinking and organising their text to present their own position. The text will be read by other panellists, as well as reported and summarised in the summary space.

A polittico structure entails an individually-driven collective writing dimension, which can be represented by the following scheme:

Panel initiator and panellist selector (the same person)
TOPIC RAISING
TURN ASSIGNING

Initial writer

Panellists give comments and complete the text

This scheme shows that each panellist is contributing individually – by giving his own personal opinion and by writing his own text – to a common project (the panel). The panel initiator completes the panel with a collective summary, which is based on reading and interpreting the point of view of each of the panellists. The panels are read in the order shown by the numbering.

(5) How can I organise my polittico-writing to get appropriate reactions?
Concentrate on what you would like to come out of the panel. Realise that polittico-writing is not for expanding your text, but is rather for raising a discussion about a controversial issue or an urgent problem you wish to solve.

Make it clear to the panellists if you only want their opinions on some controversial issue and you want them to think deeply about it. On the other hand, if you must come to some decision, let the panellists know that you need their help in the decision-making process.

Set deadlines for the panellists that are short-term, but that also allow them enough time to work on the issue before giving their opinion. Make sure the panellists realise that deadlines must be respected and ask them to confirm their own commitment to the schedule. If any panellist can't commit to the assigned deadline, he should let you know so that the other panellists won't be waiting for his text and you can invite someone else to take his place. It's important that all the panels are completed at the same time so that the whole structure can be viewed together.

(6) What should I do if I want to go back to a linear order?
Open up the polittico structure once it's completed. Then focus on each of the parts to find out the reading order. The reading order corresponds to the polittico structure itself: the central part comes first, the first pair of

left-right doors (ante) comes next; the second pair of left-right doors comes after that and so on. Then, the reverse side of the last pair of left-right doors comes after that, the reverse side of the next to last pair of doors comes next and so on until you go through the whole politico structure.

As the panel initiator, you may now summarise this sequence of text and write it down in the summary space at the bottom. This space can be as long and large as needed to contain the summary.

(7) What should I do if I want the pre-identified panellists to take some initiative?

This partially goes back to question (5). You may also send a separate personal letter, through electronic or regular mail, to invite each individual to be on the panel. Let each of them know why you decided their contributions are important as a statement of personal appreciation. Also, based on your assessment of their personal competence, indicate the areas you expect the panellists to provide detailed information and comments on. Finally, tell each of the panellists individually, as a personal reward, that you're glad about the contributions they'll be making.

(8) In politico text writing do texts touch?

Yes, they touch on their respective hinges, but this is just for connecting the whole structure and keeping it together.

(9) What are the main features of a politico structure?

Space is preset. The main part of the structure corresponds to the topic raised and discussed. Each door refers to the central part. Focusing proceeds according to the sequence in which the doors open up, starting from the central part. You assign door space to each of your panellists and each door space is filled up according to the panellist's initiative and choice.

The common summary space at the bottom explicitly relates to the entire door sequence and contains the main points contributed by the panellists. Writing can be placed on the reverse side of the whole set of doors, but not on the central part. This allows total visibility to the parts contributed by the panellist. Nothing, however, can be added to the central part, which initially raised the topic.

(10) If I've got it right, I should use politico-writing when I have controversial issues to discuss or important decisions to make that extend beyond my own personal opinions.

Yes, and make sure that the panellists are committed to this and that they feel like working on a team. Everybody's opinion is equally crucial in focusing on a common target and attaining the final result.

Obelisk

An obelisk is for creative collective text-shape-space organisation for recalling a certain event or set of events well-known to a group and then

writing a common story. The common story is presented by the group of people who experienced it or read about it. For example, if the group reads a history text, they share the knowledge contained in it and may wish to summarise it for themselves. In obelisk writing the name of the writer precedes each paragraph and the writers each take turns. Obelisk writing facilitates the shaping up of the collective writing process. Figure 5-12 shows how you construct an obelisk.

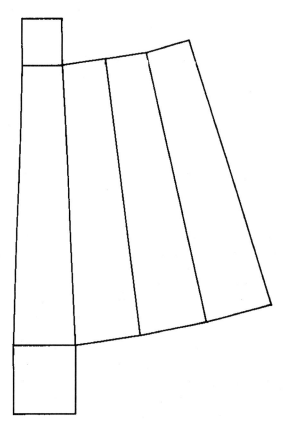

Figure 5-12. *Construction of an obelisk*

Obelisks are single freestanding monuments that were associated with the structural decoration of Assyrian temples. Assyrian obelisks were set up in public places outside temples. Like lions on either side of the temple entrance, they provided magical protection against any evil influence that might approach.

 Obelisks were decorated with a variety of narrative scenes, including writing. In the largely illiterate society, the illustrations bolstered the written inscriptions so that the story told on the obelisk was conveyed to the widest audience. Two obelisks that stood in public areas, the Rassam

Obelisk of Ashurnasirpal II and the Black Obelisk of Shalmaneser III, exhibit the pacific nature of the ninth century Assyrian empire – they both show the desirable aftereffects of successful power-politics.

(1) Why should we use an obelisk for writing?
An obelisk structure is ideal when you want to remind people of a commonly shared experience, write a collective story or read a text and rewrite it with your comments about your own story or a story you know about.

(2) When should we use an obelisk to write a story?
Whenever you have a group of four or five who want to write collectively about some event you have experienced together, but perceived differently. An obelisk is therefore a good summary device. No two people perceive the same thing in the same way, so even though people share a common experience, they summarise it differently. Another time when obelisk writing is appropriate is when a group reads a history text and decides to rewrite it by interspersing their personal comments. What is important in both cases is that each alternating writer maintains the time-sequence of the events. Each writer defines his own writing space and turn-taking. But once that writer finishes, the next one comes in according to the turn-taking strategy previously established.

The assignment of turns is decided by the writing group and can be based either on a fixed order of turn-taking (such as Mark-Julie-John-Paul and again back to Mark and so on) or on a non-fixed order based on initiative turn-taking (such as, Mark happens to start, now Julie wants to come after him, then John is invited to come next – unless, well – Paul wants to get in after Julie and John doesn't mind coming afterwards). Both kinds of turn-taking require writers to know how far they want to go with their writing. But since comments are always welcome, a writer may want to go back to what the preceding writer wrote and add more text to it. If this happens, the writer still writes within his own space. Both kinds of turn-taking also require writers to decide how much space each of them is entitled to and how many turns each has.

Each face of the obelisk is filled by one of the writers. The length of the faces is longer or shorter according to the size of each turn-space and the number of turns. An obelisk becomes increasingly taller as a story gets longer.

(3) How should we use an obelisk to write the story?
Write the story title and some basic facts and events on the top square to get the writing process started. The title serves as the triggering element for writing. The title could also be a quotation from the chapter of another book. Put on the square base at the bottom of the obelisk relevant information about the collective writing group, including:

- The names of writers.
- The kind of turn-taking order chosen by the group.
- The approximate length of each turn-taking space.
- The assignment of topics, if the writers want to be more structured – for example, Paul is writing about this event, Julie is writing about another that came after it.
- Any other information about how to proceed that the writing group wants to add as the result of common agreement and planning. The group may point out that they want to comment or just give facts – or, for example, that Julie wants to comment and Paul want to give a detailed explanation. Writers may also refer to each other within their respective text-space. The group may also decide to co-author a common text-space and sign it together. The group is always free to find new ways of writing collectively.

(4) What kind of story is good to write on an obelisk?

As already noted, the story has to be something each of the writers directly experienced (because it's a group event or a group story) or knows about (through reading or learning about it). The writers may all have different opinions and ways of interpreting the facts related to the story. They may be happy to share their opinions and curious to know each others' views.

Of course there also needs to be some traffic-control rules for the writing group so that everyone is able to work positively. Even at best, some adjustments may need to be made. For instance, Paul may have gone too far and his writing may overlap with Julie's. Once the obelisk is finished, refinements may be made.

The writing group should read everything together and decide whether some parts should be modified or deleted or whether something is missing and needs to be added. Until the whole group decides the final shape of the obelisk, during its development the obelisk may become taller or shorter. Using word processing software on a computer is a great help in modifying and reshaping writing until the final version is decided. Collective decisions and actions may produce additional revisions and modifications. These text revisions should be considered as effective ways to learn more about the writing process. They aren't a waste of time, but rather times for learning.

(5) How can we organise our obelisk structure so that good collective writing comes out of it?

Have a meeting of the writers' group first. Make sure you collectively decide on the topic or story and that each has a shared, direct experience of it or has read about it, such as in the case of writing a history chapter. In the meeting, concentrate on self-reflection and discussion about who is going to do what.

The group next needs to decide collectively the way turns are assigned, who is going to do what and the length of the turn-spaces. This initial

planning is essential to avoid confusion and overlap. Some overlap in writing, or other problems, is likely to come up anyway during the collective writing session, but you can easily handle it as a group if you previously established traffic-control rules that everyone agreed upon.

Even though you may end up collectively revising and reshaping the text, as noted before, consider these activities valuable for learning more about writing. You learn by writing, by reviewing what you've written and by thinking about how you can write it better or in a different way. Multiple versions of an obelisk before the final one are always welcome.

Although the obelisk and polittico are both for collective writing, obelisk writing better reflects group working and turn-taking. In obelisk writing, there's planning and discussion during the process so that adjustments to the final result are made cooperatively. The final version of the polittico, on the other hand, is made up of individually conceived parts. The contributors to the polittico don't confront each other until the whole structure is revealed all at once.

To facilitate the writing process, after determining the space assigned to each writer you may also graphically represent it, as in the following scheme:

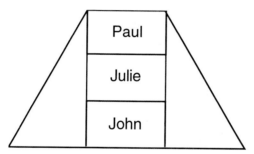

Make sure the writers each plan their own turn-space so that their ideas are worked out before they begin writing. Also include the title on the top of the obelisk and the collectively determined rules for writing and the writers' names on the bottom base. What you write on the bottom base enables you to see what the group agreed upon and trace back how the final text is consistent with that agreement. Of course, if there were changes to the original agreement, you may also include them on the bottom base.

(6) What should we do if we want to go back to a linear order?
Complete your collective text and open up the obelisk structure. If you think about it, you're already working in a linear order. You can consider the collective text as a vertical sequence of turn-spaces because they represent a logically or chronologically ordered set of events. In any case, you have to finish writing and reading each face before going on to the next one.

The writing-reading direction goes like this:

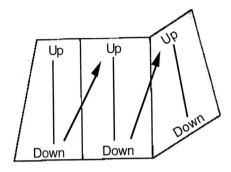

Each turn-space may be considered as a page-space because it looks like that and is organised accordingly with paragraphs.

(7) What should we do if we want to be able to take initiative in a consistent way?
Make sure all the writers know enough about their assignments. Don't try to start writing too fast, but allow adequate time for reflection about what needs to be known, planning the text-space and gathering information. If any writer realises that he is not able to fill his space, he may explicitly ask for help by inserting an invitation into his own turn-space. The invitation may be general like this: 'If someone wants to add something here, please feel free to do so.' It could also be more specific: 'I think Jane should add more details about this.' To avoid turn-taking problems that may occur (like traffic interruptions), interventions to fill up a writing space should take place during the revision process, not during the collective writing session.

(8) In obelisk text-writing do turn-spaces need to touch?
They don't touch, but instead they follow each other. The turn-spaces must be accurately organised and partitioned before writing commences. Each turn-space may be connected to the previous one by using connecting strategies such as these:
 'After what was written in the previous turn-space...'
 'As has already been written...'
 'This is what happened next...'
Each turn-space may also be connected with simpler connecting strategies such as: 'Then...', 'Meanwhile...' and so on.
 The collective revision process will point out any missing or redundant connecting strategy, resulting in a more homogeneous final version. All versions are connected because whoever is revising a version reads the previous one and may even discuss his revision with the previous writer.

(9) What are the main features of an obelisk structure?
Each face is equal and can be made longer or shorter according to specific needs and common agreement. Writing and reading go up and down faces in a page-like fashion. Each face may be partitioned to allow turn-space assignment, thus creating smaller 'pages'. The bottom base, which can be viewed separately, contains the writing criteria that were set up. These writing criteria constitute the 'rules' on which the text is based. The title, which initiates the collective text writing, is on the top base and is read first. The writing group may also keep different versions of the collective text by creating different size obelisks. The writing group also always checks the consistency between the final result and the goal stated on the bottom base.

(10) If we've got it right, we should use obelisk-writing when we want to rewrite something we all know about and have either experienced collectively or read about it. We don't want to argue about it, we just want to create the text together and enhance our capacity for working together as we plan and write. We know obelisk writing is terrific for team-working.
Yes, you really understand it. Now, just do it and you'll have fun. By doing obelisk-writing, you will also understand what summarising means and how people react differently to the same text.

Cylinder/Column/Papyrus

A cylinder/column/papyrus is for creative individual and collective text-shape-space organisation in explaining or giving instructions, such as in a manual, about what to do or how to operate a machine or a device.

The writer is an individual. The readers have different levels of knowledge and diverse backgrounds. Some readers may only want to have confirmed what they already know; others may need a detailed explanation of what to do or how 'the thing works'. Thus as a writer, you determine different levels of access to knowledge according to the kinds of readers you consider. Figure 5-13 (overleaf) shows how you construct a cylinder/column/papyrus.

Egyptian columns were inscribed. By the late period of Egyptian history, three distinct scripts were used for writing: hieroglyphic, hyeratic and demonic. The last two are cursive derivatives of hieroglyphic. Hieroglyphic was increasingly confined to religious and monumental contexts (such as on columns). Hieroglyphic inscriptions are arranged either in columns or in a horizontal line. The sequence of signs is continuous and there are no punctuation marks or spaces to indicate divisions between words.

The orientation of hieroglyphic signs is usually rightward (because humans tend to be right-handed), but a leftward orientation was also used in inscriptions that accompanied figures facing left or as a way of

Figure 5-13. *Construction of a cylinder/column/papyrus*

providing symmetry in a larger composition. There are also examples of inscriptions oriented in both directions.

 Aesthetic and calligraphic concerns played a crucial role in the organisation of an inscription or a text. Scribes were the official writers. As civil servants in ancient Egypt, they were considered superior to other men and given special privileges.

 Apart from monumental writing, which was a widespread phenomenon, Egyptians also wrote on papyrus, which consisted of carefully cut pieces from the inner stem of the papyrus plant that were pressed and dried. Papyruses could be large and rolled up. The production of papyrus was a highly profitable state monopoly as early as 3300 BC.

(1) Why should I use a cylinder/column/papyrus for writing?
A cylinder/column/papyrus is an invented object that doesn't exist in nature. It's a combination of a cylinder or column and a papyrus and as such, it allows you to write on both the outside and inside. A cylinder/column/papyrus enables you to provide two different kinds of access to the same information. These two kinds of access represent different levels of information and exhibit different writing styles.

A cylinder/column/papyrus is especially useful when you want to teach something you know and understand to a group of readers/learners. You may use a cylinder/column/papyrus to give readers instructions about how to do something. As a writer, you can also create a personalised cylinder/column/papyrus as a way of reinforcing your own learning. You can take what you learned from books, manuals and other materials and rewrite it as a cylinder/column/papyrus to make sure you really understand it.

(2) When should I use a cylinder/column/papyrus for writing?
Whenever you have a topic that entails a sequence of actions to be taken and when each action can be described at different levels of detail. You may also need to describe the nature of the technical terms you introduce, since readers need to understand them.

As a writer, you have to foresee the possible ways of reading your text. Some readers may read quickly, because they already know generally what to do and only need to refresh their memories about the details. For example, this is the kind of reading you would do when checking a computer instruction manual to make sure you remember exactly how to print multiple copies of a word-processed text.

Other readers may be unfamiliar with the terminology and may want to know precise, expanded definitions of the different terms you use. These readers may also try to get as much as possible out of your instruction text and they may read your text carefully word-for-word. For example, they may want to know all the details of logging-in or logging-out, what each function key on the keyboard does and other details.

(3) How should I use the cylinder/column/papyrus to write my explanation or instruction texts?
Open up the external continuous face of the cylinder/column. It will look like a long rectangle with one circle on the top and one on the bottom. Start writing your explanation or instruction text in a concise way on this face. You may write in a nonlinear way by using graphics to represent a sequence of actions or to connect words, such as in the examples (overleaf).

You may also make the content of your text visual by using script-like representations, semantic networks or other visual schemes that you find useful and easy for readers to understand. When you create a highly visual nonlinear text, it allows readers to see the flow of procedures or operating responses in a 'hands-on' way. You're like a traffic-controller and you

Process-Procedural Explanation

Networking-Connection Description

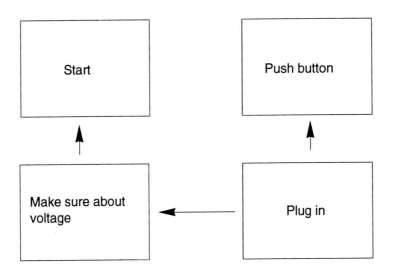

should consider what readers need to know to accomplish the task at hand.

Arrows and other links facilitate the reading process. Be aware that readers will be reading nonlinearly – 'spot reading' and 'jump and move reading'. This is because you're not giving them sentences but just words or short instructions in the form of verbal imperatives such as Move! Go! Look! When you write, make sure you select appropriate words or verbs since readers will focus on them.

Indicate the aim or purpose of your text on the top round base of the cylinder/column. What you write on the top base tells readers what they

can expect to learn from the text on the external continuous face of the cylinder/column. For example, the top base could contain something like this: 'If you know what a computer is and just need instructions for operating it, go to the cylinder/column face.'

The cylinder/column also has one more face – the internal one, which is the reverse part of the external rectangular face filled with concise or nonlinear instructions. This inside part resembles a papyrus, which is why this textual object has a third name. Turn the external face over and keep it in the horizontal position. You now have new space, the internal face, that you can organise in a different way. This new space, which you just opened up, is a 'papyrus' that you fill up with a linear text. The linear text should contain a detailed, analytical description of what you represented concisely on the external face.

You will need to change your attitude completely when you write on the papyrus side. Become a more detailed writer – one who is thinking about readers who want to read a linear descriptive or explanatory text with sentences and paragraphs. The sentences and paragraphs you write must be regularly ordered and connected and each of the concepts or terms mentioned in the external face should be fully and accurately described. You're the same writer you were before, but you're using a different perspective – you want to facilitate the learning process of readers who want understanding and not just concise 'recipe' steps for doing something. What you write on the bottom base tells readers what they can expect from the papyrus text. For instance, the bottom base could contain something like this: 'If you don't know what a computer is and want to understand what it does and how it works, read the papyrus face.'

You may be wondering if the cylinder/column structure and the papyrus represent the same text. An appropriate answer is the following: they represent different levels of knowledge about the same topic and they correspond to different ways of modelling readers and the reading process. Cylinder/column writing enables readers to jump quickly though the text, while papyrus writing facilitates a linear, accurate reading of it. The two faces provide different ways of organising the content – synthetically vs. analytically and graph-like vs. sentence-like. Like the cylinder/column face, the papyrus face may also contain figures and illustrations, but with more details, such as all the components and various elements of a computer. As in an encyclopedia, the visual descriptions on the papyrus face complement the verbal ones.

(4) What kind of text is good to write on a cylinder/column/papyrus?
The most suitable text is one in which different levels of description and explanation are required. Think about using this textual object for an explanatory text where different levels of explanation are necessary to accommodate the readers' needs. For example, you can explain a physical law at different levels. You can also instruct readers how to operate a

machine when some alarm goes off, without providing the details of what is happening. You could, for instance, write something like this: 'If the red light goes on, push the third button on the console.' On the other hand, you may want readers to understand the components of the machine, so that they know how it works and how to fix it.

(5) How can I use a cylinder/column/papyrus structure to create a multilevel explanatory and descriptive text?

Concentrate on where you want to start from. You may want to fill in the cylinder/column face first and then work on the papyrus face next. This is only a suggestion. But if it's more natural or comfortable, feel free to start with the linear-analytical version of the text on the internal face, which is the papyrus, and then go to the nonlinear synthetical version on the external face, which is the cylinder/column. The approach you choose depends on your writing attitude and cognitive tendencies. If you're a synthetical writer, start with the cylinder/column face first; on the other hand, if you're more of an analytical writer, go to the papyrus face first. Just start with what you feel most comfortable with. Focus on a possible model or reader and try to imagine what he may like or need to know according to what he may be doing. You're trying to facilitate the reader's reading and learning processes, so you have to be aware of them.

Once you've written both texts on the cylinder/column and papyrus faces, adopt a reader's perspective as much as you can and then read the texts. As a reader, check the coherence and consistency of both texts with respect to what you wanted to convey when you wrote them. You may need to revise them to make them more effective.

Also check the circular base parts. Each base should create the right expectations for the reader and each base should be consistent with its respective text. Be aware that readers will probably go back and forth from the cylinder/column text to the papyrus text. Even so, readers have to know what to expect, how the two texts differ in terms of their communicative function and what they can obtain from both texts.

(6) What should I do if I want to go back to a totally linear order?

Simply open up the cylinder/column/papyrus structure. The papyrus face is already linearly ordered. If it's too large, you may draw lines to divide it into two or three page-like spaces. This facilitates reading, which is difficult in a round-shaped structure or on a very large page.

The cylinder/column face may also contain some linear parts of text. If you wish, you may add them to the graph parts too. Understand that everything you write should facilitate reading and learning and that your role is that of a teacher.

(7) What should I do if I want the reader to take some initiative?

Your readers are in fact learners too. You may invite them to respond by sending you comments on your teaching. Your readers, for instance, may

request you to make some parts of the text clearer or more detailed. You in turn may also ask your readers to answer specific questions like these:

- Did you find the cylinder/column text useful in giving you a 'hands-on' grasp of the material? What would you like me to add to it?
- Did you find the papyrus text accurate enough to get a clear picture of what I promised in the circular base?

Comments from readers are aids in helping you become a more effective writer. As a writer, you're acting as a teacher and you need feedback about how well you're teaching what you already know. Knowing and teaching are not the same thing and you may need to do some self-reflection to organise your knowledge better so that you can transmit it to other people effectively.

(8) In a cylinder/column/papyrus where do the face ends touch?
Both face ends touch at the beginning or ending line. In the cylinder/column face this doesn't really mean that much, because you may start writing and reading the text from wherever you want (since it's delinearised text). In the papyrus face those lines indicate where the face opens up and the direction of reading. Since the text on this side is linear, the page sequence starts from the lefthand end of the face and proceeds to the righthand end.

(9) What are the main features of the cylinder/column/ papyrus structure?
This structure is very rich in what it conveys. If you think about it carefully, it allows many possibilities for both the writer and reader. It's reversible, it can be linear and nonlinear and it allows multiple perspectives in writing and reading. The cylinder/column face is compatible with a hypertext organisation, whereas the papyrus face has a sequential page organisation. Both faces complement each other. The two circular bases create specific spaces for making the writer's intention and readers' expectations explicit for both texts. What more could you possibly want?

(10) If I've got it right, I should use a cylinder/column/papyrus structure for shaping up and delivering explanatory and instructional texts, and for checking how well I'm teaching. I could also use it myself to check if I can explain something I just learned.
Yes, you got it right, and you can also use it as a memory device for something you ordinarily do. For example, you could place a cylinder/column/papyrus structure on the desk next to your computer to remind you what exactly to do to accomplish some complicated task.

* * * * *

As you navigated through this chapter you experienced a totally new dimension of writing. You saw how it's possible to shape text in space on

three-dimensional objects. You had a glimpse at the possibilities that text-space organisation opens for you.

Like an architect, you've now acquired powerful techniques for creating textual structures and buildings. You can use the textual objects as building blocks to combine in creating your own unique textual designs. For example, in one part of your textual building you might use a simple polimini structure topped off with a pyramid and in another part you might erect tall columns or obelisks. You're free to explore and create whatever special textual effects you imagine. As you do this, you will become more aware that writing isn't simply a homogeneous activity, but one that encompasses different things according to one's specific intentions and the particular function of the text. The textual objects presented in this chapter make these writing differences visible and material.

6

Imagining Textual Machines

This chapter introduces you to the concept of textual machines. Textual machines, like the canvases presented in Chapter 2, represent some cognitive processes that occur when you write and read text. Textual machines are different from two-dimensional canvases, however, in that they animate cognitive processes in a physical, mechanical way. The fourteen textual machines, which are presented here with increasing complexity, are revolutionary aids to help you reflect on and rethink the processes of writing and reading. You're not expected to construct these machines* but instead to imagine, visualise and experience their physical motion in time and space as a means of gaining understanding and insight into the complex, interconnected processes of writing and reading.

The term 'machine', as used in this chapter, means a *device that allows you – by substituting either partially or totally your own activity with that of the device – to attain a result that is otherwise unattainable by your own efforts.* 'Machine' also carries the meaning of *a device for transforming or transmitting energy.*

Textual machines model what you do when you write and read in the same way that a wheel models walking. The wheel doesn't simulate walking by copying the natural process, for if it did, wheels would have feet that would simply move more rapidly than human feet. What the wheel does is to produce linear movement, which walking also does. By interpreting walking as something that produces linear movement, the wheel models walking. It produces the same result as walking (albeit significantly enhanced), but in a mechanised way.

Similarly, textual machines model text processing, both in writing (the producing of text) and in reading (the receiving of text). They interpret what happens as you write and read, and they take these abstractions and put them into time and space where you can experience them physically. This physical, material experience of writing and reading has been lost over time, but the textual machines recover it for you so that once again you can experience the physical sensation and fun of writing and reading.

By making the processes of writing and reading text physically visible, the textual machines also help you reflect on these activities. You can observe what the textual machines do and then think about what you do as a writer and reader. As you observe the textual machines in motion, you

become a spectator, just as you are when you see a play in a theatre. As a spectator, you adopt a frame of mind that enables you to see yourself through the textual machines and to rethink what you do when you write text and what your readers do when they read it.

The textual machines are presented in order of their complexity – starting with those that represent simple processes and progressing to those that are more complex. Each machine is illustrated and its operation is explained. After the explanation, the canvas or canvases in Chapter 2 that represent the same cognitive processes as the machine are identified so that you can refer to them again to reinforce you insights. The canvases give you a snapshot in time of a specific stage of a cognitive process. The textual machines allow you to see all the possibilities of the process dynamically in space and time.

Although the machines are stand-alone devices, you can also imagine how they could be combined to produce many different complicated actions, which is what happens when you write or read. When you write or read, you activate different cognitive processes through language. The material of text is always language, but you shape it up differently according to the function of the text.

Machine for the Simple Rotation of a Word

The first machine is for the simple rotation of a word. This machine, which is shown in Figure 6-1, consists of a wheel with a hub that is free to rotate within the wheel. The rim of the wheel is divided by a series of equally spaced radial lines. The hub of the wheel provides a space for a single word. Each of the radial lines on the rim of the wheel contains another word or some attribute related to the word in the hub.

The word in the hub is free to rotate around the wheel so that it points to any word on the rim. You can envision the centred word as being written on an arrow so that as the word rotates, the head of the arrow points outward toward the words on the rim.

When the centred word points to another word, it creates the possibility of a word combination that is the starting point of a sentence. As you rotate the centred word, you can add all the word combinations or suggested sentences and then possibly create a text that contains them. The machine for the simple rotation of a word represents a totally free and unconstrained process. It's your decision to choose the word to place in the hub of the wheel, as well as the words to place around the rim.

For example, as in the canvas for a word explosion, you could place the word 'house' in the hub. Around the rim of the wheel you could also place other words you freely associate with 'house', such as 'doors', 'windows', 'kitchen', 'garden' and 'fireplace'. As you rotate 'house' around the wheel, it points to an associated word such as 'fireplace' that creates a possible combination of words that may suggest a sentence such as, 'A glowing fire in the fireplace makes my house feel warm and safe'. Rotating the word in

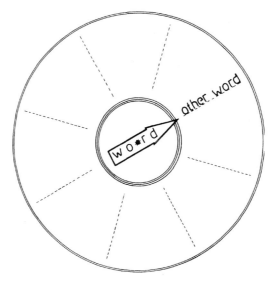

Figure 6-1. *Machine for simple rotation of a word*

the hub further around the wheel suggests other word combinations and
sentences that you may organise into a text.

The machine for the simple rotation of a word represents materially in three-
dimensional space the same concept as the canvas for word explosion, shown in
Figure 2-2. It models the cognitive process of freely associating other words with
one particular word.

Machine for the Complex Rotation of a Word

The machine for the complex rotation of a word is shown in Figure 6-2.
This machine is similar to the machine for the simple rotation of a word,
except that it includes another dimension and is constrained.

The machine for the complex rotation of a word has two parts, each of
which occupies a specific dimension. The first part of the machine, which
is in the horizontal dimension, consists of a wheel with a central hub. As in
the machine for the simple rotation of a word, the hub of the wheel
accommodates a single word. The other part of the machine is in a vertical
dimension and resembles a wall that is divided into a set of distinct
sections or spaces. The spaces on the vertical wall represent different
elements or categories with which the word in the hub may be associated.
These spaces are large because they can contain many items and
possibilities. The elements or categories represented by the spaces can be
arranged in any order and may include the following:

- Adjectives or other words that describe properties of the word in the
 hub of the wheel.
- Situations in which the word can be put. These situations are usually
 identified by nouns, not adjectives.

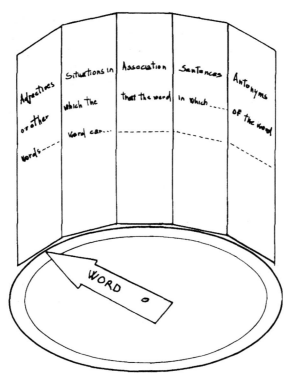

Figure 6-2. *Machine for complex rotation of a word*

 • Associations that the word freely conjures up in your mind.
 • Sentences in which the word occurs.
 • Antonyms of the word, or words that have a meaning contrary to it.
You can divide the vertical wall into as many categories as you want and
the categories can be your own choosing. Some of the categories may be
more objective than others. Occurrences and antonyms, for instance, tend
to be somewhat objective because they are lexical. On the other hand,
associations, properties and situations are more subjective. You can
establish your own mixture of objective and subjective categories. You may
even omit all the subjective categories and just include the objective ones.
Once you decide on the categories, however, you have to keep them.
 The word in the hub on the wheel can rotate, but only to the degree that
its movement projects on the vertical wall and points to one of the
categories on it. The categories constrain the rotation of the word, so that
any time you rotate the word, you have to take them into account. As the
word rotates and points to one of the sections, it triggers something in
your memory related to the category assigned to that section of the wall.
 For example, as in the machine for the simple rotation of a word, you
could place the word 'house' in the hub. You could also establish these five
categories on the wall: adjectives, situations, associations, occurrences and

antonyms. When you rotate 'house' and it points to the adjective category, 'large' might come to mind; when it points to the situation category, you might think 'the house on the hill'. The associations category could trigger 'happiness', while the occurrence category could cause you to respond with 'I need to paint my house'. For the antonyms category, the word 'homeless' might occur to you.

The machine for the complex rotation of a word represents materially in three-dimensional space the same concept as the canvases for word explosion (Figure 2-2) and word chaining (Figure 2-3). It models the cognitive processes of selecting something from multiple options and then organising it linearly.

Text Motion Machine

Figure 6-3 shows the text motion machine. The word 'motion' is used in the sense of a proposal presented in a formal assembly or a court of law. The name is a play on words since the machine moves text by rotating it to generate multiple proposals for completing a story. The text motion machine is composed of a pyramid that rotates on a horizontal base. The pyramid has triangular faces that each contain a memory text. A memory text is simply a text written about a personal experience in your life and is triggered by an initial story. A memory text usually starts with, 'This reminds me of ..'. The base upon which the pyramid rotates is divided

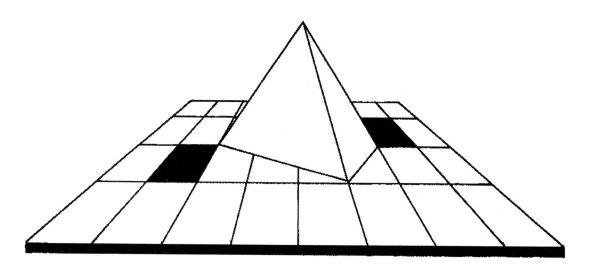

Figure 6-3. *Text motion machine*

into squares that contain alternative possible endings for the memory texts on the faces of the pyramid.

As the pyramid slowly rotates, it lights up certain squares on the base as the vertices of the pyramid touch them. The vertices of the pyramid

contain the final sentence of the memory text on the triangular faces. When a square lights up, the text on it presents another possible development or ending of the memory text story.

As a writer, you place both the memory texts on the pyramid faces and the alternative ending to them on the squares. You also control which squares light up as the pyramid rotates. The reader merely observes what happens as the pyramid rotates. The reader reads the story on the triangular face of the pyramid. When a square lights up as a vertex touches it, the reader reads that square. In this way, you present the reader with an proposal for another possible ending. The reader is able to observe all the possible ending you're proposing as the pyramid rotates.

The text motion machine represents materially in three-dimensional space the same concept as the canvas for globally planning a narrative text shown in Figure 2-7. It models the cognitive process of expanding information by adding new elements to it. Unlike the canvas, which is a static representation, this machine gives you a dynamic, three-dimensional way to think about a narrative text in which you want to keep some possibilities open.

Textual Lens

The textual lens is a unique kind of machine that has no moving parts. Instead, it consists of a transparent part and an opaque part. The transparent part is a thin plastic material that may be yellow or some other colour. The opaque part is paper and provides space outside the text that you can write on. You superimpose the transparent, plastic part of the textual lens over a word or sentence in the text you want to focus on and then expand on it by writing adjectives, relatives clauses or something else on the opaque, paper part. One of the features of the textual lens is that you can always remove it and restore the text as it was originally. You can, of course, take this idea and construct a computer program to accomplish the same result. Now let's look at the dynamics, function and possibilities of the textual lens.

A textual lens can have different shapes, depending on what part of the text you want to focus on and how you wish to position the lens over the text. You customise the shape of the lens so that it highlights the portion of text you want to select, provides the right amount of extra space you need for writing and won't cover up any of the original text.

Figure 6-4 illustrates various textual lens shapes. In the illustrations, both the text and the textual lenses are represented by rectangles. Textual lenses, however, are enclosed by thicker lines than the text. The shaded parts of the textual lenses are the transparent parts and their remaining parts are the paper you write on to expand the text. You may expand text in different ways. For example, you can add adjectives, repeat something at a more abstract level or provide an alternative.

The textual lens illustrated as 'A' in Figure 6-4 is constructed so that you can expand the final word or sentence of the text. The 'C' textual lens is a

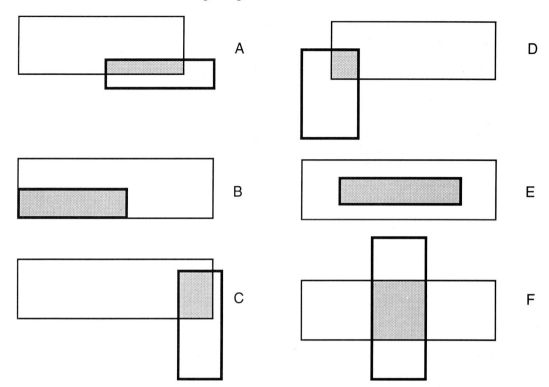

Figure 6-4. *Variously shaped textual lenses*

variation of this and has a different configuration and orientation. The textual lenses in 'B' and 'E' have only a transparent part to highlight a word, sentence, paragraph or some other part of the text. The only difference between 'B' and 'E' is their size and where they are positioned over the text. These lenses indicate to readers that you want them to pay attention to the highlighted text and possibly expand it themselves.

The textual lens in 'D' enables you to highlight the lower left edge of the original text and expand it. 'D' is similar to 'A' and 'C'. The lens in 'F' is different from all the others because it has paper parts above and below the highlighted text. You can use this type of textual lens to add alternatives to the highlighted text.

The textual lens represents materially in three-dimensional space the same concept as the canvas for textual rotation, shown in Figure 2-13. It models the cognitive processes of focusing on some element of text and then expanding it according to what is relevant to particular readers.

Wheel for Text Browsing

The wheel for text browsing, shown in Figure 6-5, resembles a waterwheel. It's composed of a large wheel with bucket-like elements around its rim. An axle goes through the centre of the wheel and is supported by brackets

on a flat stand. The axle enables the wheel to be rotated by hand in either a clockwise or counter-clockwise direction. The bucket-like elements on the rim of the wheel contain the paragraphs of a text that you've created. You and your readers can read through them by turning the wheel.

Figure 6-5. *Wheel for text browsing*

As a writer you can make your own decision about how you want readers to read your text. You can determine the speed for browsing through the text by allowing the wheel to move by itself at that speed. Alternatively, you can let your readers freely determine the speed by moving the wheel themselves. Regardless of who determines the speed for browsing through the text, since you know that the wheel rotates both clockwise and counter-

clockwise, you must determine the direction for readers. You can do this by using arrows in the text to indicate the direction you want readers to turn the wheel.

To prepare your readers, you write a word or a sentence that is evocative or significant for the entire text on the round side of the wheel. You may also write a title of a story. You place the paragraphs of your text, which are those parts of the text that you decided to organise in a certain way, on each of the bucket-like elements on the rim of the wheel in sequential order from the upper part downward. When the wheel is rotated in the direction you indicated, the paragraphs on these element move one after the other so that readers can read them in sequence. You may optionally add a cognitive symbol on the bucket-like element at the beginning of each paragraph to tell your readers what you intend to do in that paragraph.

One purpose of this machine is to help you think about movement in reading. The speed of movement may be predetermined by you as a writer or left totally free. If it's free, your readers determine the speed and turn the wheel with their own hands according to how fast they read.

The wheel for text browsing is also intended to show you how parts of the text move dynamically and how your reading speed changes as you read text. Readers don't always read at the same speed through all parts of a text. When readers are free to turn the wheel, they become particularly aware of their reading speed and know exactly when they're reading slow or fast. Even if you as a writer determine the speed, readers still experience the changes in the speed. When you control the speed, you become more reflective and must consider where the text can be read rapidly and where readers need to slow down or where you want them to slow down so that they pay close attention to the text.

The wheel for text browsing models the way you process information as you read. How fast you turn the wheel relates to the speed of your reading and how much the text implicitly or explicitly conveys. The more implicit the text, the slower your reading and the slower you turn the wheel because you need to fill in information that is missing, but which your memory provides.

The wheel for text browsing represents materially in three-dimensional space the same concept as the canvas for planning narrative text details shown in Figure 2-8. This canvas represents how narrative text has forward and backward links. If the text on the rim of the wheel is an explanatory text, refer to the canvas for planning and drawing explanatory text shown in Figure 2-10.

Carriage for Memory Text

Figure 6-6 illustrates the carriage for memory text. This machine consists of a pyramid with three wheels on each of the vertices of its triangular base. The three wheels swivel so that the machine can move in any direction. Each wheel (a round object) contains a triggering, evocative word. Each of these evocative words triggers a text on one of the three lateral faces of the

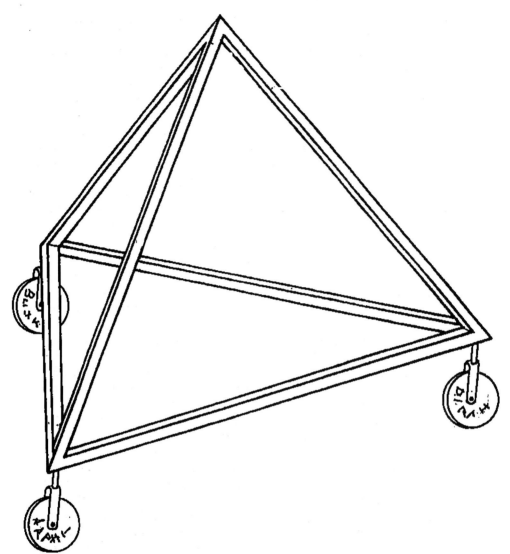

Figure 6-6. *Carriage for memory text*

pyramid. The word is repeated at the top vertex of the lateral triangular face to which it relates so that you can easily see the correspondence. For instance, if one wheel contains the word 'fear', this would correspond to a personal story about 'fear' on one of the lateral triangular faces. The word 'fear' would be at the top of this story so that you could make the correspondence. If another wheel contains the word 'pleasure', a personal story about pleasure is included on another face of the pyramid. Similarly, if the remaining wheel contains the word 'anger', another personal story related to that concept is included in the remaining face. Each word

triggers a set of memories in the writer's life related to that word or concept and the story written about it is included on one of the three lateral faces. The face that constitutes the base is always empty because this face is not visible as the machine moves and it would be useless to write something on it.

The writer has two possibilities. First, he could put a different word on each of the wheels and therefore a different text on each of the faces. In this way, the reader knows exactly which wheel refers to which face and exactly what text was written as a result of the triggering from the wheel. Alternatively, the writer could also put the same word on each of the three wheels. In this case, the writer doesn't need to repeat the word at the top of each of the faces because the three texts are related in the writer's memory to the same triggering word. For instance, the word could be 'danger' and the stories on the three triangular faces would all contain that idea.

The writer can also include cognitive symbols (such as those for define, describe and so on) on the wheels to show the style of the text on the lateral triangular faces. The cognitive symbols indicate the way the reader should receive the text. Once the reader sees the cognitive symbols, he knows that he should interpret a certain text as a description, narrative or some other specific type of text.

The reader is completely free to begin reading wherever he wants. He can start from whatever wheel he wants to and that decision determines the direction he moves the machine. The machine can move freely in three directions and it's the reader who moves it in the direction he wants to start reading. Texts are both related to each other and independent of each other. The machine therefore moves in various directions and may eventually become combined with other moving machines.

The carriage for memory text enables the writer to see the relationship between an evocative word and a story in his memory. It creates the possibility of seeing how the same word may trigger many stories about his life experiences. Similarly, the reader is stimulated to find stories in his own life. This process may entail some mirroring by the reader of what the writer intended and how that relates to his own personal experiences.

The carriage for memory text represents materially in three-dimensional space the same concept as the canvas representing the story about the fox and the grapes shown in Figure 2-6 and the canvas for finding analogies in stories shown in Figure 2-9.

Carriage for Explanatory Text (Simple)

The carriage for explanatory text in its simple form is shown in Figure 6-7. This machine is shaped like a triangular prism. The two lateral faces constitute the writing spaces. There are two wheels on each of the lateral faces that allow the carriage to move. The carriage – and therefore the lateral faces of the triangular prism – are free to move from left to right and right to left. The lateral faces, which are rectangles, are like two pages

of a notebook and the writer fills them up with explanatory text. The writer writes sentence after sentence from top to bottom, linearly across a face. When he comes to the end of one of the lateral faces, he continues at the top of the other lateral face. The writer numbers the lateral faces or puts arrows on them to indicate to the reader which is the first page of the text and which is the second.

Figure 6-7. *Carriage for explanatory text (simple)*

The reader moves around the carriage. He reads the first page and then moves around and reads the second. To facilitate reading, the reader may move the machine from left to right, which is the reading direction in our language. He may also move the machine from right to left to move backwards or to move down to the next line. The faces of the carriage contain text that is written linearly and, because the carriage has wheels, the reader can move it more or less slowly, according to his reading speed.

The speed at which the reader moves the carriage is determined by the ease or difficulty the reader experiences in absorbing information in the text. In other words, if the text is difficult because the reader is unfamiliar with the topic, he goes slower. If he finds reading easy, that means he is familiar with it and can move the carriage more quickly. By perceiving and experiencing his own speed in reading the specific explanatory text on the faces of the carriage, the reader thus is in charge of his acquisition of information and can control his learning process.

As a writer, you can visualise this machine with a possible reader in mind and you can write your text accordingly to facilitate the learning process. Moreover, you can check how clear your writing is by observing how fast you or the reader moves the machine. The reader can also use this

machine to obtain a perception of how fast or slow he is reading so that he can evaluate his understanding and learning process.

The carriage for explanatory text in its simple form represents materially in three-dimensional space the same concept as the canvas for planning and drawing explanatory texts shown in Figure 2-10.

Carriage for Explanatory Text (Complex)

This machine, which is shown in Figure 6-8, has the same basic structure as the previous machine, but it's more complex. It has three triangular-prism carriages – one large, one medium-sized and one small. Each carriage fits over the ones smaller than it, like a set of progressively larger Chinese boxes. The three carriages move the same way as the single carriage in the simple form of the machine – they move on wheels from left to right and right to left.

Figure 6-8. *Carriage for explanatory text (complex)*

The two faces of the largest carriage contain a linearly constructed explanatory text. The writer writes sentence after sentence from top to bottom, linearly across a face. When he comes to the end of one of the lateral faces, he continues at the top of the other lateral face. The writer numbers the lateral faces or puts arrows on them to indicate to the reader which is the first page of the text and which is the second.

The writer follows the same procedure for each of the three carriages, but according to different criteria that relate to the size of the carriage. The writer organises text for the same topic in three different ways. The largest carriage, which is the external one, contains the richest text – the text that is the most detailed, analytical and complete. This text thoroughly explains

the topic to the reader. It requires the reader to know little about the topic and is primarily aimed at someone who is a beginner. The internal carriages, the medium-sized one and the smallest one, correspond to synthesised versions of the text. The medium-sized carriage contains a synthesised text that is intended for a reader who knows something about the topic but is an intermediate learner. The smallest carriage contains the most synthesised version of the text. This text is for an advanced learner and contains only enough information to remind the reader of what he already knows.

The reading process may proceed in two ways. The reader can start from the largest, most external carriage that contains the most analytical text. Since it is a linear explanatory text, the reader knows how fast he is reading by how quickly he moves the carriage. If at some point he realises that he knows enough and is tired of reading all the details, he can get the second carriage out and start reading it. If he still finds that he is reading things he already knows, he can get the third, smallest carriage out. The reader does all this himself finding the level of text that he needs. If the reader is particularly diligent, he may read the text on all three carriages to see how quickly he can move through them. He may also do this if he wants to reread the texts to verify that he knows everything or to solidify and reinforce his learning.

The reader can also proceed in another way. He can start from the smallest carriage to read the most synthetical text, proceed to the medium-sized carriage and then to the largest carriage that contains the most analytical text. When the reader proceeds this way, he is progressively getting more information and expanding his knowledge. The reader in this case has to think about his own needs and observe the way he relates to the text according to the which carriage he's reading.

The carriage for explanatory text in its complex form represents materially in three-dimensional space the same concept as the canvas for hypertext shown in Figure 2-14.

Three-Floor Rotation Machine for Poetry

The three-floor rotation machine for poetry is shown in Figure 6-9. This machine has a conic base. An axis through the top of the conic base supports two parallel disks. The disks are free to rotate in a clockwise or counter-clockwise direction when turned by hand. The top disk is smaller than the bottom disk. This machine carries poetic text – evocative text created to trigger emotions and personal feelings. There is much freedom in the use of this machine, both in writing and reading. Reading can be left free or suggested. That is, readers may be left totally free to do whatever they want or directed to some particular way of reading.

How is text distributed on this machine? The poetic text is written on the two disks and on the surface of the cone. Each disk and the cone can contain a strophe (paragraph) of the poetic text or the disks and cone can

have the same text written on them in an extended or reduced way. The bottom of the conic base contains the title of the poem or keywords for interpreting it. The title or keywords are hidden so that you have to turn the whole machine upside-down to see them.

There are two different modes for using this machine. One mode is for readers to read the poetic text first by rotating the disks and then turning the machine upside-down to read the title written on the base of the cone. The other mode of reading is the reverse: readers first turn the machine

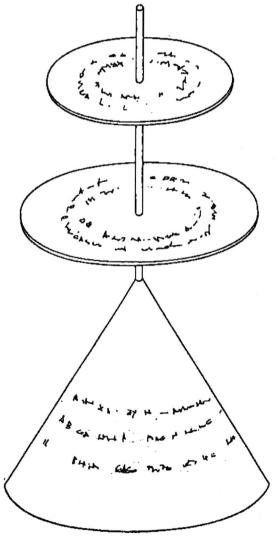

Figure 6-9. *Three-floor rotation machine for poetry*

upside-down and read the title or keywords on the base, then they read the poetry text on the disks. The writer leaves readers free to decide the mode of reading or he may explicitly say what he wants readers to do. But since poetry is free and evocative, it's better to let readers decide what they want to do. If the writer wants to direct readers he can simply give them some advice. For example, the writer can recommend that readers read the title last, but can also let them know that they're not obliged to follow the suggestion.

The title on the base of the cone may be brief or lengthy, as long as it is visible when you turn the machine over. Unlike explanatory text where the title tells you what the text is about, the title or keywords for poetry just trigger your memory. The round or circular shape of the machine is intended to evoke in you free associations and to create a space for your emotions, personal feelings and unstructured thinking. The distribution of parts of the text on the disks creates a visual perception of the content of the poem and shows where breaks in it occur. Placing strophes or parts of the poems on the two disks automatically slows down the reading process and adds a kind of audible, intoned dimension to it that enhances its interpretation.

The three-floor rotation machine for poetry represents materially in three-dimensional space the same concept as the canvas for word explosion (Figure 2-2), canvas for word chaining (Figure 2-3) and the canvas for creating a metaphor (Figure 2-4).

Machine for Transferring Text

Figure 6-10 illustrates the machine for transferring text. The concept of transferring is derived from the from Latin verb 'transfero', which means to bring across or transport. Transferring text deals globally with text and changes it, all at once, from one stage that exhibits one style into a second stage that exhibits another.

The structure of the machine for transferring text is that of a drawbridge. There's a stationary vertical part that looks like the wall of a castle or fortress. The bridge-like part extends out from the bottom of the vertical part. It's hinged so that it can be raised or lowered by two strong ropes or chains. Like a drawbridge, the machine for transferring text has two distinct operational modes: it's open when the hinged part is horizontal and it's closed when the hinged part is vertical and touching the stationary part.

As a writer, you write some text on the vertical stationary part of the machine. You may place a cognitive symbol at the beginning of the text to signal explicitly and visually the style of writing. Alternatively, you could simply include a sentence at the beginning of the text stating what style you're writing in. For example, you might state, 'This is going to be a descriptive text', and then proceed with writing.

You write all of your text using only the one style you indicated. For

Figure 6-10. *Machine for transferring text*

instance, the text might be a detailed description of how furniture is arranged in a room. Every paragraph of the text would be descriptive and the text as a whole would then globally exhibit the same style.

The horizontal part of the machine provides a space for transferring the text on the vertical part into a different style. The topic of the text remains the same, but you write it in a different style. As on the vertical part, you may include a cognitive symbol at the beginning of the text to indicate the particular style you're transferring the text into. For example, if on the vertical part you described the arrangement of a room, on the horizontal

part you could write an explanatory text that explains why the room has that particular arrangement. At the beginning of the horizontal part you could place the symbol for explain or simply write, 'This is going to be an explanatory text'.

From your perspective as a writer, the machine for transferring text shows how you can write about the same topic in two different styles. You experience directly what it's like to start with the same information, organise it and write about it with two different attitudes. When you close the machine by pulling up the horizontal part, you see that the two texts touch each other and are united because they're about the same topic. The two text are still distinct, however, because they have different styles and represent different kinds of knowledge organisation.

Your two distinctly different texts create two different ways of reading, too. A descriptive text, for example, is read in a different way and with a different attitude than an explanatory text because of the expectations carried by these two text types. What readers see when they look at the machine is the same text written in two styles that you may explicitly indicate. In some cases, however, you may decide to include a cognitive symbol for only one of the texts. You leave it up to readers to figure out the style of other text. If you decide to do this, your readers will need to become more actively involved in looking for clues in this text to discover your writing intention.

Since cognitive symbols, which visually convey your writing intention, play an important role in this machine, you may want to review the first part of Chapter 3. You will find descriptions and illustrations of the various cognitive symbols there.

Device for Transforming Text in Phases

This device differs from the machine for transferring text in some important ways. The concept of transforming is derived from the from Latin verb 'transformo', which means to change shape. Transforming text is different from transferring text in that it involves a process that takes place in multiple stages. Transformation is the process of modifying text paragraph by paragraph. It's a slow, gradual process that deals locally with only one part of the text at a time. This model is called a device instead of a machine since movement takes places on the writer's and reader's side, not within the model itself.

Figure 6-11 shows the device for transforming text in phases. This device is composed of an initial text, which appears in the foreground (bottom of the illustration) and a final version of the text, which appears further away in the background (top of the illustration). The initial and final versions of the text are connected by a rope through a series of posts.

You write the initial text in paragraph form and place it in the foreground. The paragraphs are visually distinct divisions of the text. This initial text is the point of departure for the transformation process.

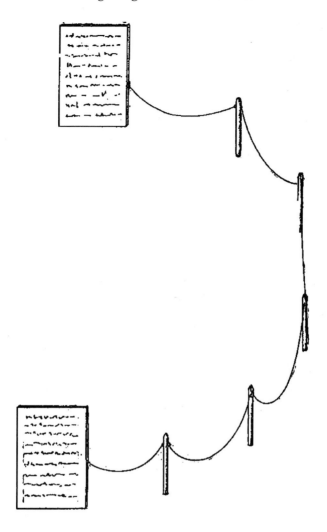

Figure 6-11. *Device for transforming text in phases*

From the initial text you place a series of equally-spaced posts that ultimately leads to some point in the distance where the final version of the text rests. The posts connect the initial and final versions of the text and create a path in space between them.

Each post has instructions for changing the style of a particular paragraph in the initial text. Together the posts form a set of instructions for modifying the initial text in phases. For instance, the first post could instruct you to make the first paragraph of the initial text descriptive; the second post might indicate that you need to change the second paragraph to an analytical style. The instructions on the posts could also include a

cognitive symbol that would visually convey the type of style change needed.

The number of phased changes that the original text undergoes in its transformation depends on the number of posts. If, for example, the initial text contains four paragraphs and there are just two posts, there would be only two modifications made to the text, each in the specified paragraph. On the other hand, if there are four posts, each of the paragraphs would be modified and there would be four distinct changes made.

The instructions on the posts allow you as a writer to change the initial text paragraph-by-paragraph in a progressive, localised manner. You are, in fact, the one who establishes the posts and their instructions. So in that way you lead yourself through a rewriting process that begins with the initial text and ends with the final version.

Readers of the text are invited to move around in the space of the device and to read the initial text, the instructions on the posts for progressively modifying it and the final version. Walking around in the space of the device has the effect of leading readers through the same process that you went through as you modified the text. By doing this, readers understand how the final text was generated. They comprehend how you as a writer conceived of modifications to the initial text and they see the process in all of its stages. When readers grasp what you were doing, some of them may want to establish their own posts and create a different path from the initial text to their own version of the text.

As with the machine for transferring text, this device also relies on the use of cognitive symbols and if you wish, you may review them by referring to Chapter 3. The device for transforming text in phases also involves text shaping, which is the main concept presented in Chapter 4.

Focusing Machine

Figure 6-12 shows the focusing machine. This machine consists of a flat table containing text. The table is fixed to a platform and raised above it. To the left of the table there is a vertical rod with a horizontal arm and a triangular pointer. This vertical rod is attached to a small carriage. The underpart of the carriage has a key that fits into a track on the platform. The key on the carriage and the track on the platform allow the vertical rod to move up or down across the lines of the text on the table. The horizontal arm can be adjusted up or down on the vertical rod so that it can be positioned closer or further away from the text. The triangular pointer freely slides back and forth along the horizontal arm, in the direction of the lines of text on the table. By moving the vertical rod, adjusting the height of the horizontal arm and sliding the pointer, it's possible to position the pointer on – and actually touch – any word, sentence or other part of the text on the table.

The writer places the paper with his text on the table. He may then say what he wants the reader to focus on. For example, he can say: 'I gave you

this text and I want you to focus on this word'. The writer then moves the vertical rod so that the pointer touches the word he wants the reader to focus on. (If the pointer doesn't cover all of the text that the writer wants the reader to focus on, a box can be drawn around the appropriate portion of the text or it can be underlined.) In this way, the writer physically, directly indicates the word or words the reader needs to pay attention to. If there's another word or words that the writer also wants the reader to focus on, he may continue by repositioning the pointer on another part of the text.

Once the reader focuses on the specified part of the text, the reader can also move the pointer and find a different textual element that he wants to

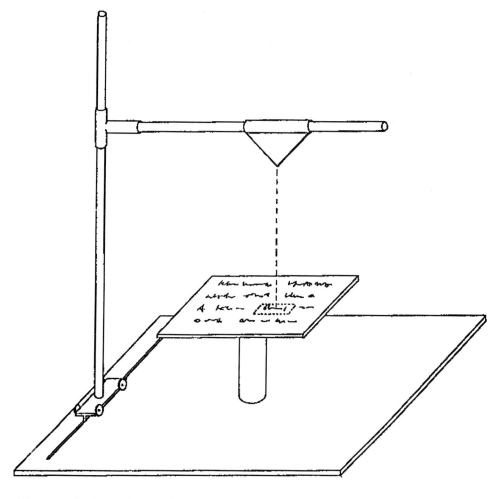

Figure 6-12. *Focusing machine*

draw attention to. He leaves the pointer in a new position on that element, ready for the next reader to come in and interact with the text. The next reader's attention is drawn to the previous reader's focus and then that reader is also free to move the pointer to another part of the text that corresponds to his own interest and focus. This process may continue successively though a whole line of readers, each of whom is drawn first to his predecessor's point of focus and then contributes his own.

During all of this the writer observes the readers and their focusing. He may choose to intervene at some point or simply allow the readers total freedom in focusing on whatever they want. As the writer reflects on what is happening, he comes to understand the importance of focusing in writing and reading. He sees in a material, physical way how people focus differently on the same text. They focus differently because they are different individuals with different backgrounds, interests and needs.

The focusing machine represents materially in three-dimensional space the same concept as the canvas for mosaic reading shown in Figure 2-12. The mosaic concept comes out progressively and you can see different interpretations of it through this machine.

Machine for Producing Ideas and Turning Them into Text

This is quite a complex machine, as you can see in Figure 6-13. It has two basic parts. The part on the left consists of a wheel that is turned by a crank. The other part is composed of a vertical post with a horizontally cantilevered arm, a pulley, a lever and a rectangle. The pulley is attached to the right end of the arm. The left end of the lever is attached to the post by a pin so that the right end pivots up and down. The rectangle hangs down from the right end of the lever on a wire. A rope goes from the wheel on the left, through a hole in the post, around the pulley and is attached to the free end of the lever. When the crank is turned, the energy it generates is transmitted through the rope and moves the lever and the rectangle up or down.

What does this complicated structure represent? The originating wheel, which is a round object, contains a word or words that are evocative. These words (ideas) represent the initial state of the creative process. They initiate the creative act and the processes of thinking, figuring out and planning a text. These ideas are the preliminary inspiration for creating a text.

The originating wheel may contain several ideas but only a few of them pass through to the other part of the machine (the part with vertical post and horizontal arm) and attach themselves to the pulley. The ideas attached to the pulley then turn into the text on the rectangle. When the machine is set in motion by cranking the originating wheel, energy is produced and is transmitted to the other parts of the machine. This flow of energy through the machine models the processes of getting an initial inspiration, working out ideas, selecting some of them and then converting them into a text.

The originating wheel represents a whole set of ideas generated by

Figure 6-13. *Machine for producing ideas and turning them into text*

brainstorming and free association. The pulley represents the processes of selecting some of those ideas, focusing on them in order to elaborate them and finally turning them into text. The rectangle contains the text. This text is linear and it is the result of selecting and focusing on only those ideas attached to the pulley. This is what is meant by *turning* ideas into text.

So there are three steps in this machine's operations. First, the originating wheel contains words triggered by the free association and stimulates the production of more thoughts, words and ideas. As a result of selecting and focusing on just a few elements and not everything on the originating wheel, some ideas pass through to the pulley, which is another round object. Finally, by expanding and linearly organising those ideas that were selected and attached to the pulley, the rectangle is filled with text.

The writer activates the machine and is the protagonist of the processes it models. The machine facilitates the writer's self-reflection and self-awareness of what happens when he selects some ideas out of an initial set and then works them out in a text. The brainstorming phase, the initial step of the process, is not linear. The writer may have many ideas bumping around in his mind in a disorganised way and these brainstormed ideas become organised into text only afterwards. For example, through brainstorming and free association, the writer may come up with some

ideas such as 'justice', 'peace' and 'freedom', but by selecting 'justice', focusing only on that idea and expanding it, he may develop a linear, organised text. The machine makes these processes visible to the writer so that he may more easily reflect on them and gain insight into how he shapes ideas into text.

This is a spectacular machine, in the sense that the writer positions the machine in front of readers and the readers are *spectators* of the machine's complex operation. The writer is the protagonist. Readers don't direct the machine's operation because that's already done by the writer. They may decide, however, which part or parts of the machine they want to observe and get closer to and actually touch. For instance, they may read only the words on the pulley and the text on the rectangle. On the other hand, they may additionally trace back to the words on the originating wheel and see the more extended set of words from which the selected words came.

The machine for producing ideas and turning them into text represents materially in three-dimensional space the same concept as the canvas for word explosion shown in Figure 2-2. It models the cognitive processes of selecting something from multiples options and then organising it linearly.

Textual Catapult

The textual catapult, shown in Figure 6-14, is modelled after an ancient war machine. Catapults could hurl stones or other objects considerable distances with great force. They were developed by the ancient Greeks as siege machines to overcome walls or other barriers. They were moved into position, loaded and then fired. If all went well, the hurled stone would strike its target. The catapult's original design of a throwing lever, mounted on a wheeled platform remained basically unchanged through the conquests of the Roman Empire and the battles of medieval Europe.

In the case of the textual catapult, the vertical wall contains a linearly written text. The text can be of any kind. It contains a missing element. This missing element, which is shown by a outlined rectangle or some other visual sign on the textual wall, may be a noun or an adjective.

Instead of a stone – which was traditionally used as a projectile – the textual catapult fires a linguistic element (a noun or adjective) at the wall. The trajectory of the linguistic element thrown by the catapult is crucial and must be planned. Unlike with the real siege machines, the linguistic element fired by the textual catapult must hit the wall and not go over it. The textual catapult has to be positioned so that when it's fired, the linguistic projectile hits the target of the missing element in the text on the wall.

The position of the catapult is crucial and relates to the context and syntax of the missing element. Since the writer is the one who wrote the text on the vertical wall, he is also the one who determines how the catapult has to be positioned so that the trajectory of the noun or adjective launched by it is exactly right. He is able to determine the correct position

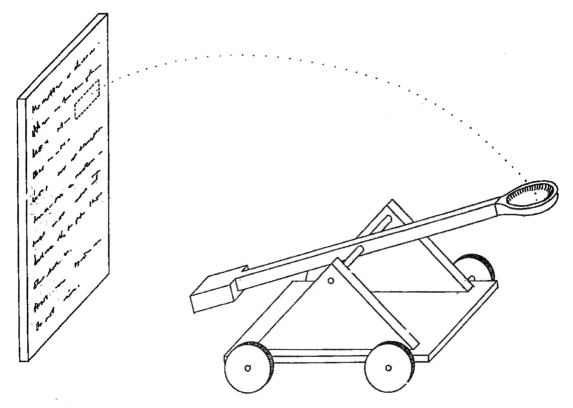

Figure 6-14. *Textual catapult*

of the catapult from clues in the text around the missing element.

There are two possible ways the writer can use the catapult. If the writer already knows the missing element, he can put it on the catapult, launch it and complete the text himself. The reader in this case is simply a spectator. The other way the writer can use the catapult is to position it, but instead of loading a word into it, he can leave it up to the reader to find one and place it on the catapult. The reader is able to find the word by reading the text and discovering the expectation created by it. Once the reader finds the word, he loads it on the catapult and fires. The word hits its target (the missing element in the text) because the writer has already moved the catapult into the position that produces the correct trajectory.

Thus this machine must be moved into the right position to achieve the correct trajectory. The missing element, which is launched by the catapult, cannot go just any place in the text but only in the precise place that is empty and which is decided by the writer.

This machine enables you to visualise the process of text completion when there is a missing element that can be filled in based on the *context*. The context is the expectation that the text creates and the information

already present in the text. The context helps the reader or writer complete the text. The catapult can be directly guided by the writer or the writer can leave it open and see what the reader does.

If you consider the textual catapult as it may be used cooperatively by the writer and reader, it represents materially in three-dimensional space the same concept as the canvases in which the writer and the reader cooperate, as well as those textual objects that entail text planning and turn-taking. The textual catapult models the cognitive process of the relevant selection of information to complete missing, implicit information.

<p style="text-align:center">* * * * *</p>

The machines presented in this chapter may operate simultaneously in a theatre. They create a play of our mind that shows the wonderful way we're able to use language in writing and reading text. Seeing these machines operate makes you aware of the different possibilities available to you on a cognitive level. They help you visualise and reflect on how to go from simple cognitive processes to those that are more complex as you create and revise text.

Notes
* Models of the textual machines have been constructed of wood in Italy and are used in demonstrations and workshops.

Anthology

The word 'anthology' has an interesting origin that's particularly appropriate here. 'Anthology' comes from two Greek words: 'anthos', which means a blossom or flower, and 'logia', which means a collection. In its original sense then, an anthology was a flower collection – a bouquet of specially selected beautiful flowers. Its use here carries with it some of the original meaning. Instead of being a lovely floral bouquet, however, it's a collection of specifically chosen examples that beautifully illustrate some of the concepts and techniques presented in the chapters of this book. Once you read the anthology, you're invited to get into action yourself.

This anthology has two parts. The first part, Text Origami, gives several examples of how to shape text and construct textual structures. Text origami relates to both the geometric signs for shaping text in Chapter 4 and the textual objects in Chapter 5. The second part, Text Decoration, provides examples of visually embellishing text. Text decoration concerns the use of textual symbols as explained in Chapter 3.

The examples in the two parts of this anthology cover only some of the visual techniques presented for writing. There are, for instance, no examples of the canvases in Chapter 2 since you can always go back to their descriptions and try to experience them directly yourself. There are, however, many examples in the Text Origami section that show how geometric textual signs such as squares and triangles can be combined and transformed into textual objects like cubes and pyramids. The Text Decoration section contains several examples that illustrate how symbols can be combined with text to enhance its intention visually.

The texts used in the examples relate in some way to the contents of this book. In some cases, text is taken directly from one of the chapters so that you can compare the linear version that you've already read to a visually enhanced version. The examples as a whole are intended to make the concepts and techniques in this book concrete and to support and reinforce your appropriation of them. As you read through this anthology, you're encouraged to create your own examples of text origami and decoration.

Text Origami

Origami is the ancient Japanese art of folding paper to create interesting and sometimes very intricate objects. Text origami, as alluded to in

Chapter 4, is a metaphor for shaping and organising text in space. Text origami has to do with wrapping up text to create a variety of geometric shapes and objects.

The shapes and objects that result from text origami give you a visual, global impression of the text contained in them. By simply looking at text that has been shaped and wrapped up into a physical object, you can immediately perceive the kind of text it is and how it's organised and structured.

The following pages contain a text origami collection that includes such textual objects as cubes, pyramids, cylinder/columns and obelisks.

Cube

As a first example of text origami, consider what happens when you wrap up the six squares faces in Figure A-1 into an object. The result is a cube, with text written on each of its six faces.

This cube represents the contents of this entire book in three-dimensional space. Each face of the cube narrates in a summarised way a chapter; the number preceding the text on the face identifies that chapter. Face 1, for example, contains a summary of the first chapter. There are six chapters in this book, so each face of the cube is filled with text. To read the cube, you simply rotate its faces in numerical order.

When you look inside the cube, you will see a three-dimensional table of contents. Each of the chapter titles is written on a plane inscribed inside the cube. Figure A-2 illustrates how the chapter titles might appear inside the cube.

The textual cube you just considered is a visual representation in space of the contents of this book. You can explore it by holding it in your hand, turning it around and peering inside it.

1 This chapter looks back through history to see how writing was originally derived from drawing and how the materials chosen for writing have affected the writing itself. The chapter closes by briefly explaining Graziella Tonfoni's Text Representation System and Communicative Positioning Programme which are the methodological foundations on which this book is based

2 Through strong visual metaphors and hands-on exercises this chapter leads you to experience writing in a totally new way – as an act of creating a drawing or painting. The second part of the chapter presents twelve 'canvases' (visual schemes) that correspond to different kinds of writing.

3 This chapter starts by explaining the concept of visual symbols: Visual Symbols are like road signs that tell a driver what lies ahead or the notation that directs a musician to play a movement slowly and softly or brisk and lively. The chapter quickly progresses to describe a set of 15 visual symbols explicitly for writing.

4 The first section of this chapter introduces the concept of the 'shape' of text, a textual attribute that conveys intent. The chapter continues by discussing textual shaping. Textual shapes are related to textual meaning in the same way that ceramic objects are related to the type of clay that is used to create them.

5 This chapter carries the metaphor of writing as a drawing and painting to a third dimension. It explores how to conceive of writing text as constructing a three-dimensional object. Each textual object carries with it evidence about its particular meaning. When text is 'shaped-up' to form a textual object the text's shape conveys exactly the kind of information needed for reading the text.

6 This chapter introduces the concept of textual machines – textual devices or engines in motion that represent cognitive processes exhibited in texts. It describes, illustrates and gives examples of 14 textual machines. As you work through the examples in this chapter you gain awareness of your own cognitive processes by being able to visualise them through the various textual machines.

Figure A-1. *Cube summarising the chapters of this book*

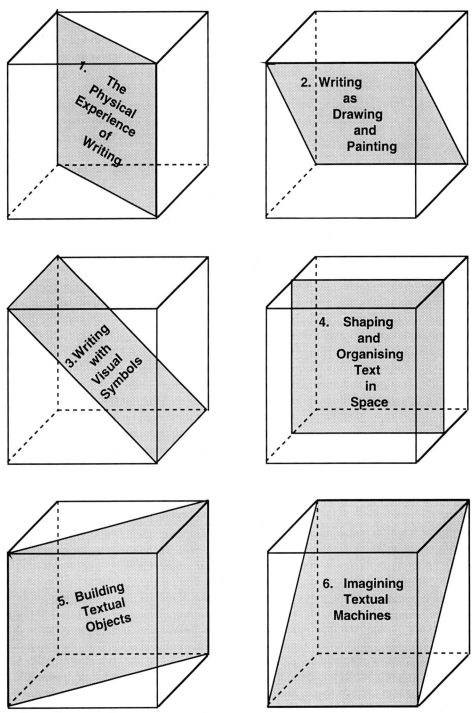

Figure A-2. *Chapter titles inside the cube*

Cylinder/Column/Papyrus
Figure A-3 shows an example of the outside faces of a cylinder/column textual object. You construct the cylinder/column by rolling up the rectangular face lengthwise into a tube. Then you fold the top circular face down and the bottom one up to close the ends of the tube.

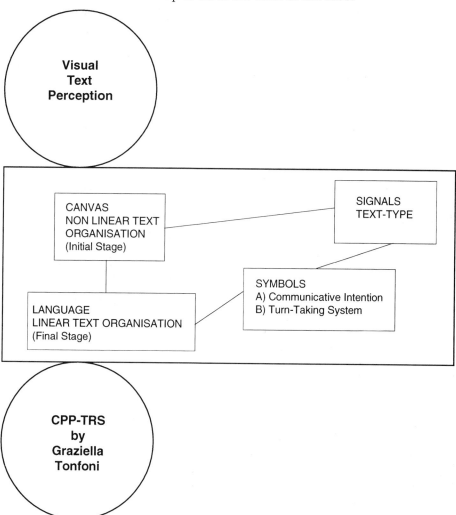

Figure A-3. *External faces of a cylinder/column*

The cylinder/column in Figure A-3 represents, in a synthetical way, the CPP-TRS methodology on which this book is based. The circular bases tell you this. The side of the cylinder/column, which is the rectangular face in Figure A-3, gives you more information by depicting the CPP system in a simple block diagram.

The internal face of the cylinder/column – the papyrus face – contains the text shown in Figure A-4. This text is an analytical statement of what is presented pictorially on the external face.

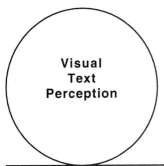

When you write using the TRS and CPP methodology as implemented in this book, you're designing text from a specific perspective in a visual, physical way. You plan your text so that it has shape in space. Your text then has its own physical structure so that its shape visually and materially enhances the perception and meaning of the text it contains.

Figure A-4. *Internal face of the cylinder/column.*

This cylinder/column gives you a strong impression of what the CPP-TRS methodology is all about. It provides two ways of accessing the same information. The outside of the object represents the CPP system synthetically in a diagram, whereas the inside gives you a linear text that represents it more analytically.

Obelisk

The CPP-TRS methodology may also be represented in an obelisk textual object. An obelisk, as you learned in Chapter 5, is an ideal structure for representing a commonly shared experience. As shown in Figure A-5, the lateral faces of the obelisk contain text that conveys some common experiences of using the CPP system.

The obelisk that results when you fold up the textual structure in Figure A-5 serves as a visual, physical monument to people's experience in using the CPP system. Once you acquire your own experience, you could add it to one of the faces of this obelisk.

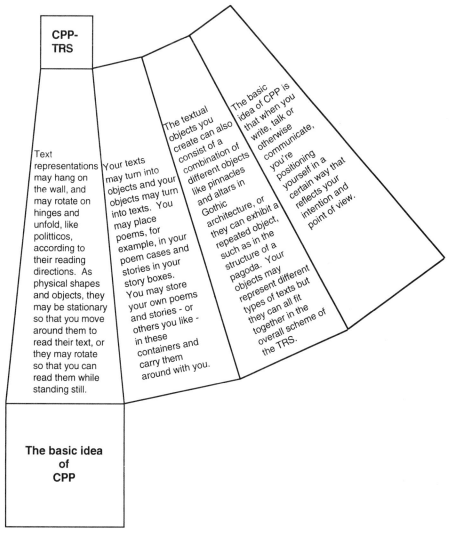

Figure A-5. *Faces of an obelisk*

Polimini

As you will recall from reading Chapter 5, a polimini is a structure built by putting cubes together into some configuration. One use of a polimini is to help you visually navigate through text.

Figure A-6 shows the faces of a polimini designed to help you navigate through the fourteen textual machines presented in Chapter 6. Each square in this figure is a face of the polimini structure. The number on each of the faces identifies the specific page number of this book where you find a description of one of the textual machines. The page number indicated on the uppermost left face, for example, tells where to find the Machine for the Simple Rotation of a Word.

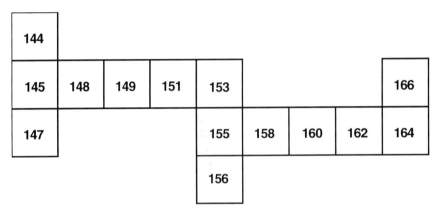

Figure A-6. *Square faces of a polimini to help you navigate through Chapter 6*

The order of the square faces corresponds to the order in which Chapter 6 presents the machines. This order reflects the complexity of the machines: the simplest one is presented first, followed progressively by those of increasing complexity.

The structure that results when you construct the polimini gives you a three-dimensional map of the locations of the textual machines in Chapter 6. There are, of course, other paths through this section. For example, you could move through them with reference to their functional or dynamic characteristics. You could even visit them in alphabetical order.

When you determine an order for the textual machines, you can construct a polimini as a reading map. Figure A-7 illustrates some of these possible polimini structures.

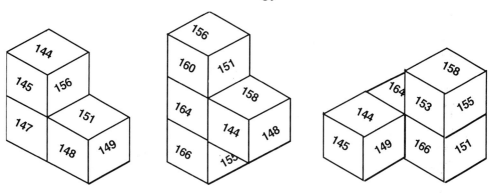

Figure A-7. *Other possible polimini structures for Chapter 6*

Trittico

As you will remember from Chapters 4 and 5, a polittico text structure is a visual aid for representing opinions or comments about a particular topic. The simplest form of a polittico is a trittico, which has three panels. Figure A-8 (overleaf) shows a trittico that contains three people's comments about the CPP methodology. The most significant comment is in the centre panel. Each of the side panels also contain comments. The space at the bottom indicates what the comments on the panels are about.

Pyramid

You can shape up text that contains personal memories into a pyramid textual structure. This textual structure consists of four triangular faces and a square base. Triangles, as Chapter 4 indicates, are the geometric sign for shaping memory texts. Squares, on the other hand, are for shaping stories and narrative texts. The combination of triangular and square faces in the structure of a pyramid makes it well suited for shaping a biography, curriculum vitae, resume and other types of writing that have both narrative and memory components.

As an example, consider a pyramid representing selected parts of my curriculum vitae. This pyramid consists of the four triangular faces shown in Figure A-9 on page 179. Each of the triangles has text that tells you something related to my work in developing the CPP.

I think that the whole set of descriptive strategies and techniques that Tonfoni has developed are very helpful in making explicit, both for teaching and describing, all those different ways a text can be conceived of and written (I mean both literary texts and non-literary ones).

Paolo Valesio
Director of the
Department of
Italian Studies,
Yale University

Grammar and punctuation show the local structure of a text but do not clearly indicate the intended rhetorical function of each part, and amateur story tellers often fail in that domain. Tonfoni's system of explicit function symbols could help both language theorists and working writers.

Marvin Minsky,
Toshiba Professor of Media Arts and Science, Massachusetts Institute of Technology

This idea, when implemented on a computer, would help to create new writing methods that would help to bring about the computer revolution.

Roger Schank,
Director of the
Institute for the
Learning
Sciences,
Northwestern
University

The basic idea of CPP is that when you write, talk or otherwise communicate, you're positioning yourself in a certain way that reflects your intention and point of view. This means that anything you write can be written in different ways, if you change perspective. Your perspective affects how you perceive what you're writing about and how you 'package' it in text.

Figure A-8. *Trittico showing comments about the CPP*

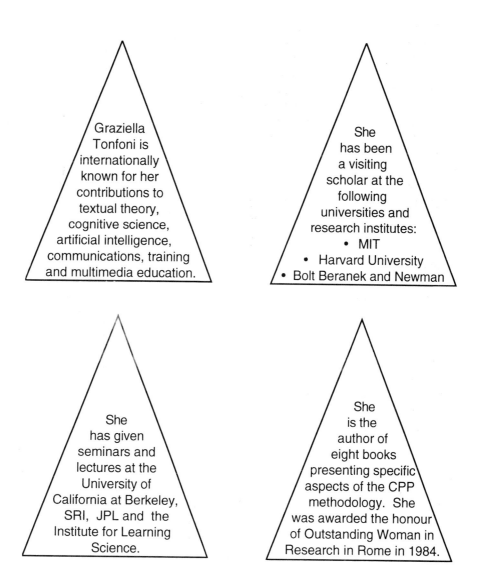

Figure A-9. *Triangular faces of a pyramid*

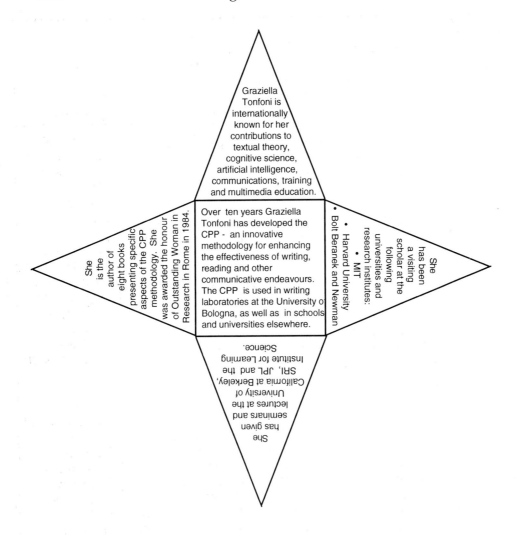

Figure A-10. *Pyramid structure consisting of four triangular faces and a square base*

The triangular faces in Figure A-9 are placed around a square base, as shown in Figure A-10. The text on the square base provides a brief 'story' about the CPP. When you fold the triangular faces up from the base so that they come together at a point, you create a pyramid. This pyramid then visually represents in space some aspects of my work.

This book is the result of discoveries made by Graziella Tonfoni during ten years of research in the fields of linguistics, cognitive science and artificial intelligence.

Writing as a Visual Art

You, the readers of this book, are the recipients of this miniature. Here's a brief prospectus!

This book appeals to a wide audience. Its approach and contents are designed to capture the interest of anyone, regardless of age or background, who wants to experience a new way of writing effectively, including:

- Business people who write letters, memos, reports, proposals, directives, legal documents and other business communications as a normal part of their working day.
- Journalists, writers, teachers, students and academics who write articles, stories, books, research papers and other documents.
- Would-be novelists, screenwriters, story-tellers and others who write for enjoyment and self-expression.

The book is for anyone interested in creativity and writing.

Within 200 pages, clearly written and liberally illustrated chapters examine how writing text is akin to creating a drawing or a painting and designing a structure. Intriguing concepts such as 'textual objects', 'textual machines' and 'shaping up text' are presented as aids and techniques for writing effectively.

This book makes Graziella Tonfoni's contributions available to the English-speaking general public for the first time. For readers at all levels, the book offers a new way of thinking about the process of writing, visual tools for creating text, and encouragement in the belief that writing is a natural, enjoyable and effective way of communicating.

Figure A-11. *Miniature for this book*

Miniature

As you learned in Chapter 5, the structure of a miniature enables you to circulate news among people with varying information needs. A miniature has a fairly rigid text-space organisation but this rigidity lets you convey messages concisely and effectively.

Figure A-11 shows a miniature announcing this book to you. The text-space across the top of the miniature contains the title, which in this case is just the title of this book. Below the title, the recipient's name is given,

which is you, and there's also a brief indication of the purpose of the miniature.

The centre part of the miniature tells you the main message of the miniature. The miniature as a whole is summarised in a small space in the lower right corner of the centre part. There are also text-spaces to the left and right of the centre. The text-space on the left contains an explanation, while the one on the right contains a note. The bottom part of the miniature is the glossa, which in this case contains a comment about the book.

Text Decoration

Up to this point the examples in this anthology have dealt with visually representing text globally, so that the shape of the text conveys a perception about the text as a whole. This part of the anthology, however, gives examples of visually representing the text *locally* – that is, sentence by sentence, paragraph by paragraph. This local visual representation of text is called text decoration.

Text decoration concerns how you use the symbols presented in Chapter 3 to enhance and 'adorn' text. Ornamental text decoration is an art that was widely used in ancient times to make text beautiful. Ornaments were placed around and inside text. They made reading more pleasurable and also added significance to certain parts of the text.

In a similar way, symbols can be used to decorate text to enhance its creativity and effectiveness. The symbols provide a visual representation of the intent of a specific piece of text. When used throughout a text, they visibly indicate how the style of the text changes.

To illustrate the use of symbols in decorating text, consider the text about this book on the next page. In this illustration, the symbols appear to the left of the text they represent. The symbols are placed there for visibility. They could also be placed within the text, at the beginning of the sentence they reflect.

Notice that the first paragraph is a narration and therefore the symbol for narrate is placed next to it. Below the narrate symbol there is one for reformulate. This symbol is included only to show explicitly that the text style switches into another style in the next paragraph. The text style continues to change from paragraph-to-paragraph whereas the reformulate symbol is omitted in those places.

The style of text can also change within a paragraph and you can also use the symbols to show this. The text on pages 184-186 is taken verbatim from the beginning of Chapter 3. The symbols are again included on the left side. When the text style changes within a paragraph, you can mark the place it changes with a '/ ' and place the symbol beside. You can also start a new line of text so that you can easily differentiate the text and have enough room for inserting the symbol. The reformulate symbol is omitted when the text changes style because this is implicit.

Writing as a Visual Art approaches creativity in writing as something separate from the content or style of writing. Instead of emphasising techniques to develop dramatic plots or creative writing structures, the book explains how to think about writing in a visual, spatial way so that the *shape* of the text conveys creativity. As readers of the book experience for themselves shaping text, they will develop a new awareness about their own process of writing.

It is the first book to provide concrete, visual aids for writing. These aids, which include specific textual objects and machines, facilitate writing in ways fundamentally different from those offered by technological advances such the personal computer and desktop publishing software.

Finally, through visual metaphors and explicit examples, the book illustrates how to write all kinds of text including narratives, explanatory texts and collectively written texts. The experiences that readers receive apply to all types of writing.

Writing as a Visual Art has almost 200 pages and includes approximately 50 illustrations depicting concepts such as visual writing schemes, visual symbols and textual shapes, objects and machines.

It is written in a conversational, yet economical style. The book brings Graziella Tonfoni's revolutionary concepts and discoveries about writing to a popular level, where they are accessible to and can be experienced by a broad, varied audience.

An appropriate format for the book, coupled with numerous illustrations, provides a visual impact for readers that is consistent with the book's contents. An illustration on the cover of the book can also provide a glimpse of the new ideas presented inside: it could show a textual object, ready to be wrapped up and turned into a cubic story.

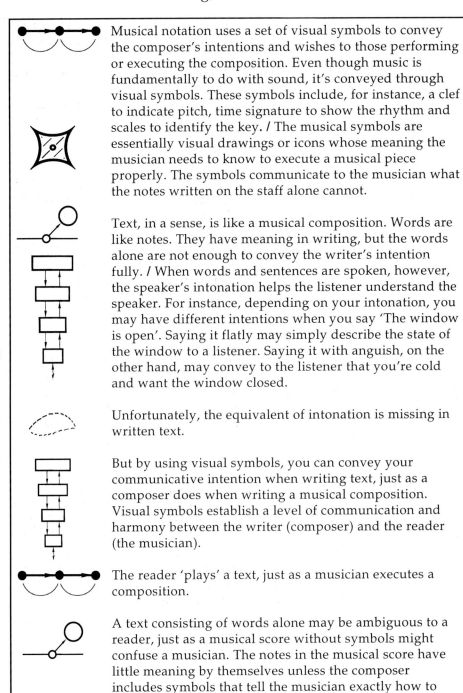

Musical notation uses a set of visual symbols to convey the composer's intentions and wishes to those performing or executing the composition. Even though music is fundamentally to do with sound, it's conveyed through visual symbols. These symbols include, for instance, a clef to indicate pitch, time signature to show the rhythm and scales to identify the key. / The musical symbols are essentially visual drawings or icons whose meaning the musician needs to know to execute a musical piece properly. The symbols communicate to the musician what the notes written on the staff alone cannot.

Text, in a sense, is like a musical composition. Words are like notes. They have meaning in writing, but the words alone are not enough to convey the writer's intention fully. / When words and sentences are spoken, however, the speaker's intonation helps the listener understand the speaker. For instance, depending on your intonation, you may have different intentions when you say 'The window is open'. Saying it flatly may simply describe the state of the window to a listener. Saying it with anguish, on the other hand, may convey to the listener that you're cold and want the window closed.

Unfortunately, the equivalent of intonation is missing in written text.

But by using visual symbols, you can convey your communicative intention when writing text, just as a composer does when writing a musical composition. Visual symbols establish a level of communication and harmony between the writer (composer) and the reader (the musician).

The reader 'plays' a text, just as a musician executes a composition.

A text consisting of words alone may be ambiguous to a reader, just as a musical score without symbols might confuse a musician. The notes in the musical score have little meaning by themselves unless the composer includes symbols that tell the musician exactly how to interpret them.

This chapter presents several visual symbols that you can use when writing to enhance the communication and cooperation between you and your readers. These symbols raise the semantics of text by making its meaning explicit. By using these symbols you will make more apparent to yourself and to your readers what you're doing in the text you write. You will become more aware of how your writing style deeply affects the way your readers react to what you've written.

Two kinds of visual symbols are presented. Each kind of symbol has its own particular use, just as various kinds of symbols do in a musical score. The first kind of symbol characterises the style or type of text. There are eleven of these symbols with the following names: describe, define, narrate, point out, explain, regress, reformulate, inform, synthesise, analyse and express. The name of each of these symbols has a technical meaning that relates to a cognitive process and identifies a specific intention of text.

These symbols are designed so that they intuitively convey the intention of text. They're dissimilar so that you won't confuse them. Their names are all verbs whose precise meanings are based on ancient Latin words. These Latin words carry in their original meaning a strong suggestion about the cognitive process that each symbol represents.

The second kind of symbol facilitates the interaction between you as a writer and your readers. These symbols – called turn-taking symbols – enable readers to interpret text more explicitly and they also indicate when and how you want them to interact with it. You can use these symbols to direct the turn-taking among readers of a text, much as a composer uses notation in a composition to direct the actions of orchestra members.

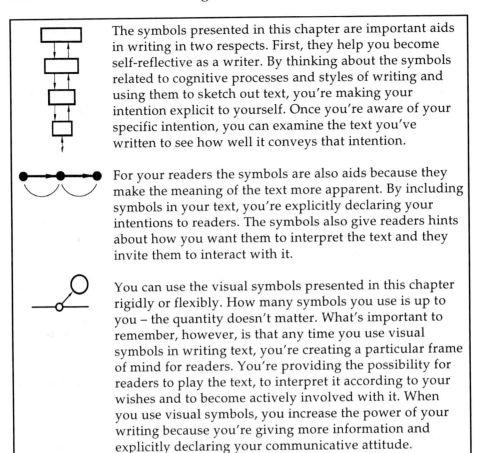

The symbols presented in this chapter are important aids in writing in two respects. First, they help you become self-reflective as a writer. By thinking about the symbols related to cognitive processes and styles of writing and using them to sketch out text, you're making your intention explicit to yourself. Once you're aware of your specific intention, you can examine the text you've written to see how well it conveys that intention.

For your readers the symbols are also aids because they make the meaning of the text more apparent. By including symbols in your text, you're explicitly declaring your intentions to readers. The symbols also give readers hints about how you want them to interpret the text and they invite them to interact with it.

You can use the visual symbols presented in this chapter rigidly or flexibly. How many symbols you use is up to you – the quantity doesn't matter. What's important to remember, however, is that any time you use visual symbols in writing text, you're creating a particular frame of mind for readers. You're providing the possibility for readers to play the text, to interpret it according to your wishes and to become actively involved with it. When you use visual symbols, you increase the power of your writing because you're giving more information and explicitly declaring your communicative attitude.

In the foregoing example, several styles of text were exhibited. The changes from one style to another were generally not repeated. This is not always the case, however, as you can see from Chapter 3, which deals with the symbols themselves. The following example illustrates how changes in text style sometimes follow a pattern.

'Describe' comes from the Latin word 'describo', which means to write about or write around.

You can write a description in a free, unconstrained manner. You can provide as much or as little information as you choose. You can order the information in a description as you want – you don't need to put it in a logical or chronological order.

'Define' comes from the Latin word 'definio', which means to put limits on. Originally 'define' meant to mark off the boundaries of a territory or parcel of property. A definition is similar to a description, except that instead of being open and unconstrained, it's restricted to the selection of relevant information.

When you define something, you provide just the relevant information about it. A dictionary, for instance, gives only specifically selected information that conveys the general, usual meaning of a particular word. It doesn't include every nuance of meaning.

'Narrate' comes from the Latin word 'narro', which means to talk about facts and events in a given order, to tell a story.

Narrating is concerned with writing about a set of facts and events in order. Narration is common in novels, newspapers, magazines and other texts that tell a story.

'Point out' means to take a point (specific event or fact) out of a narrative, focus on it and add more information about it.

When you point out something, it doesn't mean that the other events in the narration are irrelevant. It just means that you're turning your attention for a while to one specific thing and amplifying it.

'Explain' is derived from the Latin word 'explano', which means to unwrap or open up.

When you explain something, you present facts in a cause and effect order. You may start from the original cause and move downward progressively to a set of effects or, alternatively, proceed from the effects and move upward toward the original cause.

'Regress' comes from the Latin word 'regredior', which means to go back.

When you regress, you give more information about a certain item within a chain of information. The regression provides a context for the item so that readers can understand it from a less informed or different viewpoint.

'Reformulate' comes from the Latin words 'reformo', 'reformulo', which mean change shape and to shape again.

To reformulate text, you reposition yourself with a different attitude. You change your writing by switching from one style to another.

'Inform' comes from the Latin word 'informo', which means to put into shape or to shape up.

The symbol for inform is shown in Figure 3-8. This symbol consists of two lines that converge on a point and then depart from it. The point represents some specific information.

'Synthesise' is derived from the Greek word 'synistemi', which means to put together or collect.

You synthesise when you shape up information from a broad or undefined domain to a specific point.

 'Analyse' comes from the Greek word 'analyein', which means to dissolve, loosen or unfasten.

 As the arrow shows, you expand from a small, tight central kernel of information outward. You inform analytically as you break apart, unloosen and unfasten a kernel of information.

 'Express' comes from the Latin word 'exprimo', which means to push out, to press out.

 To express means to give personal and emotional opinions about facts. Expressing is the most subjective style of writing.

As you can see in this example, the style of text written for each symbol generally changes from a definition to a regression. The definition relates to the etymology of the word, while the regression gives more information about its precise meaning in relation to the textual intention.

As a final example of text decoration, consider the following paragraphs:

 'Writers are made, not born', goes the old saying. It's abundantly clear, however, that not nearly enough writers are being made. A survey recently commissioned by the Oregon Progress Board revealed that a majority of the 2,000 Oregon residents randomly surveyed lacked the literacy skills needed to handle the ordinary tasks of daily life.

 Although numerous books herald ways to improve writing skills, few, if any, have succeeded.

 Even among the literate, writing is at best a difficult activity that frequently results in discouragement and ineffective communication.

The first paragraph has the inform symbol beside it and conveys some general information. The next paragraph is synthetical, while the last one is more analytical.

The turn-taking symbols that were explained at the end of Chapter 3 could also be used with these paragraphs. For example, you could include the symbol for saturated rhythm next to the first paragraph like this:

'Writers are made, not born', goes the old saying. It's abundantly clear, however, that not nearly enough writers are being made. A survey recently commissioned by the Oregon Progress Board revealed that a majority of the 2,000 Oregon residents randomly surveyed lacked the literacy skills needed to handle the ordinary tasks of daily life.

The saturated rhythm symbol indicates to you that the writer of the text considers it to be complete and accurate and that you should not add anything to it.

If on the other hand, the writer wants you to add information to the text, the writer could include the unsaturated rhythm symbol and leave some blank space for you to fill up like this:

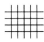

'Writers are made, not born', goes the old saying. It's abundantly clear, however, that not nearly enough writers are being made. A survey recently commissioned by the Oregon Progress Board revealed that a majority of the 2,000 Oregon residents randomly surveyed lacked the literacy skills needed to handle the ordinary tasks of daily life.

The unsaturated rhythm symbol invites you to complete the text by adding more information. For example, you may know more details about the survey commissioned by the Oregon Progress Board. If so, you could write this in the blank space provided below the text.

The other two paragraphs could also have turn-taking symbols associated with them, as this illustrates:

Many books have been written to increase writing skills but most have not been very successful

Even among the literate, writing is at best a difficult activity that frequently results in discouragement and ineffective communication.

The symbol beside the first paragraph is major scale. It signals you that the writer intended the text to be interpreted exactly as it's written, without any discussion. The second paragraph, however, has the minor scale symbol. This time the writer is signalling to you that the text only expresses the writer's opinion and that you're invited to express your own opinion in the space provided.

* * * * *

This ends the anthology. You've read the chapters of this book linearly in the traditional way and they have clearly conveyed the main concepts of the CPP system to you. The anthology, which you've just read, has given you concrete examples of how these concepts may be applied to shape, structure and decorate text. Now you're ready to begin exploring how to write with shapes in space on your own. Have fun as you begin your own explorations and feel free to establish new visual ways of writing that may be very different from the ones presented in this book!